Decade by Decade

Decade by Decade

Twentieth-Century American Photography
From the Collection of the Center for Creative Photography

Edited by James Enyeart

WITH ESSAYS BY

Estelle Jussim Helen Gee

Van Deren Coke Terence Pitts

Martha A. Sandweiss Charles Desmarais

Naomi Rosenblum Nathan Lyons

Bulfinch Press · Little, Brown and Company
Boston · Toronto · London
PUBLISHED IN ASSOCIATION WITH
Center for Creative Photography, The University of Arizona

ILLUSTRATIONS ON PAGE I, FROM LEFT TO RIGHT FROM THE TOP:
PL. 10, Lewis Hine; PL. 18, Paul Strand; PL. 51, Francis Bruguière; PL. 53, Louise Dahl-Wolfe;
PL. 68, Jerry Uelsmann; PL. 85, Judy Dater; PL. 89, Ralph Gibson; PL. 101, Brett Weston.

Center for Creative Photography, The University of Arizona
Copyright © 1989 by Arizona Board of Regents

The Recording Angel and the Sovereign Laws of Beauty: Photography's First Century · Copyright © 1989 by Estelle Jussim
The New Vision in Europe and America: 1920–1930 · Copyright © 1989 by Van Deren Coke
The Way to Realism: 1930–1940 · Copyright © 1989 by Martha A. Sandweiss
From Protest to Affirmation: 1940–1950 · Copyright © 1989 by Naomi Rosenblum
Photography in Transition: 1950–1960 · Copyright © 1989 by Helen Gee
Public Places/Private Spaces: 1960–1970 · Copyright © 1989 by Terence Pitts
From Social Criticism to Art World Cynicism: 1970–1980 · Copyright © 1989 by Charles Desmarais
Afterword · Copyright © 1989 by Nathan Lyons

Copyright notices for the photographs appear in the List of Illustrations.

FIRST EDITION

Library of Congress Cataloging-in-Publication Data

Decade by decade: twentieth-century American photography
from the collection of the Center for Creative Photography/edited
by James Enyeart with essays by Estelle Jussim . . . [et al.].—1st ed.
p. cm.
Includes index.
ISBN 0-8212-1721-6 (hc.) ISBN 0-8212-1722-4 (pbk.)
1. Photography, Artistic—Exhibitions. 2. Photography—United
States—Exhibitions. I. Enyeart, James. II. Jussim, Estelle.
III. University of Arizona. Center for Creative Photography.
TR646.U62T833 1988
779'.0973'074019—dc19 88-25798

This book, which accompanies the exhibition *Decade by Decade*,
organized by the Center for Creative Photography of the University of Arizona,
was supported in part by a grant from the National Endowment for the Arts, a federal agency.

Bulfinch Press is an imprint and trademark of Little, Brown and Company (Inc.)
Published simultaneously in Canada by Little, Brown & Company (Canada) Limited

PRINTED IN THE UNITED STATES OF AMERICA

Contents

Acknowledgments

The architecture of a book, like that of a building, is the result of many minds and talents, all dedicated to a common goal. There are also individuals in both enterprises that contribute in special ways to the spirit of such architecture.

In the course of producing this book, and others before it, I have depended upon the critiques of my friend and spouse, Roxanne Malone. I am grateful for her comments, criticism, and passion for books.

The editors (especially Betty Childs), designers, and production staff at Bulfinch Press, with whom I have had an opportunity to work on several projects, have always made the process pleasurable and rewarding. I am especially thankful for their high standards of design and production.

All aspects of this book have involved staff members of the Center for Creative Photography. I wish to acknowledge the following for their expertise and contributions: Stuart Alexander, Sharon Alexandra, Lawrence Fong, Victor LaViola, Dianne Nilsen, Terence Pitts, Amy Rule, Nancy Solomon, and Marcia Tiede.

I wish to express my admiration and appreciation to the authors of the essays who have provided insight into a unique era of American art history. They have written with eloquence and objectivity.

Finally, I wish to thank the National Endowment for the Arts, a federal agency, for its recognition and support of this project and to gratefully acknowledge all of the photographers, agencies, and individuals who provided permissions for reproduction.

<div align="right">J.E.</div>

vi

Preface

Among humanity's more positive attributes is the unrelenting desire for truth. So insistent are we in apprehending it that, from time to time, we declare that truth's perfect vessel has been found in one or another of the arts or sciences. Oaths are taken to obligate us to its tenets even at the expense of self-preservation, so horrible is the prospect of the wound that the opposite has inflicted upon entire nations. Truth is the measure by which we gauge the value of perception itself: we are told to "read between the lines," where it will always be found; that "beauty is truth, truth beauty."

The desire for truth is as basic to our nature as the desire for pleasure. Yet, we know from experience that recognition and interpretation of what is true greatly varies and defies definition as much as the question of what is art. It is, in fact, the art of telling the truth that historians have taken as their mission in life. While we allow that philosophers are always in search of it, somehow we have come to expect historians to succeed where the rest of humankind has but a tentative grasp.

All history is incomplete, needs constant revision, is guided by individual experience and knowledge, and may be truthful, but it is never the whole truth. The need to be selective is what makes the discipline of writing history an art form. This does not, as the cynic would have it, impair historians or their mission. Rather, the complexity of human enterprise is far too great for a single mind to encompass. Likewise, the path to truth is best observed through the recognition of quality, and that is the goal of selectivity.

With these thoughts in mind, I invited a group of historians and curators to write essays on the history of twentieth-century American photography. *Decade by Decade* is a survey viewed through the collection of the Center for Creative Photography at an unusually propitious moment for both the Center and the history of photography. The Center dedicated a new museum building to house its collection and programs in February 1989, which is also the one hundred and fiftieth anniversary of the public announcement of the invention of photography. The exhibition *Decade by Decade* serves as the inaugural exhibition for the Center's new facility. While cumulatively the essays form a survey of the twentieth-century American portion of that history, each is an independent accounting and judgment of a shorter period of time. Each author was asked to write about a particular decade, and the choice of decade was mine rather than the writer's. In this regard, the authors' greatest difficulty was in trying to write about a restricted period of time rather than the natural flow of events through time. The result was that each essay, necessarily, overlaps with the decades that immediately precede and follow it. But that is the way that life itself is experienced. There is not a clear division between points of time or events within them. Reading about artists and events that are deemed significant by more than one writer is valuable, especially when their reasons for inclusion may not be the same. Various interpretations of a subject by different historians also lend a certain humanity to the otherwise inherent abstraction of the past.

Decade by Decade, in both the essays and selection of artists, is intended to be an introduction to a subject that is now larger than the scope of a single book. In like manner, no single collection, including the Center's, contains the work of all artists who deserve to be included, so there will inevitably be "missing links" in this historical introduction.

Because the authors were each writing about history in this format, decade by decade, the style of each essay is different. In order to ensure their independence of thought and to protect their preference of style, the authors were asked to write without knowledge of the content of each other's

essays. In this way, each essay could stand on its own, independent of the others, and form a closure around each decade. This process helped to reveal the layered nature of history, instead of the usual artificial sense of reality, which suggests that everything happened in sequence, unfolding like a string of postcards hinged accordion-style.

Even in this attempt to divide history as if we wanted to fit it in an egg carton, decade by decade, the complexity of the subject defied simplification. Estelle Jussim was asked to write about the first two decades of this century, but in order for her introduction to be credible, she also had to lay groundwork from the nineteenth century. In a larger sense, the refusal of events and personalities to be isolated from their whole context plagued all the authors. In writing about twentieth-century American photography, authors found it necessary to include references to the international history of the medium. This is as it should be and in no way diminishes the goal of surveying the American contribution. However, in some cases, when major events and contributions did not take place in the United States or when significant influences came from outside the country, the authors found it necessary to write more about the international scene than about American photography.

Van Deren Coke, Martha Sandweiss, Naomi Rosenblum, and Helen Gee had the enormously difficult task of writing about the four decades, from the twenties through the fifties, that encompass the photographers and movements that have come to characterize American photography. Such characterizations are the product of active rather than passive memory. That is to say, everything that transpired within this time period still has living constituents today. What can be described and written about in any of these four decades remains in the memory of society as something that happened yesterday, too close to recent, or active, memory to be assigned to the far-off regions of history, or passive memory. Those who are too young today to have been there are nevertheless subject to memory transplants from those who were. If you know people who experienced World War II and have talked to them, their experiences are now a part of your active memory.

Active societal memory is filled with detail and emotion that have not yet been fully distilled by the passage of time. This makes the writer's task all the more difficult, at least in terms of pursuing a historical perspective. Cézanne is reported to have said that art without excitement is not art. The same is true of writing about history. History without passion is mere accounting. The writers on these four decades had to distill emotional myth from events and personalities without losing the sense of passion that made them stand apart from all else that took place.

Terence Pitts and Charles Desmarais had a similar challenge in writing about the sixties and seventies. Their task was to survey recent history while allowing for what Herbert Read referred to as the all too "atomic" nature of contemporary history. Read preferred to have about a hundred years' distance from events in order to assess their value and contribution. But then he was weaving a much finer net and casting it farther from shore than is necessary today. With the aid of the media and the proliferation of publications on photography during these two decades, we can literally drop the net at our feet and pull in more information than can be included in a single book. An important difference between the tasks of these two authors and the other essayists was that they needed to write about major developments and contributions of photographers who have worked for as much as sixty years, while simultaneously including younger artists whose careers are as short as ten years, in the extreme.

The decade of the eighties presented a dilemma in that it was only half over when this book was conceived, and a survey of its artists and events would necessarily be incomplete if written about in the context of history. However, since artists from previous decades are still working in the eighties, their work and that of a few recently recognized artists are reproduced in the plate section. If American photographers continue to be as prolific and innovative for the remainder of the century as they have been through the end of the seventies, the last two decades will be the beginning of a new era, rather than simply the finish of a century.

The photographs associated with the essays were selected not from those tread-worn images that have become the "masterpieces" of various artists' work, but rather from works of equal quality, yet less known and appreciated. As might be expected, some exceptions could not be avoided and some famous works are included in the figures for reasons of reference or historical perspective. Except where noted, all the photographs reproduced are from the Center's collection.

In 1958, Beaumont Newhall wrote in an editorial for *Image* (the journal of the International Museum of Photography at George Eastman House, no. 63, p. 147): "Each decade since [the first American history of photography in 1864] has seen the publication of a history, by Gaston Tissandier, W. Jerome Harrison, J. M. Eder, Georges Potonniée, Robert Taft, Erich Stenger, Helmut and Alison Gernsheim, and the present writer.

"What we have all forgotten is that history begins with the present, that every era 'is one of the most important that has ever presented itself to the attention of mankind . . . ' To document the present so that it will be available to future historians in a precise and objective form is difficult, but it is important. As historians we should place no time limit upon our researches; we should collect what is available from yesterday as well as yesteryear."

Although it was not possible to include the decade of the eighties in this historical survey, there was still a desire to bring the authors' research as close to the present as possible, not only to heed Newhall's advice, but to represent the Center for Creative Photography's commitment to collecting contemporary work. Also, an interpretive look at recent institutional and critical activity in American photography was needed to give this historical survey a sense of having concluded with the present. For these reasons Nathan Lyons was invited to write an afterword that would explore the support systems that have grown out of this history and that will accompany contemporary American photography into the next century.

The twentieth century is just over a decade from its conclusion. This book, through the Center's collection, presents a view of the American contribution in this century for the benefit of future historians and audiences. Their perspectives on the medium will doubtless be influenced by the radical changes in electronic imaging, which invite contemporary artists' embrace. The "mirror with a memory" may become a CRT with an erasable memory. If so, the artists of the twenty-first century will have a different challenge before them, and the historians' quest for truth will continue to grow in complexity.

JAMES ENYEART

The Recording Angel and the Sovereign Laws of Beauty:
Photography's First Century

ESTELLE JUSSIM

To capture the evanescent forms of nature, to stay the onrushing hands of time, to memorialize the living and remember the dead – these were desires of humankind for centuries, satisfied only partially by the illusionistic art of painting. With the arrival of photography, all forms of visual communication seemed possible. The photographer swiftly became the ubiquitous reporter of the world's happenings, the transmitter of history, the documenter of wars, politics, disasters, feats of engineering, and royal celebrations. The portrait was instantly democratized, each family maintaining its thick albums of tintypes, cartes de visite, or cabinet photographs, collecting the passing shadows of the inexorable progress from birth to dying. The stereograph's imitation of three-dimensional space astonished and delighted the general populace, with Oliver Wendell Holmes bestowing upon photography the ultimate accolade: that it was the Recording Angel, seeing all, even the faintest imprint of a withering vine or the fleeting smile of a bemused child. With photography, there seemed to be the chance of seizing life in all its variety, to set it down for the study and contemplation of phenomenological reality.

Yet there were other needs, longings, desires. To interpret the mysteries of the soul, to express the emotions of passion, awe, or fright, to create the beauty that was spiritual truth and the truth that beauty symbolized, to pay homage to subjective responses to nature and to make manifest the God that was in Nature, to explore the dark secrets of the psyche and of dreams, to give physical form to the indescribable and the imaginary – these, too, were the aspirations of humankind, realized and displayed magnificently in centuries of paint-

ing, sculpture, and the graphic arts. How, then, could an insensate machine that obediently collected light from whatever happened to be in its line of vision, a mere mechanical contrivance for recording, say, the grim visage of your grandfather – how could such a passive instrument pretend it could be an agent of creativity and art?

Contradictions ruled nineteenth-century discussions of what was "Art." Those who were infatuated with verisimilitude and illusionism believed that every minute detail captured by the Recording Angel was proof of the intrinsic artistry of photography, since illusionism and painstaking detail had been twin goals of painting since the Renaissance. Others, like the poet-critic Baudelaire, scoffed at this obsession with representationalism and scorned that aspect of photography that could be admired only for its manufacture of metal and paper simulacra of "reality." Art, said the protesters, had nothing to do with mere illusionism. The art in image-making, they said, was evidenced by a mastery over the undifferentiated chaos of nature. Art consisted in forcing nature to submit to the sovereign laws of beauty, and photographers like Disderi would so proclaim.

Because the images it produced were based on new technologies, photography was destined to call into question almost every notion of what constituted the aesthetic experience. The idea that there might be "sovereign laws of beauty" was not new, although it had been only recently that the late-eighteenth-century philosophers had established the term *aesthetics*. Realism, which defied these sovereign laws, was only then emerging as a style of painting. In trying to understand how a machine could create art, the early critics of pho-

1

ALBERT SANDS SOUTHWORTH & JOSIAH JOHNSON
HAWES, untitled, ca. 1850, daguerreotype, half-plate

OSCAR GUSTAV REJLANDER, *Grief*, 1864, albumen
print

tography, many of whom tended to dismiss the photographer as a mere technician, had to begin to examine problems that would continue to plague the following decades, and that even well into the twentieth century would continue to arouse controversy. These problems centered on issues of form versus content as the primary stimulus for the aesthetic response. For example, in Fox Talbot's calotype of the banks of a Scottish loch, was it the picturesque scene or the photographer's mastery of picturesque composition that elicited visual pleasure? We know now that Talbot, the inventor of negative-positive paper photography, had been conditioned in the art of picture-making by the ideologies of the picturesque, canons based upon paintings, formulated by William Gilpin and Uvedale Price and still current in the 1830s and 1840s. But was there simply something picturesque about Scottish scenery itself?

What photographers as well as critics were

wrestling with was a fundamental issue: of what could photographic *art* consist if the subject (what was photographed) and the object (the photograph itself) were inextricably connected? The photographers' typical response was to imitate painting. Oscar Rejlander created intricate moralizing tableaux by assembling individually posed pictures into a multinegative pastiche like his well-known *Two Ways of Life*. Julia Margaret Cameron, a high-society matron with access to the Pre-Raphaelite painters, imitated their historicisms, their religious charades, and their moralizing genre scenes; many of her portraits, fortunately, escaped this tendency. It must be remembered that much of nineteenth-century painting before the impressionists, and continuing with the academicians, was of a moralizing nature. Only in landscapes, already sanctified because God *was* Nature, were artists freer to pursue the sovereign laws of beauty without serving moralistic purposes.

Decade by Decade

FELIX BONFILS, *Vendeurs d'eau fraîche dans les rues du Caire*, undated, albumen print

Thus, the French calotypists, like Baldus, Henri Le Secq, and Louis Robert, masterfully subdued the distracting details of landscape by subduing them to broadly conceived masses, and followed the ideals of the Barbizons in the serenity and calm of their pleinairism. In this goal they were aided by the physical characteristics of the calotype, Talbot's paper process, which could not supply the infinite detail of the daguerreotype or the succeeding paper process, the albumen print, a product of the 1850s.

With the albumen print, capable of mass production, and the new wet-plate collodion negative, photographers began to record exotic locales from all over the world, from Egypt to India to Cambodia to Japan. In the superlative plates of photographers like John Thomson, Francis Frith, and Felix Bonfils, the extraordinary vistas they were making available seemed of greater fascination to the public than any question of whether or not photography could be called art. Frith and Bonfils were greatly admired for their rendering of light and deployment of compositional features. Their American counterparts of the 1860s and 1870s were admired not so much for their artistry as for their ability to convey geological and travel information about the unknown western United States.

In the large plates of Timothy O'Sullivan or of Eadweard Muybridge, there was, nevertheless, artistry of an equal kind. It was as if the Recording Angel had been taking lessons in the sovereign laws of beauty – the term *beauty* being more or less synonymous with *art* – for many western expeditionary photographers were influenced by the dominant aesthetician of the age, John Ruskin. The intermediary for Ruskin's impact on O'Sullivan was none other than Clarence King, his leader on the United States Geological Exploration of the Fortieth Parallel into some of the most desolate areas of Nevada and Utah. Muybridge was already artistically inclined and had relied upon King's aesthetic advice to help him produce plates he hoped would be considered more beautiful than those by Carleton Watkins, an enterprising photographer who had preceded him into stirring valleys like that of the Yosemite. The government expeditions frequently combined the talents of painters and photographers, with Thomas Moran

CARLETON WATKINS, *View from Camp Grove [Yosemite Valley]*, ca. 1863, albumen print

GEORGE FISKE, *Upper Yosemite Fall (1600 feet) and Ice Cone (550 feet)*, ca. 1878, albumen print

and William Henry Jackson traveling together on the F. V. Hayden tour; Moran eventually painted huge panoramas based on Jackson's landscape views. When John Wesley Powell made his intrepid journeys through the gorges of the Colorado River, with E. O. Beaman and Jack Hillers, they were much too busy with cataracts and clumsy wooden boats, not to mention the bulky wet-plate technology, to concern themselves with anything but straight documentation.

It was with two wars that documentary photography had come into its own, thereby establishing several new issues for the Recording Angel. What was fact? Truth? Accuracy of reporting?

Could photographs be faked? Could the camera capture action or would only the pre- and post-conflict scenes be photographable? Roger Fenton and James Robertson, two pioneers of English photojournalism, bravely documented the carnage of the Crimean War but were forced to depict peaceful campsites and dragoons waiting for battle more than the battles themselves: the light-sensitive emulsions and the lensless cameras were too slow to record movement and action. This would be true also in the next decade for the Mathew Brady entourage (which included Timothy O'Sullivan, Alexander Gardner, and A. J. Russell, among others who later became western expeditionary photographers), and one can only imagine the difficulties of carrying heavy equipment by cart onto the fields at Gettysburg and Antietam, or to the ramparts of Richmond or Atlanta. There are many fascinating comparisons between the experiences of the English and American photographers, many of whom followed the course of empire or frontier after the wars, with men like James Robertson going on to British India and O'Sullivan similarly engaged in a kind of scouting for expansionism through territories being usurped from the Native Americans. In each case, photography served the cause of colonialism, and it is interesting today to look at the photographs of, say, William Henry Jackson or Samuel Bourne, and wonder what they thought about the possible consequences of their enterprises for Washington or London. And, it should be noted, by no means were the sovereign laws of beauty abandoned: Samuel Bourne called himself "the picturesque photographer."

Meanwhile, the French, Germans, Austrians, and Italians busily hauled cameras up to the heights of the Alps, down into the valleys of the Italian lakes, and into the streets of Paris, and peered into every corner of Europe where they could record either natural beauty or the artistic monuments that still summoned travelers to undertake the Grand Tour. The Alinari Brothers, in fact, made quite a business out of recording artifacts — paintings, sculptures, buildings, antique ruins — and by selling them internationally they established the foundations of modern art history.

We can still be grateful for their energies, for much of what they recorded was destroyed in the massive bombing raids of World War II. Adolphe Braun not only climbed the glaciers but also produced charming landscapes. August Bisson made it possible for his contemporaries to view the magnificence of Mont Blanc and the Mer de Glace from their armchairs. Hundreds of Europeans, fascinated by accounts of America's natural wonders and its wilderness, crossed the Atlantic to view for themselves the roaring waters of Niagara. It was the advent of the stereograph that encouraged this frenzy, for with it, as that astute commentator Oliver Wendell Holmes observed, the parlor became the viewing stand of the world. He himself had seen over a hundred thousand stereographic views in just a few years.

The stereoscope, invented by Sir David Brewster in 1849, had an almost immediate effect on the commerce of photography. The English and French daguerreotypists, still active despite Talbot's contributions – or perhaps because of his restrictive patents – were quick to take daguerreotype stereographs, but these could not match the paper prints, usually albumen, which could be cheaply mounted on cardboard and sold in sets. It is well known that Queen Victoria, enthusiastically praising stereographs at the Crystal Palace Exhibition of 1851, began what became known as the stereograph craze. Unlike the daguerreotype, however, which lasted only a few decades, the stereograph became such a ubiquitous instrument of communication and entertainment that it lasted well into the twentieth century, and schoolchildren were still learning from its paper images held in wooden frames in the 1920s. Almost all landscape photographers, or recorders of artistic monuments, carried with them not just the heavy large-plate cameras and plates but the much more convenient stereographic cameras. It was by the sale of stereographs that many photographers earned their livings. Many small companies were founded to take advantage of the stereograph craze, and these often grew into huge conglomerates, like Underwood & Underwood, suppliers of photographs to publishers everywhere. Because it was so popular and so inescapable, stereography ultimately fell

EDWARD AND HENRY T. ANTHONY & CO., *El Capitan, 3300 Feet High, from Merced River,* undated, albumen stereoview

from favor, and thousands upon thousands of stereographs were tossed onto trash heaps, thus destroying what the Recording Angel had worked feverishly to preserve. Not all stereographs were worthy of being saved, of course: there were ridiculous comic tableaux and racist jokes in stereographs, but even these, no matter how inartistic, still preserve humankind's social history as few other artifacts can. A historian could probably reconstruct much of nineteenth-century mores, attitudes, and ideologies from examining an extensive collection of stereographs.

By the late 1870s, with the increasing speed of photographic emulsions, interest in the potential of photography for capturing movement was considerably accelerated. It was at this point that the camera became an adjunct to the science of animal and human locomotion, with reverberations that would ultimately lead to cinema. Stationary objects of scientific interest, like the full moon, had already been successfully recorded. Now it would fall to one of the most artistic of all landscape photographers, Eadweard Muybridge, then living in California, to devise a method whereby an object in motion – a horse in full gallop – could be recorded accurately. Did a racing horse actually lift all four feet from the ground during the gallop, as had been depicted by artists for a century of sporting prints? With considerable ingenuity, in

view of the relatively primitive state of the technology available, Muybridge invented a method whereby such a galloping horse would trip successive wires in tiny fractions of a second. Despite the crudity of the wood engravings reproducing his first results, Muybridge had his findings published in *Scientific American* and *La Nature*, causing many painters of energetic steeds to falter and rethink their depictions.

In the following decade, inspired by Muybridge's progress with photographing motion, Etienne Jules Marey also pursued such problems as the swiftness of a bird's wings in flight or how a cat manages to land on all four feet when dropped from a reasonable height. With Marey, too, there would be repercussions in painting. Ultimately, not only Edgar Degas, with his dancers, but also Marcel Duchamp, with his famous nudes descending staircases, would reveal the direct impact of Marey's studies. Thomas Eakins especially became engrossed in the problems of motion, making a number of motion studies himself, including the famous *History of a Jump* (1884), which featured a nude male lifting his body into the air with a jumper's pole.

It was becoming evident that painters were as much influenced by developments in photography as photography had been by painting. The shining, flat monotones of the daguerreotype had certainly changed the character of portraiture, with even the great Ingres finding it embarrassing to admit his extensive dependence on the invention of Daguerre. Painters began taking photographs of models, among them Delacroix's exotics and the nudes of Eugène Durieu. Later, Cézanne painted from small paper prints of woods and mountains, while in the studio of the American landscapist Frederic Church were to be found dozens of photographic studies of the cloud formations that he used to give authenticity and drama to his large canvases. A paradigm of what was happening in painterly illustrations for magazines and books can be seen in the career of Frederic Remington, who would be discovered to have based almost every one of his dashing pictures on photography. Not only did he rely on photographs for content and details, but he was ultimately enabled to paint for

the publishers in color, thanks to a series of printing inventions that were technological advances in the photographic reproduction of pictures.

The problems of reproducing photographs themselves had been evident from Talbot's earliest publications of *The Pencil of Nature*, a volume that has been called the first book to have been illustrated by photographic prints. The paper prints were glued down and ironed onto the text pages. Several thousand books were illustrated in this tedious, expensive fashion before methods were devised to break up the continuous tones of the photograph into either tiny relief dots or intaglio pits to carry ink to the page. There were several distinct advantages to any procedure that could transform a photograph into a printing surface, as early photographs – including those by Talbot and his calotypist colleagues – had tended to fade, a phenomenon that could have proved the demise of paper photography had not a series of ingenious inventors realized that there had never been any medium as permanent as the carbon inks used in printing typography on linen papers. The carbon print, the Woodburytype, the collotype, and a variety of other complex technologies became the media for reproducing photographs. Finally, there came the intaglio process of photogravure, a superlative medium, printed from copper plates like etchings. Photogravure was to have a significant impact not simply on the making of finely illustrated books, but on the art of photography itself. It became an integral part of photographic conceptual thinking, and perhaps no other single technological invention can be said to have had a greater influence on the development of pictorialism and of pictorialism's monument, the *Camera Work* of Alfred Stieglitz.

The subtlety, permanence, and beauty of photogravure caused one of the prime movers of the 1880s to announce that if platinum papers and photogravure were no longer available, he would renounce photography. The author of that declaration was Peter Henry Emerson, a distant cousin of Ralph Waldo Emerson who had been born in Cuba and who lived in England, independently wealthy and devoted to rambles in the countryside. At a time when literature and all the arts were

revealing increasing preoccupations with "naturalism," a tendency that can be traced to the pervasive influence of photography and the aesthetic and philosophical issues it was raising, Emerson decided that there had to be a scientific basis to art. That basis was to be fidelity to nature, not the kind of minutiae that Ruskin had advocated, but a broadly accurate rendition of the impression that nature makes upon the human eye. That such an idea was coincident with the domination of impressionistic painting could have been expected. Emerson, who had been studying Helmholtz's theories of vision, decided that in order to render in an absolutely faithful fashion the impression of a landscape, something he called "differential focusing" had to be employed. It was his notion that photographs ought to mimic the image received by the human eye, which saw clearly in the center of focus and much less clearly at the edges of vision.

As Nancy Newhall noted in her biography of Peter Henry Emerson, what he was developing was a theory well suited to "the soft light and moist air of England," a theory that would founder when photographers tried to apply it to the sharp, clear light and smogless air of America's enormous vistas. For Emerson, however, who apparently had not seen Timothy O'Sullivan's plates, "nothing in nature has a hard outline, but everything is seen against something else, often so subtly that you cannot quite tell where one ends and the other begins. In this mingled decision and indecision lies all the charm and mystery of nature."

Unfortunately, many untalented photographers mistook this dictum to mean they now had license to produce blurred, unfocused, generally fuzzy pictures. This would lead to many criticisms of the lack of definition in pictorialist prints of the 1890s. Despite his intention of purifying photography of all its storytelling and literary propensities, Emerson's fate was to encourage just the opposite. He wanted scientific truth, or so he thought. His first album of platinum prints (platinum papers had been newly introduced), *Life and Landscape on the Norfolk Broads*, published in 1886, was produced in conjunction with the landscape painter

PETER HENRY EMERSON, *Gathering Water Lilies*, 1886, platinum print

T. F. Goodall. While the prints were greeted with wild acclamation, the strenuous labor of printing eight thousand platinum images made it obvious that a speedier method was needed. Subsequent albums, including *Pictures of East Anglian Life*, reveal some of the clumsy methods he was forced to adopt on his way to discovering that photogravure would be the perfect medium for his poetically diffused landscapes and eloquent Barbizonesque portraits of worthy peasants and fisherfolk.

By 1887, Emerson was a respected, greatly admired photographer, with his first album correctly regarded as epoch-making. A picture like *Gathering Water Lilies* exemplified the potential for beautiful effects relating to his theories of vision, while one like *Cutting the Gladden* revealed the closeness of his ideologies to those of the Barbizon landscapists, especially Jean-François Millet in his peasant threnodies.

Acting as the only judge for a "Holiday Work" contest run by *Amateur Photographer*, Emerson was thrilled by the directness and spontaneity he saw in the work of the young and as yet unknown Alfred Stieglitz. Delighted by Stieglitz's pictures of Venice urchins, which he believed adhered to his own principles of naturalism,

Emerson awarded Stieglitz his first medal. Emerson's pictures as well as his theories made an indelible impression on Stieglitz, who incorporated Emerson's naturalism into his own work and opinions but later failed to give Emerson the credit he deserved or even the honor of an exhibition at his famous Manhattan galleries.

There was an important confluence of technological developments in the 1880s that made it possible for Alfred Stieglitz and his pictorialist colleagues to take advantage of a historic opportunity for innovation in picture-making. Orthochromatic film permitted the more accurate rendition of tones, for previously emulsions had been largely color-blind. Film emulsions became faster. The gelatin dry plate revolutionized the practice and art of photography, first by making the cumbersome and difficult wet-plate collodion process obsolete, and second by making it possible for hordes of amateurs to take pictures with the new hand-held cameras. The new platinum papers, introduced by the Platinotype Company of London in 1879, offered a superlatively subtle, pearly-gray, and permanent image. The perfecting of engraving technologies, especially that of photogravure, made it possible to distribute photographic images to the general public, with the importation of tissue-thin Japan paper offering a definite improvement in reproduction. To this impressive list was added the potential of the gumbichromate process in 1894, which finally gave photographers what some had believed would be necessary for the production of art: the ability to directly manipulate the print, from omitting unwanted detail to changing tonal values almost completely, as well as being able to add pigments to color the final product. It was this invention that precipitated the most vociferous arguments about the nature of photography and that simultaneously made it possible for photographers to claim, once and for all, that their hands – like those of the painter – and not a passive machine, created the print.

Since it now seemed possible that photography could be considered equivalent to painting, or at least to the traditional graphic arts, groups of photographers determined to remove their prints from the museums of science where they were hitherto displayed and bring them into the galleries of art. To announce their intentions, a number of English photographers established the Linked Ring Brotherhood, which first met in 1892. The original members of what became the most important international photographic society of the 1890s included Henry Peach Robinson, George Davison, and A. Horsley Hinton, among others similarly devoted to the cause of photography as art. Conspicuously absent despite his epochal contribution to that cause was Peter Henry Emerson, who in a fit of spleen in response to some scientific discoveries about photographic emulsions renounced photography as art in 1891. Besides, his theories were in direct opposition to those of Henry Peach Robinson, a maker of charming tableaux and an enunciator of the sovereign laws of beauty as implicit in the great masters of painting. Emerson would have nothing to do with painting, not if following the precepts of that art led to the false tableaux using multiple negatives that Henry Peach Robinson produced. Robinson, nevertheless, had been one of the staunchest defenders of art photography and had, in fact, led a rebellion against the Royal Photographic Society's emphasis on the technology of photography rather than on imagery. In forming the Linked Ring Brotherhood, the art photographers were seceding ideologically from the older, established societies, and this idea of secession – which had strong support in avant-garde Vienna as well – led ultimately to Stieglitz's own Photo-Secession.

The Links considered themselves amateurs in the sense of being devoted to art without thought of commerce. They refused to admit studio hacks or photojournalists. Their choice of members on the continent or in America revealed their loyalty to the avant-garde, most of whom were amateurs, although some did become members of the Kodak company, for example, while others earned a living at artistic portraiture. Shiny silver prints were excluded, even condemned; only platinum, photogravure, gum, and other soft-textured, manipulable media were approved. Heavy frames for photographs were excoriated; what was to be encouraged was the use of subtle layerings of

cardboard or paper mats leading to a thin, sub-dued, ungilded frame (a type perhaps initiated by Frederick Evans, a bookseller turned architectural photographer and portraitist Link). Photographs were no longer to be exhibited helter-skelter on walls but were to be treated with refinement, two or three rows only on top of each other instead of rows up to the ceiling. While any examination of the Links' prints and those published in Stieglitz's *Camera Notes* and the later *Camera Work* will reveal a continuation of the tradition of story-telling, many of the pictures seem to be striving for a kind of symbolism. It should be remembered that this was the era of the symbolist painters, of the symbolist poets as well, and that the shimmer-ing poetry, dark prints, and unexpected subject matter of the American Links matched the mood of nuance so beloved by the French poets, espe-cially Mallarmé.

Art historians tend to agree that the twentieth century really began in 1890, with the triumph of the aesthetics of art for art's sake; decorative sym-bolism; the arrival of the Arts and Crafts move-ment spurred on by William Morris and the later Pre-Raphaelite painters; and the powerful influ-ence of Japanese prints – introduced into Europe in midcentury – on the subsequent development of the sinuous line of Aubrey Beardsley and other art nouveau illustrators. What defined postimpres-sionism, as it was called, and the art of Gauguin, for example, was the adoption of Maurice Denis's slogan that before a picture was a war-horse or a nude or anything else, it was first of all a combina-tion of colors and forms on a flat surface. Art was to be decorative, free from moralizing, and sym-bolic. As if to counter the spread of naturalism, which they regarded as only another disguise of materialism, the secessionist painters wanted to restore spiritual and metaphysical auras to their pictures. The photographers were caught between the naturalism promulgated by Emerson and Stieg-litz, and the intense desire to make photography expressive rather than informational.

The ambitious Alfred Stieglitz returned to New York in 1890 and began at once to vilify the retrograde photography of Americans, which seemed far inferior to what he had seen in Europe. Outspoken, energetic, charismatic, Stieg-litz quickly became an inescapable force in Ameri-can photography when he became editor of the *American Amateur Photographer* in 1892. His influence was felt everywhere. He joined or orga-nized photo clubs; he judged exhibitions and salons; he wrote, lectured, inspired, harangued. He exhibited his own pictures. In 1894, after a dis-appointing first rejection, he was elected to the Linked Ring as one of the two first American members. He corresponded regularly with George Davison, one of the most influential Links, whose picture called *The Onion Field*, made with a pin-hole camera, created a sensation in 1890 for its misty impressionism. It was through George Davi-son's enthusiastic letters that Stieglitz learned he had a formidable colleague in Boston, a man of his own age named F. Holland Day. Unlike Stieg-litz, Day was immediately elected to the Linked Ring; like the New York photographer, Day's striking portraits were exhibited all over Europe. Stieglitz was so impressed by the Bostonian's pic-tures of nude "Nubians" that they appeared in the first issues he edited of *Camera Notes*. He thought so highly of them, in fact, that they were repro-duced in photogravure, as any other photo-mechanical process would have been too coarse for their subtleties.

GEORGE DAVISON, *Onion Field*, 1890, photogravure

The Recording Angel: Photography's First Century

It was perhaps inevitable that two internationally famous men who had ambitions for leadership would clash, and clash disastrously. The explosion came in 1899 and 1900, when F. Holland Day, assisted by his young cousin Alvin Langdon Coburn and Edward Steichen, mounted an exhibition at the Royal Photographic Society in London. He was prevented from exhibiting at the salon of the Links by Stieglitz's unconscionable interference. In a blatantly political move, Stieglitz warned the Links that Day's selections for this all-important show were second-rate. Despite Stieglitz, however, the *New School of American Pictorial Photography* was accorded both controversy and wild acclaim, the latter being Day's reward when the exhibition crossed the Channel to be seen at the Photo-Club de Paris. Both Coburn and Steichen defended Day's selections of prints and totally rejected Stieglitz's unfounded canards.

The exhibition of the *New School of American Pictorial Photography* in 1900 was an event of great significance in the history of the art photography movement. It managed to encapsulate much of the controversy that had raged over photography's status as an art. The condemnation it earned from the conservative Britons, who were still insisting that technical perfection was of primary importance, can be contrasted with the enthusiastic raves by the French, especially well articulated by Robert Demachy. What was all this furor about? Essentially, it spelled the temporary end of the dominance of sharp focus as a prerequisite of artistic achievement; it paid homage to the art of picture-making, as opposed to mere picture-taking and technical expertise. Technique henceforth was expected to be subordinate to expressive character, to decorative composition, to nuance, poetry, and symbolism. If the traditionalist English scolded the darkness of the American pictorialist prints, especially a print like Clarence White's *Lady in Black*, the French lauded their delicacy, poetic instinct, decorative structure, and subtle range of tones.

It seems extraordinary that while this fracas was in progress, a genius of photography was quietly walking the streets of Paris documenting almost every aspect of that remarkable city. The Recording Angel had reappeared in the personage

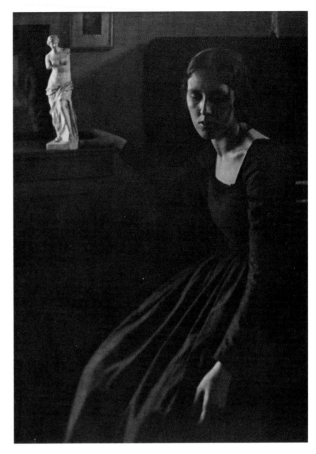

CLARENCE WHITE, *Lady in Black with Statuette*, 1908, photogravure

of Eugène Atget, who unfortunately was destined to live out his exceptional career in relative obscurity and poverty. Yet today he is considered to be perhaps the greatest photographer of the twentieth century, surpassing even the monumental achievements of Stieglitz himself. Like several other noted photographers, among them William Bradford and Eadweard Muybridge, Atget was interested in selling pictures to other artists, especially painters who might want to use the details of his architectural studies and street scenes. André Derain, Maurice Utrillo, and even Georges Braque purchased Atget's prints, but most of them found their way into various archives, like that of Les Monuments historiques and the Bibliothèque Nationale, where Atget remained so little known that his pictures were filed away under subjects without mention of their author.

EUGÈNE ATGET, *Magasin, Avenue des Gobelins,*
1925

EDWARD S. CURTIS, *Woman's Costume & Baby Swing –
Assiniboin,* ca. 1900–1906, photogravure on tissue

Atget's records of buildings, interiors of mar-
kets, shop windows, women lounging in doorways,
artisans trudging the cobblestones, empty vistas of
baroque gardens, riverbanks, and crowds share a
remarkable vision that is haunting and surreal.
Rescued and brought to America by Berenice
Abbott in 1927, Atget's prints had a resounding
effect on Walker Evans and other document-
makers. Without subscribing to the artistic
pretensions of the Links or the American Photo-
Secession, Eugène Atget nevertheless brought to
photography a rare patience and perception that
would prove inspirational to art photographers and
documentarians alike. In fact, it was Atget's
genius to erase the presumed separation of these
two categories, for in his documents of reality he
used great art.

There were, however, times during the first

decade of the twentieth century when the separa-
tion of "art" and "documentation" should have
been more closely observed. The Recording Angel
was not well served by the likes of Edward S. Cur-
tis, for example. Although his motivation was
ostensibly similar to that of Atget – to record what-
ever might be lost irrevocably to the inroads of
modernization – Curtis's pictures of the American
Indians were handsome but unreliable. Years
later, he was discovered to have been cavalier, to
say the least, in his adherence to truth. He had no
qualms about posing Modocs in Sioux costumes,
or photographing native ceremonies that he must
have known were being faked in order to preserve
the sacramental character of the genuine ritual.
His monumental twenty volumes of *The North
American Indian* were compilations of idealized,
romanticized, falsely ennobled portraits of Native

LEWIS HINE, *Homework, Artificial Flowers, New York City*, 1908

Americans who existed largely in his own imagination. No grim details of poverty or exploitation marred his images; nor did such reminders of reality subvert the attractions of, say, Arnold Genthe's photographs of San Francisco's Chinese Quarter. It would be a long time before anthropologists would articulate strictly scientific standards for representing indigenous populations and ethnic groups.

Of all Curtis's contemporaries, it was Lewis Hine who would demonstrate that truth could be artfully rendered, and his *Albanian Woman*, Plate 10, taken in 1905 on Ellis Island, was a masterwork of straightforward beauty in which Hine's exceptional strength of composition evokes powerful emotion. Unmanipulated fact could, in the hands of a great photographer, be as exquisite as fiction.

Lewis Hine was not the kind of photographer that Stieglitz would admire, certainly not when he founded the Photo-Secession in 1902. Stieglitz's vaunted belief in redemption through art apparently did not extend to the downtrodden in the sweatshops; Hine's frank pictures of homeworkers and their exploited children would never interest Stieglitz. The Cause was Art, not social justice. Social concerns never animated any of the so-called Secessions, not in Munich, not in Vienna or Hamburg, nor in Paris or London. All these

Secessions, of which Stieglitz's was only one, were merely intent on removing themselves from the conventional, technically oriented societies. But perhaps no other single photographer ever reached the messianic fervor with which Stieglitz devoted himself to the Cause – the Cause of art photography superseding any other concern. Photography was to be an art equal to any other in an art-for-art's-sake world. But, in 1902, what *was* to be the art of the photograph?

In 1903, Alvin Langdon Coburn sought an answer to this question by attending the Ipswich, Massachusetts, summer school run by Arthur Wesley Dow, a charismatic teacher who had already published a most influential book in 1899; it was called, simply, *Composition*. Dow expounded the theories of oriental art that had already influenced James McNeill Whistler and Edgar Degas. *Japonisme*, as it was called, outlined a complete schema of compositional strategies, all of them involving the organization of shapes with respect to the rectangular shape of canvas or paper, structures of decorative lights and darks called *notan*, the obliteration of illusionistic Renaissance perspective, and the complete rejection of sentimental storytelling, moralizing, or literary values. This strong emphasis on pure visual form was in contradistinction to many of the Photo-Secession's pictorialist themes, with their mawkish symbolism and a continuation of Biedermeier and impressionist styles of painting. Coburn was not only a member of the Photo-Secession but of the Linked Ring, and young as he was, he soon had prodigious fame in both England and America. More than a simple adherent to *japonisme* – he even called himself a "Whistler" of photography – Coburn exemplified the serious aspects of the search for a new spiritualism. He was not alone in seeking answers in Swedenborgianism: Stieglitz, too, was profoundly interested in any philosophy that could counter materialism.

While *japonisme* was a major influence on photography during the first two decades of this century, other painterly revolutions would soon help to demolish the weaker aspects of pictorialism. By 1907, Stieglitz himself was beginning to relinquish impressionist approaches to photogra-

phy. What we today call modernistic art -- cubism, fauvism, futurism, and allied styles -- was already beginning its ascendency. In that year, however, there was an important technical development that further complicated the question of what art was. Thanks to the exigencies of publication, it was generally believed that the history of photography was the history of either black-and-white images or hand-colored ones. Nothing could be further from reality. Depending on what compounds were used, even the earliest calotypes were purple, green, yellow, brown; albumen prints were close to being "black-and-white" but quickly turned brown; printing-out papers (P.O.P.) were customarily washed with gold toning, which gave them an elegant brown hue; photogravures could be printed in colored inks; gum-bichromate prints, similarly, could take on almost any color, from pale orange to greenish tones. None of these was directly colored by nature, however, until the invention of the Autochrome by the Lumière brothers in Paris. To Paris, then, went Stieglitz and his close friend and adviser, Edward Steichen, and soon their fellow Photo-Secessionist, Coburn, joined them to learn the wonders of the new process.

Perhaps the only drawback to the Autochrome was that it was essentially a transparency that had to be viewed against a light. It was not a medium to be hung on walls at exhibitions. Nonetheless, it was so strikingly beautiful a medium that it created a sensation. The technology of the process sounded absurd: glass plates were coated with tiny grains of potato starch that had been dyed blue, red, and green, and the whole was covered with a thin panchromatic emulsion. The dyed particles of potato starch acted as color filters when the plate was exposed. Further manipulations were required before a transparency could be obtained; it was composed of tiny dots of primary colors, giving the charming effect and freshness of light such as pointillist paintings afforded. Next, methods had to be discovered to reproduce these fragile entities in their original colors as illustrations for journals.

In 1903, Stieglitz had begun publication of that remarkable journal, *Camera Work*, in which problems of reproduction were solved in an aston-

EDWARD WESTON, *Sadakichi Hartmann*, ca. 1920, platinum print

ishing variety of technologies ranging from photogravure to mezzogravure to color halftone engravings. It is in the pages of *Camera Work* that we find not only the more famous of European and American pictorialists but also essays on photographic art by a wide range of critics, from Arthur Wesley Dow to Maurice Maeterlinck to Sadakichi Hartmann.

Camera Work nevertheless does not offer us a complete picture of what was happening in photography. Because of quarrels with Stieglitz, photographers who were then considered first-class artists, including Rudolf Eickemeyer and F. Holland Day, were missing from *Camera Work*, although both had appeared frequently in Stieglitz's prior journal, *Camera Notes*. A good study of attitudes toward the treatment of photographs as journal-article illustrations can be undertaken through examining the progress of journals like *Philadelphia Photographer*, *Camera Craft*, *Photograms*, and *American Amateur Photographer*. In

these journals can be found a confusion between the photograph as an artifact of edge-to-edge integrity and the photograph as simply an adjunct to editorial design. What *Camera Work* established as a canon of usage was treating the art photograph with utmost respect, inviolable, as sacred as any art form even in reproduction.

Reading the technical notes for *Camera Work*, a question arises that remains to plague the connoisseur, the collector, and the historian. Many of the plates read, for example, "Original negative; photogravure." Since photogravure was acknowledged as an art medium, equal to any of the printing processes of the traditional graphic arts, how were the reproductions in *Camera Work* to be regarded? Since original negatives were being used to prepare the photogravures, were the five thousand or so prints made for the early issues of *Camera Work* to be considered *original prints*? Today each issue of *Camera Work* is marketed as if this were true, despite the fact that many of, say, Robert Demachy's or Steichen's images were merely photomechanical reproductions. It is true, however, that Frederick Evans and Alvin Langdon Coburn sent Stieglitz photogravures for inclusion in *Camera Work* that they themselves had produced or had supervised at a professional company's press. These problems have become part of the historical context in which an achievement like *Camera Work* requires study.

Despite the popularity of the early issues of *Camera Work*, the circulation of Stieglitz's fascinating journal soon waned as pictorialism itself was passing out of fashion. Even Stieglitz began losing interest in pictorialism as Steichen brought the new moderns – Rodin, Matisse, Picasso, and their influential forerunner, Cézanne – to his attention. The great pictorialists – Clarence White, Gertrude Käsebier, Frank Eugene, Demachy, Kühn – were lagging behind the painters. After years of waging campaigns for his Cause, Stieglitz temporarily dismissed photographic art as having been exhausted. In 1910, he brought the pictorialists together for one last monumental exhibition at Buffalo's Albright Gallery. He even invited F. Holland Day to be represented in this giant retrospective of pictorialism, but, of course, Day refused.

EDWARD STEICHEN, *Henri Matisse*, undated, photogravure

And Stieglitz's once-loyal following began to scatter, several of them, like White and Käsebier, driven away by what they thought to be Stieglitz's tyranny and his occasional irascibility.

The Links, too, were having their own troubles. Competition for places in the international exhibitions was fierce. The ideals of impressionism, naturalism, symbolism, even of *japonisme* were crumbling under attacks by the modernists. Although pictorialism by no means disappeared, and can be discovered repeating its original formulae in the journals of the 1920s and 1930s, its reputation as the avant-garde of photographic picture-making vanished. The new avant-garde was absorbing the lessons of abstraction and pure form, and it was inevitable that photographers would turn to the modernistic painters for renewed inspiration.

The year 1890 had ushered in impressionistic naturalism with George Davison's *The Onion*

Field. The year 1900 marked the success of japonistic pictorialism in Day's New School exhibition. The year 1910 saw the grand funeral of the pictorialist movement as embodied in the Buffalo retrospective mounted by Stieglitz. But 1910 also witnessed the birth of the decade in which abstraction abruptly altered the sovereign laws of beauty.

Having enjoyed the rather wild lectures of futurists like Marinetti, who propagandized his ideas in London, and having acquainted himself with the works of Picasso and Matisse, Alvin Langdon Coburn decided to return to America for a two-year tour of California, the Grand Canyon, Pittsburgh, and New York. During this tour (1910–1912), Coburn, who had already provided evidence of an interest in pure form, is considered to have taken the first abstract photograph. The view was of Madison Square from the Flatiron Building; called *The Octopus*, it was aided in the elimination of unwanted detail by a fresh fall of white snow. What matters more than who took the first abstract photograph, however, is the fact that in the new decade an increasing number of photographs were taken in which the play of pure form was the content of the image.

Much of the impetus for the interest in abstraction came from the increasing presence of the skyscraper and other technological wonders. With ever greater urbanization as the rule rather than the exception, to continue to photograph only rustic lanes or mists rising over the mountain lakes seemed not only anachronistic but perverse. The human form itself seemed to be diminishing in both importance and interest. The airplane, the auto, electric dynamos, gigantic bridges, the mounting inventory of weapons for war — all these, praised by the impassioned futurists as signs of a new age of speed and bombastic energy, would be more suitable subjects for the painter and ultimately for the photographer. The motion picture, made viable by the Lumière brothers in 1895, was now enjoyed by that new social entity, "the masses." The telephone was drastically changing conventional conceptions of time and space. Space was collapsing back on itself with the roar of trains and cars; time was shrinking into milliseconds of activity. The countryside was becoming the envi-

ALVIN LANGDON COBURN, *The Octopus, New York* [a variant], 1912

ALVIN LANGDON COBURN, *The Singer Building, Noon,* ca. 1910, photogravure

The Recording Angel: Photography's First Century 15

KARL STRUSS, *Vanishing Point II: Brooklyn Bridge from the New York Side*, 1912

JACQUES HENRI LARTIGUE, *Cousin "Bichonade" in Flight*, 1905

ronment for holidays for the city dwellers, whose children had never seen a farm. Printed posters screamed from every wall. The dominant environment consisted of the shadows of the crowded tenements, the steel towers soaring above tumultuous streets, the searing pavements of summer, the hiss of steam from giant turbines, the ponderous smokestacks of industry. The world was rushing toward the cataclysm of World War I.

Meanwhile, another aesthetic had arrived, a new array of sovereign laws that would come to dominate the new avatars of the Recording Angel. It had its origins in the hand-held cameras, which Stieglitz had begun to exploit as early as the 1890s. It would be called the "snapshot" aesthetic, and it relied upon few, if any, of the traditional laws of composition or subject matter. Possibly no better exemplar of this snapshot aesthetic existed than the astonishing prodigy Jacques-Henri Lartigue, the epitome of the talented amateur. Like Atget, Lartigue would not be recognized until many decades had passed, but his humorous, childlike vision came as a response not only to the new speedier technologies of photography but to speed and motion themselves. It would be difficult to say which of the two new aesthetics of the 1910–1920 decade would prove more influential subsequently.

In a sense, the famous early abstractions of Paul Strand were balanced on both aesthetics: his hurrying workers on Wall Street, mere dehumanized shadows scurrying beneath the geometry of power, could only have been captured with a fast emulsion and an eye for what would come to be known as "the decisive moment." On the other hand, Strand's pear and bowls of 1915 were playing with pure form in the manner of the cubists. It was the appearance of Strand's powerful images in the last issue of *Camera Work* that truly signaled the end of the pictorialist era and the ascension of the modernistic ideologies. Even so confirmed a pictorialist as Paul Anderson could be discovered seeking to express the vitality of new ideas in his view of the underside of a mammoth bridge (Plate 8).

Strand was not alone in his exploration of pure form. Edward Steichen, highly regarded for

ALVIN LANGDON COBURN, *Vortograph*, 1917

PAUL STRAND, *Still Life, Pear and Bowls, Twin Lakes, Connecticut*, 1915/1983, platinum print

his poetic pictorialist landscapes and bravura portraits, turned to abstract flowers in 1915. Paul Haviland, Morton Shamberg, and Charles Sheeler photographed geometrical or biomorphic forms. Sheeler's exquisite balance between negative and positive space and the classic purity of his vision would lead the way toward the precisionism of the next decade. Even Clarence White, formerly noted for his mystical lyricism, began to experiment with simplified forms and abstraction in his ship pictures of 1917. By 1920, Imogen Cunningham, who began as a pictorialist depicter of fanciful nymphs and diffused forest studies, was putting together abstractions fabricated to be photographed. But perhaps the most surprising event of the decade was the exhibition of total abstractions called Vortographs by Alvin Langdon Coburn in London in 1917. His portraits of the imagist poet Ezra Pound began with a prism that flattened, multiplied, and

distorted the quirky face of his friend into flat, two-dimensional forms. Meeting little approval for this complete rejection of nature as content, Coburn never repeated this extreme experiment.

When the war broke out in 1914, the Recording Angel did not hesitate to follow the armies into the trenches. No outstanding practitioner emerged to equal O'Sullivan or Gardner, but photojournalists and the picture press became more influential than ever; the Spanish-American War of 1898 had been good practice for action-seeking cameramen, and more practice had been available in 1905 with the Russo-Japanese War. New standards of truth made possible by the hand-held camera introduced in the late 1880s and by the faster films perfected by Kodak and other film manufacturers allowed photographers to send back to the civilian population the perfectly clear and horrifying representations of what happened to fathers, hus-

bands, sons when artillery began a barrage. There could be no turning back from the shock of reality ever again. Reproduced with ever greater facility in the magazines and the picture press, photographs brought home war as it had never been seen before.

During the ferocious and senseless carnage of World War I, many poets, painters, dramatists, and graphic artists fled to Zurich and other neutral cities. There they proceeded to savage all conventions of a society that had instituted such a war. They defied the logic of language and praised chance and irrationality as fundamentals of art. Not only did they destroy the sequence of words we call grammar and syntax, but they dismembered the last vestiges of that single-viewpoint vision bestowed upon us by the Renaissance. To do this, the dadaists, as they named themselves, cut apart newspapers and magazine articles, old prints and photographs, recombining them to create parodistic messages and propaganda. These activities – the making of collages – continue today, having had an extraordinary impact on advertising and the graphic arts in general.

Several of the dadaists fled to America, where they were greeted by an enthusiastic and cooperative Alfred Stieglitz, ever the would-be leader of the avant-garde. Stieglitz not only supported the work of artists like Picabia but helped them establish a typographically liberated journal whose effects were made possible by photo-offset print-

ing. In fact, without the advances in reproductive technologies that photography empowered and that were inundating society with thousands of printed pictures weekly, much of the dada revolution in collage and typography would have been impossible.

When the war interrupted shipments of platinum from Russia and Bolivia, several photographers whose aesthetic depended on platinum papers as the basis of subtle gum prints simply relinquished their art. These included Frederick Evans, F. Holland Day, and Robert Demachy. With Europeans fighting for their very lives, an epochal Bolshevik Revolution in the making, and the ultimate entry of America into the war in 1917, many crusaders for photography undoubtedly lost heart. Stieglitz, whose star seemed momentarily dimmed, closed up shop on *Camera Work* with a remarkable issue on Paul Strand and crept away to the solace and eventual inspiration of the abstract artist Georgia O'Keeffe. The postwar generation, dominated by Paul Strand and Edward Weston, along with the constructivists and the precisionists, would reinvent the sovereign laws of beauty. The swing of the aesthetic pendulum brought back shiny silver prints and infinite detail, this time not in the service of the Recording Angel but of "equivalents," *f*/64 geometries, and the snapshot aesthetic. Talbot and Daguerre would have been astonished at what they had wrought.

The New Vision in Europe and America:

1920—1930

VAN DEREN COKE

The twenties were framed on one side by the end of World War I in late 1918 and on the other by the Wall Street crash of 1929. In the early twenties the Americans led the way in innovative photography, especially in the use of the medium for artistic purposes. Paul Strand, for example, moved in close and made a very powerful photograph of the front wheel and related parts of a sporty low-slung car to symbolize that the twenties were destined to be an age of speed and advances in design as well as in manufacturing technologies. To make a living, Strand soon turned from still photography to motion-picture camera work, buying the finest movie camera made in America, an Akeley. Its beautiful mechanical forms and precise way of operating so impressed him that he photographed it in detail, with emphasis on the textures of the machined parts and their exact meshing and interrelatedness (Plate 18). In addition, he photographed the precision machines used to manufacture the camera, treating them as three-dimensional works of art.

As early as 1915, Alfred Stieglitz had recognized Strand's understanding of how details of geometric subjects could be made to stand for much that was new. Stieglitz had long been an energetic advocate of the avant-garde. His enthusiasm and thirst for adventure helped encourage such progressive American painters as John Marin, Arthur Dove, and Marsden Hartley by showing their work in his gallery at 291 Fifth Avenue in New York, where he also exhibited vanguard paintings, drawings, and sculpture by such European artists as Picasso, Matisse, and Brancusi. From "291" there emanated a spirit of liveliness and awareness of new trends. As a con-

sequence, Stieglitz was asked in 1917 to jury the Wanamaker photography exhibition, which attracted entries from major figures like Strand, Charles Sheeler, and Edward Weston. Prizes were awarded to Strand and Sheeler, which demonstrated the increasing significance of photographing modern subjects with clarity and conciseness as opposed to the fuzziness and manipulation seen in the imagery produced by the conservative pictorialists. Stieglitz's espousal of new subjects executed in a straightforward style was a major factor in America's great strides in progressive photography.

Another influential figure was Clarence H. White, who taught classes at Teachers College, Columbia University, and at the school of photography he directed in New York City. White had been an early associate of Stieglitz in the formative years of the Photo-Secessionist movement. He was also a close friend of Arthur Wesley Dow, the head of the art department at Teachers College, whose very imaginative studies of oriental art had resulted in influential new design theories rooted in simplification of all elements. Also influential were the lectures on modern art and design given at White's school by Max Weber, America's most outspoken cubist painter. The key element in Weber's aesthetic was the idea that simplified design was a basic underpinning in all art, whether made by hand or with a camera.

The kind of instruction offered at White's school, plus the example of Stieglitz's and Strand's work, stimulated American photography that stressed simple geometric form and celebrated optimistic attitudes about the future. In Europe, on the other hand, photography was taught as a commercial craft in trade schools without the

ALFRED COHN, [group discussion at the Clarence White School], ca. 1918, platinum or palladium print

attention to modern art developments that made the photographers trained at White's school so successful. They were united in their determination to break with romantic traditions and to incorporate in their work a modern sensibility. Their pictures included informative elements that functioned as exciting abstractions while also having practical illustrative values for advertisements. Commercial photographs of this nature were seen in magazines, newspapers, and posters by millions of people who consciously or unconsciously absorbed a sense of pictorial space and a fresh treatment of time as active ingredients in pictures. A wider understanding of the move to abstraction in painting and sculpture was thus fostered.

The White-trained students paid homage not only to the new aesthetic but also to the achievements of the engineers who were creating powerful and millimetrically exact objects. Paul Outerbridge photographed the crankshaft of the Marmon touring car as if it were a piece of sculpture. Equally sensitive to the aesthetic value of pure geometric form, Anton Bruehl made a dynamic, slanting composition of three large, high-wattage industrial light bulbs. Ralph Steiner worked in the same way when he made a detailed

study of the keys on a typewriter, then an increasingly used and rapid means of communication. Another student at White's school was Margaret Bourke-White, who came into prominence at the end of the twenties as the daring photographer of Cleveland's steel mills. Her images of white-hot caldrons of molten metal symbolized America's surging industrial power. Some of the steel made at the mills Bourke-White photographed was used in New York City's skyscrapers, which were changing the skyline of the rapidly expanding city.

By the twenties, Stieglitz was again photographing New York City after devoting almost a decade to organizing innovative exhibitions in his gallery. He had become increasingly alert to the changes in the height and density of the soaring buildings he saw from the window of his apartment in midtown Manhattan. As early as 1910, he had photographed the skeleton of steel girders being erected above the city's nineteenth-century brownstone row houses, seeing these early skyscrapers as symbols of progress and of America's might. This was still his view in his twenties photographs, but now he was older and deplored the loss of human scale caused by the drive to occupy all of the airspace of America's largest city. He made his point visually with long shadows that cast portions of the city into darkness. By this means he questioned the quality of life led in such an environment and expressed his distress at the new industrial age's potential for dehumanization.

During summers in the twenties, Stieglitz lived away from the city, at Lake George in upstate New York, where he spent much of his time out of doors. Here he conducted one of his most imaginative pictorial experiments, photographing clouds to symbolize his moods. Arranged in specific sequences, these pictures give us a clearer idea than any of his others of how he observed all that was about him and how he turned what he saw into metaphors for his states of mind. The lyricism he found in clouds relates to the freedom of expression composers enjoy when creating sound combinations equivalent to feelings. Indeed, in the 1924 exhibition in New York of a selection of his cloud pictures, Stieglitz used the title *Songs of the Sky – Secrets of the Skies as*

ANTON BRUEHL, untitled, 1927

JOHAN HAGEMEYER, *Castles of Today*, 1922

Revealed by My Camera. But Stieglitz's results were more like the impressionistic or romantic music of Debussy or Brahms than the music of Stravinsky or Schoenberg, the two great modern masters active when he began his work with "equivalents." Stieglitz's imaginative groups of photographs set the mind to work responding to the formal semiabstract qualities of clouds and dealing with long-remembered experiences of childhood, when one found faces or animals or mountains and seas magically suspended in the air.

In the same period as the cityscapes and pictures of clouds, Stieglitz made his extraordinarily compelling collective portrait of Georgia O'Keeffe that was given such vitality by his great love for this woman and the fulfillment he experienced when in her presence. Both the O'Keeffe portraits and the "equivalents" affirm Stieglitz's idea that subjects were merely nominal, that the true subjects were the psychological patterns set up or the spiritual energy felt in a perceptive viewer's mind.

In California, Edward Weston, one of photography's true masters, was making great changes in his aesthetic, beginning in 1920. Weston was exposed to new artistic ideas through his studio partner, Margrethe Mather, who had been a member of the small bohemian art community in Los Angeles for some time and was acquainted with the new directions in international art. Weston's close friendship with Johan Hagemeyer was also influential. Hagemeyer, a well-educated Dutch horticulturist, left his professional field to become a commercial photographer and met Weston in Los Angeles in 1918. As a longtime student of art, literature, and music, he added much to Weston's sophistication, knowledge, and appreciation of these fields. A fine photographer in his own right, Hagemeyer progressed from apprenticeship in Weston's portrait studio to national and international recognition as a photographer in only four years. He was an early and imaginative photographer of urban and industrial subjects

EDWARD WESTON, *Armco Steel, Ohio*, 1922

ing salutes to American technology, these images of carefully engineered industrial architecture are indicative of Weston's dedication to keeping forms simple and of his talent for creating semi-abstractions out of complex subjects.

In 1923, Weston went to Mexico where, over the following three years, he produced some marvelous examples of the ways in which a camera can be used to transform visual reality into universal symbols. For Weston, going to Mexico was like going to Paris for other American artists. There he found very intelligent acceptance of his new sharp imagery, and he greatly expanded his range of subjects in the presence of the rich artistic culture of the Indians. Throughout the twenties he defined his aim of recording "the thing itself," yet we can now see that his dominant concept was not only to reflect what was in front of his camera but also to create forms analogous to observed reality and rich in other dimensions. In this way he leaves the viewer free to profit fully from the range of his imagination, a notion close to Stieglitz's. We sense that the moment Weston chose to take a picture was a moment of exultation. The thing before his camera was certainly there to be seen in his photograph, but in his prints the emphasis was brilliantly placed on forces that had defined a subject's shape and surface as it had filled out and matured, whether it was a shell, green pepper, rock, tree, or especially the nude figure. Weston's responses to the curved outline of a female body were direct and at the same time sensuous. He caused languorous as well as taut flesh to convey a feeling of magic and mystery. Stieglitz's intimate figure studies celebrating his love for O'Keeffe are of a quite different order. Stieglitz was enthralled by a specific woman, Weston by a collection of women; Stieglitz almost furtively revealed the deep passion O'Keeffe's nude body aroused in him, whereas Weston joyously fused form and feelings. From the standpoint of arriving at the absolute essential form of a thing, Weston's viewpoint was more modern, and related, for example, to that of Brancusi, whose work he knew from reproductions in books and art and literary magazines.

After Strand and Stieglitz, Edward Steichen was the most important figure in the early devel-

couched in terms of simple geometric shapes, forms Weston would incorporate more and more into his own pictures of the twenties.

A specific catalyst for Weston's change from soft-focus pictorialism to hard-edged semi-abstraction was an exhibition he saw in 1920 at the Los Angeles County Museum that included a large group of semi-geometric paintings by American artists such as Charles Sheeler, Marsden Hartley, Arthur Dove, Joseph Stella, John Marin, and other pioneers who were evolving various responses to European abstraction. In 1922, Weston decided he must break out of his isolation in California and travel to New York to show his recent work to Stieglitz, the person whose opinion he most valued. While on this journey he made a group of photographs of the Armco steel mill in southeastern Ohio, where he had stopped to visit his sister, his longtime supporter. Uncompromis-

opment in New York of new attitudes toward photography. Steichen was one of Stieglitz's early protégés and a key member of the Photo-Secession group in the pre–World War I years when romantic photographs were printed by various hand-manipulated processes to make them look like paintings. In 1917–1918, Steichen was in France in charge of aerial photography for the U.S. Army's infant air force. To be effective, this type of reconnaissance photography must produce pictures as sharp as possible. This approach carried into Steichen's photography when he realized that his moody, indistinct images made before the war were out of keeping with the world of mass-produced cars and towering skyscrapers. He began creating clearly defined photographs for fashion advertisements and also as portraits of prominent personalities in the arts, literature, and the cinema. He joined the staff of *Vanity Fair*, a picture-oriented monthly magazine directed at well-to-do and sophisticated readers, and also worked for *Vogue*. In his twenties photographs he incorporated aspects of, or paraphrases of, modern art and design – the aura of modernism courted by people who followed new fashions in clothes, interior decoration, entertainment, and literature.

In Europe early in the twenties it was an American painter, Man Ray, who boldly moved photography in new directions. He had begun to experiment with photography as a secondary expressive medium in New York in 1917–1920 under the influence of two new friends from Paris, Marcel Duchamp and Francis Picabia, who initiated the New York dada movement in 1915 while sitting out the war in Europe. Post–World War I New York was slow to respond to Man Ray's painting, his primary interest, so he moved to Paris in 1921 where he rejoined Duchamp and Picabia and continued to create enigmatic dada images and objects. His paintings and objects did not sell very well, so he turned to his camera and began to make his living as a portraitist. Artists and personalities in the fashion, music, and theater worlds were his major subjects. The portraits led to fashion assignments. Both the portraits and fashion photographs were often executed with a flair for unexpected juxtapositions of elements

EDWARD STEICHEN, *Lynn Fontaine*, undated

inspired by dada ideas. However, his most important single contribution to the history of photography was the discovery in 1921 of the cameraless photogram process. While working in his darkroom, he accidentally put a funnel, graduate, and thermometer on a piece of unexposed sensitive paper that had already been in the developer. He has said of what happened, "before my eyes an image began to form, not quite a simple silhouette of the objects as in a straight photograph, but distorted and refracted by the glass more or less in contact with the paper and standing out against a black background, the part directly exposed to light." The dada poet Tristan Tzara was living near Man Ray in Paris and saw some of these photograms soon after they were made. He was very excited by what were subsequently called Rayographs because they were so in keeping with the experiments in automatic writing being carried out by some dadaists. In 1922 a limited edition album of Man Ray's photograms, given the title

Les Champs délicieux, was published. Tzara wrote the preface – a sign of true acceptance into the ranks of the Parisian dadaists. It should be recalled that in the early twenties X-ray pictures were not so well known as today. The mysterious dark and often negative imagery found in X rays linked science with the enigmatic world of dada. Man Ray and his friends saw these images as witty and yet disturbing confluences of very modern concepts of time and space as physical entities. Making photograms and later surreal photographs allowed Man Ray to live a double life, part devoted to commerce, part to art. He bridged the gap and often used his creative photography as a source of ideas for his assigned commercial work.

In Paris, Man Ray became acquainted with the older photographer Eugène Atget, a neighbor, in the early twenties. Through Man Ray, the surrealists became aware of Atget's pictures of mannequins and reproduced some of his work in their magazine *La Révolution surréaliste.* Man Ray and the surrealists thought of this work as the product of a primitive photographer who had a special and intense vision, and it was therefore in line with surrealists' concepts of the unconscious as a source of deeply buried revelations. The pictures that most attracted the attention of the surrealists were those Atget took of mannequins set out in front of stores on the sidewalk. They were seen to have special significance, for these dummies were inanimate, yet possessed aspects of living persons. The incongruity of being headless and handless but dressed in work clothes and apparently witnesses to the passing scene made these mannequins seem to be elements in a dream. Atget's photographs of these clothes-display forms encouraged people to muse about the individuals who would eventually wear the garments so limply displayed. One could supply in one's mind a head or arms and a personality for these strange beings that with a spark of life would change a drably clothed dummy into a living, breathing human. The surrealists, many of whom were philosophical supporters of the proletariat, saw in the coarse clothes draped over the mannequins targets for liberation through their poems, paintings, and photographs.

Man Ray's studio assistant, the American Ber-

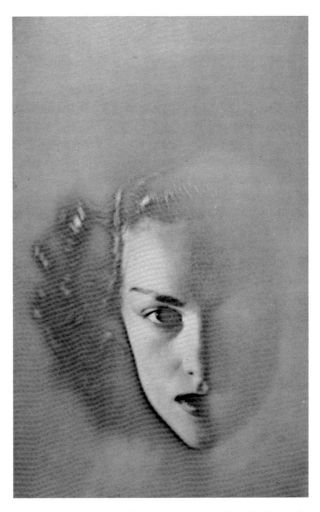

MAURICE TABARD, *Portrait,* 1948, toned and solarized gelatin silver print

enice Abbott, visited Atget in his last years and became so enthusiastic about the special qualities of his pictures that she went on a crusade to acquaint the world with his unusual, straightforward vision, a vision that influenced not only Abbott in her later work in New York City, but Walker Evans and other photographers. In the presence of Atget's pictures the past fills our thoughts, but under the surface of scrupulously recorded reality he was able to express in a new fashion and without sentimentality his emotional responses to the old parts of his beloved Paris. Soon after World War I, Atget sold many of his negatives and a number of his prints of Paris to the French government for a substantial sum. For

the first time this gave him the freedom to photo- graph what he pleased without much regard for the commercial consequences. Little studied until recently are Atget's landscapes of the twenties made when he was in his sixties. He carried out a project in Versailles and St. Cloud on the outskirts of Paris that could be related to Stieglitz's "equiv- alents" produced in America at the same time. Atget photographed trees, carefully tended bushes, and garden urns in a poetic fashion that conveys a feeling of loneliness and makes one consider one's mortality. Because Atget's glass plates were very sensitive to blue, the skies in his negatives were overly dark, which meant that they were recorded in prints as cloudless. This caused trees to be sil- houetted against bald skies, which made for very evocative and symbolic pictures. These late images, taken often in series, evoke a feeling of mystery and make wide-ranging demands on our visual and emotional capacities.

Maurice Tabard, who was initially a commer- cial portrait photographer in the United States, returned in the late twenties to his native France and worked in Man Ray's studio. Unlike most photographers of his day, he often showed his pic- tures, as did Man Ray, in gallery exhibitions. But, like most photographers, he made his living by carrying out commissions for advertisers and cre- ating photographic illustrations for magazines. In Man Ray's studio Tabard became acquainted with surrealist ideas. He soon became a master at using two or three related images to create a sense of fantasy. His most effective procedure was to sand- wich different negatives and print them together. In this way a nightmarish expression – a face seen in two aspects, for instance – could be used to cre- ate the effect of a snarling man with twisted lips and four eerie, offset eyes. The results can be related in formal terms to the overlapping planes found in early cubist paintings, but the emotional effect lies somewhere between surrealism and expressionism. Photographs of this nature make a deep impression, for a sense of wrenching pain is conveyed that focuses our attention on our own past experiences that involve suppressed anger or hurt, whether in a dream or in actuality. Roger Parry was the very talented assistant to Tabard

ROGER PARRY, untitled, ca. 1928–1929, gelatin silver print collage

when he opened his own studio in the late twen- ties. Surrealist photography, Parry realized, could consist of ordinary things brought together yet unaccountably enigmatic in their relationships. The appeal of such pictures may lie in part in the fact that our eyes grow used to seeing in a certain way, and when confronted by something new we tend to be surprised – the surprise being explained as dreamlike. The straightforward representational approach to evoking the feeling of a dream – by subtle inclusions or omissions, combined with unusual illumination – was Parry's way of using enigmatic photography to create surreal images of great subtlety.

In the last few years of the twenties, a number of other photographers in France embraced surre- alism. One of the most imaginative of these was American-born Florence Henri. Early in her life she was taken to Europe where she began a career as a musician; then painting became her focus. In Paris she studied with Fernand Léger and painted some very fine constructivist pictures. By 1927 she had taught herself to use the camera in what soon turned out to be an unusually sophisticated way. By 1929, Henri was creating semi-abstract photo- graphs that were formal in a cubist-constructivist

FLORENCE HENRI, *Obst*, 1929

sense but also enigmatic due to the overlapping of forms and the sense of spatial ambiguity evoked.

Very little avant-garde photography was done in England in the twenties. To a degree, Francis Bruguière's work alone makes up for this lack, so imaginative and inventive was it. He began his career in the early years of the century and subsequently became a professional photographer in his native San Francisco. In 1918 he moved to New York and began studying with the Photo-Secessionist Frank Eugene. Work by Bruguière was soon reproduced in *Harper's Bazaar, Vogue,* and *Vanity Fair.* He also became the Theatre Guild's photographer, which gave him a special appreciation of light as a vehicle for emotional expression. Commissioned in 1921 to photograph the abstract, projected-light compositions created by Thomas Wilfred with his "color organ," Bruguière was enthralled and made his first photographs of pure light. Drawing upon this experience and his knowledge of theater lighting, he made pictures that were created by playing lights across designs sharply cut into sheets of paper. The abstract photographs created in this way reflect the then-current interest in New York and at the Bauhaus in Germany in light as a new art medium. After moving to London in 1928, Bruguière further perfected this technique of using paper as a light modulator and produced some of the most

subtle abstract photographs ever seen. At the same time, he experimented with multiple imagery in a single print to represent two states of mind or actions that could be interpreted as taking place in different locations or at different times. In Paris, Man Ray and Maurice Tabard were carrying on similar experiments, which is indicative of the strides creative photographers were making toward the same goals as abstract and surrealist painters.

In the year 1926, Edward Weston returned to California, never to visit Mexico again, and André Kertész moved to Paris from Budapest. He had spent a decade in his native Hungary doing serious photographs with a hand-held camera, taking as his subjects ordinary people on city streets and peasants out in the countryside whose activities called attention to the importance of freedom for the human spirit. In Paris, to find similar subjects, he became a wanderer along the boulevards, by the Seine, and in the narrow streets in the old parts of the city. Kertész had intuitively recognized from the beginning of his career the value of carefully arranging the elements that make up a photograph in his viewfinder. He achieved a unity of forms, making his pictures more effective as pictorial statements when reproduced in periodicals, the primary commercial outlet for his work. His sensitivity was to subjects that evoke emotional responses, both on his part and on the part of the viewer of his pictures. Children running in a park, adults declaring their love for one another or their pets, or people going about their everyday business in a perfectly normal but somehow curious way were his subjects in Paris. Editors of periodicals in France, Germany, and England liked what he did, and Kertész became a very well known photographer in the twenties. His work for periodicals could be compared to lemonade, that is, it is sweet and refreshing with a hint of acidity to keep it from becoming uninteresting.

Paris in the twenties was just right for a man of Kertész's talents. Not many French photographers understood the possibilities of the hand-held camera, which Kertész used with such originality. At a time when fewer people had cameras, the inconspicuous roll-film camera and, after 1928, the Leica did not call attention to the photogra-

pher's actions, making it possible for Kertész to move close to his subjects without causing them to freeze or shy away. Many of the pictures he made show his sentimental side, but he was a man of great curiosity and saw in surrealism a way to add a novel twist to his photographs. He frequented the café where André Breton and his followers met each evening and soon became acquainted with the group. Some of Kertész's pictures from the twenties indicate that he was alert to their ideas about the effects that could be achieved through the use of incongruities found in quite ordinary things and events.

In the new Weimar Republic, the policies of the German monarchy were denounced as a cause of the nation's defeat in World War I. Traditionalism, a cornerstone of German thought, was challenged by a somewhat liberated society. The new, more democratic society dispensed with many of the trappings of the genteel aristocracy. More broadly educated and assertive in cultural terms, the new generation looked to the future rather than to the once-valued past that had not served them and their parents very well. From 1923 to 1929 prosperity reigned in Germany. Manufacturers and distributors realized that to win public acceptance of their products they must create new ways of presenting the goods they had for sale, and many of those who were involved with advertising turned to photography as one of the most effective means of creating a receptive audience for all kinds of products.

In this period new schools were established and old schools reoriented. Photography as a separate field was only rarely taught, but it entered the teaching programs as a part of graphic design, illustrative art, or as a means of exploring new viewpoints and materials. The most famous of the progressive schools was the Bauhaus, led by the architect Walter Gropius. Here was established the idea of major artists working with technicians to explore new materials, shapes, color combinations, and the integration of the arts and manufacturing processes. László Moholy-Nagy, one of the most influential teachers at the school, was a leader in the twenties in the exploration of new viewpoints for photography, new materials for

sculpture and painting, and new concepts about design. In Berlin, where Moholy-Nagy came when he left his native Hungary after World War I, he met El Lissitzky, a Russian who was studying architecture in Germany but had kept up his contacts with members of the constructivist movement in Moscow. From Lissitzky, Moholy-Nagy became intimately acquainted with the constructivist canons and began working as a designer in a geometric style. While he was aware of abstraction as an aim in art, only in some of his early photograms did he use photographic materials to create non-objective pictures. He found excitement in photographing from high above, which gave ordinary subjects a planometric appearance because a lens tends to flatten out forms rendered from above. With this compression comes surprise and a new appreciation of the relatedness of urban forms. As a result of Moholy's eye for a geometric framework, his photographs reveal the underlying geometry of bridges, sidewalks, and buildings. He became one of the most successful apostles of the new photography, for he saw that the world in the twenties was distinctly different from that of the past. This difference was environmental as well as psychological. Time and space took on new meaning with the widespread use of telephones, artificial illumination, electric streetcars, and fast automobiles. He had great faith in new products, such as plastics, or in new uses of old products, such as glass. Machine-manufactured goods and efficiently assembled buildings did not require elaborate and laboriously created decorations, which for him symbolized a past dominated by an elitist class who used such costly adornment as a symbol of wealth.

Moholy believed that photography was especially suited to deal with the post–World War I modern world of streamlined architecture and manufactured objects neatly packaged in geometric shells. For him the modern camera, an instrument born of technology, was ideal for the twenties because it created images with light, making it possible for photographers to dispense with laboriously learned manual skills. He often expressed the view that the camera, being accessible to everyone, would become a means of

communication on a par with writing. In his foundation course at the Bauhaus, where he became a master teacher in 1923, he did not teach photography as such but did acquaint his students with the medium and had them make photographs to liberate their minds from convention. The future in his view was exemplified by the action of light on photosensitive materials, a process distinctly removed from any hand-manipulations, which he associated with the past.

In the effervescent twenties, the arts flourished in Berlin, with new directions in cinema, drama, painting, as well as photography. Prosperity reigned and gratification of the senses was an accepted aim. In the late twenties, a new breed of photographers very attuned to the times began to catch on film Berlin's flashing lights and jazz musicians playing in cabarets where men wore women's makeup and art talk flourished. Newspapers like the *Berliner Illustrirte Zeitung* and the *Münchner Illustrierte Zeitung* and magazines such as *Die Dame, Die Koralle*, and *Uhu* eagerly published photographs of such subjects. But these mass-circulation periodicals and newspapers also presented examples of the new sharp realistic photography used to enliven reports on international and domestic events of major and minor importance. Among the leaders of this new use of photography were Dr. Erich Salomon, Felix H. Man, Martin Munkacsi, and Umbo (Otto Umbehr). These four men shaped the definition of what came to be called photojournalism, a new and sophisticated form of reportage, quite separate from routine newspaper photography. Whether photographing topical events or directing their cameras at newsworthy personalities such as film stars, politicians, and famous felons, they presented a point of view. Photojournalists, who worked in quite individual styles, often used the picture-essay form when commenting on – rather than merely recording – the activities of the rich and famous or the obscure, or natural or man-made disasters.

Dr. Salomon specialized in secretly photographing courtroom activities and, without their subjects' knowledge, diplomats and world leaders discussing privately – so they thought – the prob-

lems of the post–World War I world. He was able to do this because people were unaware of the ability of his small camera to take photographs in low-light situations. He would conceal his Ermanox, which was equipped with a very fine and extra-large lens, and await his unsuspecting subjects. While only as large as two packs of cigarettes, the Ermanox had to be used on a tripod or some other solid base because of the slow shutter speed needed in what was often a low level of light. Frequently, he would place it behind window curtains located near his subjects and casually wait until the moment when gestures or facial expressions would suggest the conversation taking place; then he would quickly pull the curtain aside and make an exposure on one of his little glass plates. Salomon was a dignified man who looked and dressed little differently from his special subjects. When it was necessary for him to talk to these people or their aides, they found he spoke a number of languages and was well versed in politics and the changes taking place in the twenties as Germany began to assume a major role in Europe again. His photographs made with candor took on new dimensions, for they had such immediacy that the readers of the periodicals he served accepted them absolutely as unposed and truthful, and ordinary people were given the feeling that they were seeing firsthand the famous personages mentioned so often in news reports.

Hans Felix Siegismund Baumann took the simpler name of Felix H. Man in 1929. A year earlier he had become a free-lance photojournalist after a career as a draftsman for the *Berliner Zeitung am Mittag*. He had been introduced to art at various universities where he took courses in fine arts and art history. Like many people, he photographed for his own pleasure, and when he became a professional draftsman, he used the camera to provide visual notes for drawings. By the late twenties he had come to the conclusion that the camera was more successful than the pencil in expressing his views of everyday life and more convincing for viewers. It was Man's aim to catch his subjects in a natural state, whether at work or at leisure. To do so, he used an unobtrusive camera and existing light (like Salomon, he

did not work with the then-popular magnesium-powder flash, which was very conspicuous when being used, as well as smelly and smoky after it was set off). He often used evidence of psychological relationships in his famous photo essays, which were designed to convey a feeling that the viewer was present at the event, as well as to suggest underlying responses to situations without posing his subjects or disturbing them by his presence.

Munkacsi, the least studied but one of the most accomplished of these four photographers, began his career in Budapest as a photographer of sporting events, then came to Berlin in the early twenties. He often demonstrated his keen eye for moments of gripping intensity, moments that summed up the dangers and excitement of a sport, such as his split-second picture of a motorcycle racer splashing through a puddle of water at high speed causing a geyser of mud to erupt around him.

Umbo studied design at the Bauhaus beginning in 1921. This gave him a greater awareness of form as an element in picture-making than either Salomon or Man had. He was by nature an experimenter. For instance, he used X-ray film to create a limited range of tones in his stark pictures of the actresses who frequented Berlin's fermenting cabarets. He shot from high above and straight down on people on city streets, often working late in the afternoon on clear days so that the people cast long shadows. In doing so, he reduced references to reality and created enigmatic shapes that, while decodable, are interesting as semi-abstract forms.

The work of these photographers was in tune with the interests of the public. Recognizing that "new vision" photography, as it was called, could feed the appetite for pictures freshly and honestly arrived at, editors in Germany provided prime space in all kinds of periodicals for the work of those who had liberated the medium from aggrandized portraits, Arcadian landscapes, and sentimental narrative pictures. Among the insightful editors who had a special appreciation of the new look these photographers brought to reportage were Kurt Korff of the *Berliner Illustrirte Zeitung* and Stefan Lorant at the *Münchner Illustrierte Zei-*

UMBO, *René Cretin and Sylta Busse*, 1930

tung, who later became an influential editor in England and in America and thus transplanted the innovative ideas of these photographers who had created a new means of visual communication.

In Germany there were a number of other innovators working with the camera. One of these was Albert Renger-Patzsch, who did not allow his personal responses to subjects to intrude in his pictures of buildings, machines, and botanical specimens, which he photographed with a formal certainty free from such artifice as unusual angles and dramatic shadows. His low-key approach made it seem as if the subjects presented themselves, but careful spatial and textural organization were used to give visual interest to his clinical-level records. His pictures might have been made for a casebook or a sales catalog, which in fact was sometimes true. There is, nevertheless, a somber

FRANZ ROH, untitled, ca. 1925

elegance to them that possibly reflects the photographer's abiding respect for technology and science, the new religions of the twenties. A selection of his pictures was reproduced in his landmark book, *Die Welt Ist Schön* ("The World Is Beautiful"), published in 1928. These images made one very aware of the nature of surfaces – whether they were clean or dirty, smooth or rough – and emphasized the repetition of forms and details of construction of plants, machines, buildings, and even animals.

Renger-Patzsch's book was one of a number of influential books published in the late twenties that contributed greatly to the increasing awareness of creative photography. Others were *Es Kommt der Neue Fotograf* ("Here Comes the New Photographer") by Werner Graff, 1929, and the trilingual *Foto Auge/Oeil et Photo/Photo Eye* by Franz Roh and Jan Tschichold, which also appeared in 1929.

In writing about his aims, Renger-Patzsch did not emphasize art or beauty but did demonstrate frequently in his photographs that that which is well made and functional has beautiful qualities. Some of his photographs of plants resemble the close-up photographs taken by Karl Blossfeldt, a sculptor who taught modeling at a Berlin technical institute. Early in the century he made enlarged photographs, against a plain background, of stems and branches of plants to be projected as lantern slides so that his students could see the forms nature takes and model their designs for decorative ironwork after botanical specimens. His photographs are very important for the twenties because their clarity and emphasis meshed with the new ideas about basic forms that were being broadcast by the cubists and constructivists. His work was known only in a narrow circle initially, but in 1928 a fully illustrated book of his photographs was published, *Urformen der Kunst* ("Art Forms"), which became widely known and respected for both the technical sophistication it represented as well as the amazing revelations the photographs provided about the beauty of nature's "architecture."

August Sander was another German photographer representing the flow of creative energies that characterized the twenties. Sander, who made some of the most compelling portraits ever taken, is often classified as a social commentator, which is correct when we consider the man's stated reasons for carrying out his program of photographing all kinds of people. We must also realize, however, that his pictures were created with the eye of a man who had trained for a time as a painter – and was conceptually influenced by his close association in 1919 with members of the Cologne Progressives such as Heinrich Hoerle and F. W. Seiwert. As early as 1904 he gave his studio the name "August Sander's Laboratory for Artistic Photography." Prior to World War I he set out on his course of documenting the various social classes that existed in Germany. In the post–World War I period he more carefully divided

KARL BLOSSFELDT, *Cucurbita* [magnified 4 times]

them into clergy, craftsmen, free-lance persons, intellectuals, the military, and peasants. His technique was to photograph his subjects in environments that were connected with their daily work and that he thought were symbolically significant and would give us a clearer understanding of what he wanted to tell us about each person. Sander intended to be objective and bear witness to the part individuals played in the makeup of a class and the influence various classes exercised in shaping the "Germanness" of the population of the country as a whole. Like most artists who begin by observing reality, he created portraits that masquerade as reality but in truth are metaphors for people's narcissism, their empty coziness, and the suffering that results from the regimentation of the human spirit. Sander sought to reveal what was behind the facial mask held up to the world, to disclose, through poses assumed by his subjects or chinks in their psychological armor, pretensions and personality traits that result in unconscious

mannerisms. He used the camera's ability to catch unconscious class distinctions based on a subject's vocational garb and surroundings. There are questions about the success of his project, but no question about the interest his portraits have generated, because we too are human beings and see encapsulated in Sander's photographs common emotions and desires of people conditioned by patterns of behavior shared in Western society.

We must again turn to America. In 1927, Ansel Adams, now a major figure of photo folklore, turned from aspiring pianist to professional photographer, having used his camera for a decade as an amateur's tool to record trips into California's high mountain country. The physical world of nature in its grandest manifestations attracted Adams, a reflection of his birth and residence in the American West. He developed in his best work of the twenties a romantic and very popular aesthetic based on a passion for geology, climatology, and the great trees that flourish in the higher altitudes of the mountains. By the end of the decade he would join with Edward Weston and establish a "school" of photography that could be called "California Sharp," so crisp were the images produced.

In the East, Charles Sheeler, a well-established photographer as well as a painter of first rank, was commissioned in 1927 by the Ford Motor Company to photograph with full freedom their River Rouge works, the largest in the world, located near Detroit. For this group of needle-sharp pictures he borrowed the geometry of cubism and looked back to his early years as an architectural draftsman. He chose to address most of the structures of this huge and pristine new plant square on, to invoke a schematic sense of the plant's layout and to refer to the systematic way cars were assembled in the most efficient manner. This approach to the building, plus the absence of people, give his quite realistic images a semi-abstract quality that raises them to the status of symbols standing for much more than an arrangement of industrial structures. They convey a feeling of compressed energy and are emblematic of the dynamic achievements brought about, with much pride, by American engineers, whether

working for Ford or other giant manufacturers of precision-made products.

Edward Weston's son Brett, whose ultra-sharp photographs are in some way similar to both Adams's and Sheeler's, began his career as a photographer in Mexico in 1925 when he was only fourteen. In the years when Adams was establishing his professional career and Sheeler was creating symbols of America's industrial might, young Weston, still a teenager, became a seasoned creative photographer carrying out assignments for various industries in the Los Angeles area. Intuitively, he had absorbed from his father how to place his camera exactly to call attention to the formal relations of parts of industrial buildings, power transmission towers, and manufactured products such as high-fired ceramic pipes. He had a sure eye for interesting patterns and the technical skills needed to make telling pictorial use of the differences between the textures of variously finished metals or types of ceramics, or, when addressing subjects in nature, the surfaces of leaves. In these respects, by the late twenties he was the equal of his father.

In the twenties large photography exhibitions were organized in Germany unlike those held elsewhere. These contributed to the popularity of photography as a medium in that country and made advances in camera design and improved films and papers known to the rest of Europe. In 1928 at the *Neue Wege der Photographie* exhibition in Jena, examples of "new vision" photography were first included, such as the needle-sharp and impersonal pictures by Renger-Patzsch. Also included in this key exhibition were examples of the work of Moholy-Nagy, his wife, Lucia Moholy, Walter Peterhans, and Umbo – all very innovative photographers with Bauhaus connections.

Large exhibitions of innovative photography did not take place in the twenties in other European countries except in France, and even there in only one instance. There was held in Paris in 1928 the *Premier Salon Indépendant de la Photographie.* Included in this major exhibition was the work of such masters as Man Ray, Paul Outerbridge, Berenice Abbott, Germaine Krull, André Kertész, and Eugène Atget, who had only recently died and

BRETT WESTON, untitled, 1928

whose special vision was beginning to be appreciated.

The culmination of the series of exhibitions in Germany that concentrated on the display of new technical achievements and the use of photography in advertising, science, and communication as well as creative work was the 1929 *Film und Foto* organized by the Deutsche Werkbund in Stuttgart. This international exhibition brought together usual displays of photographs used in science, commerce, and industry plus large selections of experimental work. Moholy-Nagy created an introductory gallery for this exhibition that gave a synopsis of the history of photography. Of special importance was the exhibition of "new vision" photographs, designated as such and organized by photographer rather than by subject, which gave these avant-garde photographers new status and increased public awareness of the revolutionary photography that was gaining acceptance in Germany. The *Film und Foto* exhibition also included

outstanding examples of creative photography as it was practiced in the United States. Edward Steichen was asked to select the photographers from the East Coast best representing that part of the country, and Edward Weston did the same for the West Coast. The East Coast was represented by Steichen, Sheeler, Steiner, and Paul Outerbridge. Weston chose pictures by his son Brett, his own work, and the work of Imogen Cunningham, his longtime friend, who was photographing details of flowers and cacti to call attention to their structure. Her pictures were much admired in Germany, for they were similar in many aspects to the close-up photographs they were familiar with by Renger-Patzsch and Blossfeldt.

Outside of the United States, Germany, and France, some strong and imaginative photography was also being produced. The Russian Alexander Rodchenko was one of the most daring photographers of the decade. He began a career in painting in 1914 in Moscow and soon evolved an abstract, geometric style. When the Russian Revolution took place in 1917, he was wholeheartedly in favor of the movement's major aims, for he saw art as a means of reshaping society after generations of oppressive czarist autocracy. Rodchenko continued to work in a geometric style in the early twenties when dealing functionally with type and poster layouts, but he realized that recognizable elements in propaganda imagery evoked the most effective responses. For pictorial ingredients he turned to photography, an outgrowth of his belief in Lenin's dictum that "art belongs to the people." He became adept at cutting up and using other people's work, but by 1924 he was taking his own eminently recognizable photographs. His diagonal compositions of lines of marchers shot from above exaggerated the effects of foreshortening, divorced events from firsthand experience, brought pictorial vitality to his pictures, and generalized his message that there is strength in discipline and unity. Some of the most striking photographs were those in which he used new viewpoints: he might photograph large groups from above to evoke a sense of the collective power of workers, or isolate a standing courier using a wall telephone, shooting from directly above the subject to convey a sense of fic-

IMOGEN CUNNINGHAM, *Agave Design I*, ca. 1920/ ca. 1975

titious reality as one might find on a billboard. Rodchenko's photographs reflect his ideas about mass culture and the proper functioning of "artist-engineers," among whom he numbered himself. His philosophical aim was equal access to his imagery by all members of the community, but as a creator of "pictures," he could not repress his sense of the powerful role of geometry and the free spiritedness of the constructivists who so influenced him as he was maturing artistically.

As the result of the Versailles Treaty and President Woodrow Wilson's strong belief in self-determination for the people of Europe, Czechoslovakia became an independent country in 1919. The capital, Prague, a wealthy industrial city and long a center of artistic ferment, quickly became a place where experiments in abstract painting, sculpture, and photography were fostered. As early as 1922, Karel Teige, a member of the group "Devětsil," strongly presented in an article titled

"Foto Kino Film" the view that photography and film were the truly authentic means of expression for the twentieth century. Jaroslav Rossler and Jaromír Funke were two of the pioneers in the avant-garde photography movement who gave substance to this view. They often took as their subjects architecture and details of machine-made products that had geometric characteristics. Close-ups and angular arrangement of the elements in their images related their photographs to constructivism; thus they were pivotal in the spreading of the concepts of modernism as they relate to photography, for their pictures were seen all over Europe in the form of reproductions in magazines directed to the art-oriented public.

Photography in Europe and America during the decade 1920 to 1930, influenced by new art movements, major social changes, and the availability of new equipment, reached a high level of innovation. Formal inventiveness was displayed and new subjects were photographed as a deeper understanding of the language of the medium was developed. By 1929 the three streams of new photography – photojournalism, formalism, and surrealism – were in flood stage. This was due to increased competition in photojournalism and commercial photography to be "modern"; the assimilation of constructivism into Art Deco as a style that could be adapted to all kinds of subjects; and the example of surrealism as a new avenue for self-expression as well as a means of creating startling new commercial work and fashion photographs. Rich ideas were opened for expansion by younger photographers such as Walker Evans, who in 1928 was just beginning what was to become a very distinguished career. He initially enlisted under the T-square and triangle banner held high by Sheeler and concentrated on the formal elements of looming bridges and skyscrapers shot looking up. In his later work, form became the foundation for content as he evolved a greater concern for the vast social changes that took place in the thirties.

The twenties were, for Evans and many others to come, heroic years for photography. It was a period when profits and practicality reigned, which created a demand for camera-made pictures because they were accepted as being true, as opposed to the drawn or painted illustrations popular with advertisers in the pre–World War I period. After the war, editors of picture periodicals and advertising agencies created a burgeoning demand for new visual stimuli that would reflect the spirit of modernism that was burning so brilliantly in this ten-year period. The photographers who broke with traditional concepts to bring into focus events taking place all over the world also invoked the new vision to make striking images to stimulate the sales of a new and refined generation of products and services. New techniques and approaches – among them carefully calculated dizzying perspectives, photograms, negative prints, and solarized part-negative/part-positive images – were used by artists like Moholy-Nagy in Germany and Man Ray in France and their followers to objectify the period's fascination with Freud's ideas about the subconscious on the one hand and machines and steel-and-glass architecture on the other. The avant-garde photographers of the period turned flat facts into bold pictures that are still aesthetically challenging and that provide fresh insights today about the incongruities of the fast pace of life in the major centers of Europe and America.

The Way to Realism: 1930–1940

MARTHA A. SANDWEISS

"The arts alter their modes of expression and their emphasis on subject matter, their ideology and their iconography, as society changes," art critic Elizabeth McCausland wrote in 1939. "Today we do not want emotion from art; we want a solid and substantial food on which to bite, something strong and hearty to get our teeth into. . . . We want the truth, not rationalization, not idealizations, not romanticizations. . . . The new spirit in art (if, after all the talk, we agree that photography is an art) represents a drastic reversal position from the twenties. One cannot imagine a Joyce or a Proust producing documentary photographs, if photography were their medium. . . . The cult of non-intelligibility and non-communication is no longer fashionable; only a fringe of survivors makes a virtue of a phrase which is a dead issue."[1]

Thus, McCausland summed up the central change that had taken place in American art and literature during the Great Depression of the thirties, as the modernism of the late teens and twenties gave way to realism. As a concern for the present superseded a faith in the future, debates over the proper use and function of art replaced discussions of style, straightforward depictions of social conditions predominated over abstract compositions, and artists took a renewed interest in America's rich vernacular culture.

All of these changes took place in photography, and no group illustrated them so well as the association known as Group f/64, which in its brief history moved from an exclusive concern with stylistic problems to an interest in the proper subject matter for art. Founded in Oakland, California, in 1932 to promote the tenets of straight, unmanipulated photography, this loosely organized group of seven photographers – Edward Weston, Ansel Adams, Willard Van Dyke, Imogen Cunningham, Sonya Noskowiak, John Paul Edwards, and Henry Swift – crystallized many of the tenets of the so-called new or modern photography of the twenties. They derived their name from the smallest f stop, or aperture, on the camera lens to suggest their dedication to clean, sharply focused images, and they used view cameras and glossy silver printing papers (instead of the textured papers preferred by many pictorialists) because they could produce sharper, more precisely realized photographs. Echoing some of the interests of American and European modernists of the twenties, they placed an emphasis on purity of form and had a deep respect for the camera and its technical capabilities. Although the group never had any formal structure, it articulated its point of view through a highly visible exhibition at the M. H. de Young Memorial Museum in San Francisco in 1932 and an articulate letter- and article-writing campaign in the West Coast journal *Camera Craft*, led chiefly by Adams and Van Dyke.

The group's stylistic stance was directed at both the popular California pictorialist William Mortenson, whose elaborately staged and manipulated historical portraits and tableaux had a wide audience, and the influential New York photographer and art dealer Alfred Stieglitz, whose arrogant attitude toward West Coast artists had disturbed several group members. The vehemence of the group's critique of the soft-focus, idealized imagery of pictorialism – Weston referred to it as "anemic impressionism" – was a measure of the fact that the members of the group had all begun as pictorialists themselves and had only recently repudiated its philosophy.[2]

In the early thirties the Great Depression had not yet made itself felt in the group's insular Cali-

EDWARD WESTON, *Dunes, Oceano*, 1936

fornia world. As Willard Van Dyke recalled, "It was a time of unrest and poverty, but for many West Coast artists the stock market crash of 1929 brought little change to their ways of living. . . . Many of our homes and studios were simple, and rents were low. Our needs were simple, also, and few of us owned a share of stock. The East Coast, with its breadlines and apple sellers, seemed like a faintly heard rumor."[3]

It seemed at first that Group *f*/64's well-articulated style could be realized only through select subject matter, a problem that had also plagued practitioners of the "new" photography of the twenties. The show at the de Young included a preponderance of close-up views that emphasized the pattern, texture, and inherent qualities of the subject, what Weston called "the very quintessence of the thing itself."[4] There was an emphasis on found objects – plants, bones, vegetables, old fence posts. The subject matter seemed so closely linked to the style that in the fall of 1933 a California critic looking ahead to a new Weston show could write, "Landscapes have been something of a bugaboo to the 'new photography' and it will be exciting to see what Mr. Weston can do with this problem."[5]

Weston's close-ups of found objects suggested

the influence of Diego Rivera and the other Mexican muralists he had met in Mexico in the twenties. The Mexican muralists used folk motifs and commonplace objects in their work as political emblems of popular culture, but Weston used vernacular objects differently. He did away with their political meaning, as he switched from photographing clay figurines in Mexico to photographing peppers in California. The apolitical content of his work was typical of the work included in the one and only *f*/64 exhibition. The pictures were intended to be perceptual not conceptual, totally unlike the work of the pictorialists, for whom an "idea" or concept was the key ingredient for a successful photograph. Weston wrote in 1932, "Fortunately, it is difficult to see too personally with the very impersonal lens-eye: through it one is prone to approach nature with desire to learn from, rather than impose upon, so that a photograph, done in this spirit, is not an interpretation, a biased opinion of what nature *should be*, but a *revelation,* – an absolute, impersonal recognition of the *significance of facts.*"[6] Ironically, by suggesting that the intrinsic spiritual and aesthetic value of a photograph was more important than its potential documentary or cultural use, Weston and his fellow members of Group *f*/64 actually shared some of the aesthetic principles of the pictorialists.

Considering the tenor of the times, it seemed inevitable that Group *f*/64's emphasis might change, and indeed, by 1934, they had begun to embrace a broader view of photography. In that year, Van Dyke invited young Bay-area photographer Peter Stackpole to join the group on the strength of some 35mm pictures he had made of the construction of the Bay Bridge. Though Stackpole's work bore some superficial resemblance to pictures done in the precisionist style of photographers like Charles Sheeler, his true emphasis was not on industry but on people. With his pictures of brave construction workers risking their lives on the steel girders of the bridge, he created a West Coast counterpart to the work Lewis Hine had done in New York for his Men at Work series. Stackpole's subject matter expanded the rather narrow range of most *f*/64 pictures and gave group members, particularly Ansel Adams, a new respect

for the miniature camera they had scorned.[7] Also in 1934, Van Dyke invited Dorothea Lange to exhibit at his Oakland gallery, one of the main showplaces for work done by the *f*/64 photographers. Lange had never been known for the exquisite quality of her prints, but Van Dyke was deeply impressed by her photographs of the victims of the Great Depression. They seemed to make real the drama of the times and they stimulated a change in Van Dyke's own work.[8] He quit making precisionist-style photographs of the gas tanks and smokestacks of industrial America and began to search for the makeshift homes and abandoned stores that marked the Depression.

By early 1935, less than three years after Group *f*/64 was formed, it was, as Ansel Adams wrote, "transitional in character," and the conformity of its subject matter was breaking down. In an article on the group done for *Camera Craft* in March 1935, John Paul Edwards solicited statements from four of the original *f*/64 members. Only Weston stuck to something close to his original formulation, praising the camera's "indiscriminate lens eye" that directed "the worker's course toward an *impersonal revealment* of the objective world." Van Dyke's statement reflected the change that had come about in his work as a result of his encounter with Lange and his growing belief that photography must offer more than spiritual revelation: "I believe that art must be identified with contemporary life. I believe that photography can be a powerful instrument for the dissemination of ideas, social or personal. I believe that the photo-document is the most logical use of the medium." Imogen Cunningham noted that despite all the attention she had given to plant forms, she was most interested in "the bigger significance in human life." Adams summed it up. They had all made an aesthetic point and reestablished the importance of "pure" photography. Now it was time for each of them to find their own subject: "Our ultimate objectives of expression are not identical by any means. The variety of approach, emotional and intellectual, — of subject material, of tonal values, of style — which we evidence in our respective fields is proof sufficient that pure photography is not a *metier* of rigid and respected

IMOGEN CUNNINGHAM, *Fagoel Ventilators*, 1934

ANSEL ADAMS, *Sculptor's Tools, San Francisco, California*, ca. 1930/1978

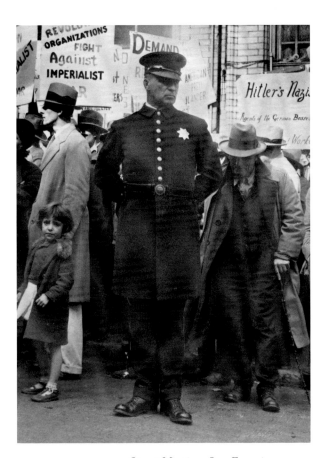

DOROTHEA LANGE, *Street Meeting, San Francisco, California*, 1937

rule. It can interpret with beauty and power the wide spectrum of emotional experience."[9]

Adams's statement was the final acknowledgment that the rhetoric of Group f/64 was directed more to issues of style than content and, thus, more a part of the ongoing debates about modernism of the twenties than of the emerging concerns for the social functions of art. The group's impact on subsequent photography was mixed. Several photographers linked to the group went on to address social issues in their work. Lange went to work for the Farm Security Administration. Stackpole put his proficiency with the miniature camera to use for *Life* magazine when it started publication in 1936. Van Dyke abandoned still photography altogether because he became convinced that motion pictures could be a more powerful form of social art. Others, notably Weston and Adams, remained hostile to the growing interest in photo-

graphing the social scene. Adams confessed that he admired the "honest human realism" of documentary photography but disliked its propagandistic potential and decried its general lack of technical excellence: "Comment is legitimate in art, but comment, motivated by reform or personal advantages, blends dubiously with aesthetic purpose."[10] In 1940, he addressed the members of the Photo League, telling them, "I have always been disturbed at the lack of attention to what might be called, for the lack of a better term, technical quality. . . . Something perceived – no matter how important in itself – and photographed without a true 'feeling' for the medium, is not conveyed with all the impact it deserves."[11] Ironically, the documentary photographers of the New York–based Photo League found in photographers like Weston a model of the clear, straightforward style they strove for in their photographs of city life.[12] But critic Elizabeth McCausland, an early champion of Lewis Hine, Eugène Atget, Berenice Abbott, and other documentary workers, saw the f/64 photographers only as examples of spiritual sterility, inheritors of Stieglitz's precious artiness, who had nothing to offer the hardworking photographers of the Farm Security Administration.[13]

The lasting impact of Group f/64 was through its articulation of a sharply focused photographic style and its insistence that photographs were best when they were realized through purely photographic – as opposed to painterly – means. This photographic style became the prevailing one for subsequent American photography. Collectively, however, the members of Group f/64 never hit upon what would become the dominant subject of American photography during the thirties: America itself.

In 1932, Berenice Abbott, recently returned from Paris and already engaged in an ambitious project to document the changing face of New York City, wrote, "I am overwhelmed by the importance of American material so often ignored by our native artists. Neglecting our own material, we are leaving open a very rich field to foreign artists who will interpret the American scene too much from the European viewpoint."[14] Even before federal New Deal programs gave support to

Abbott's own project or to Roy Stryker's grand-scale effort to compile a photographic record of rural America under the aegis of the Farm Security Administration, other photographers had begun to meet the challenge posed by Abbott. Impelled more by personal interests than political concerns, these photographers sought to catalog traditional aspects of American life. The culture they photographed seemed deep rooted, full of virtue, and compelling (a seeming rebuke to the fast-changing culture of America's urban centers). But because it was so traditional, it also seemed fragile and perilously at risk.

Doris Ulmann, a well-to-do New York portrait photographer who had studied with the pictorialist photographer Clarence White, was traveling to areas relatively close to New York to photograph interesting American types by the middle twenties. By the late twenties, she was making annual summer visits to Appalachia to photograph the traditional mountain people, and in 1929 and 1930 she went to South Carolina to photograph rural black life. Continuing her work by photographing traditional craftspeople in the mountains of Kentucky in the early thirties, she sought to record a way of life that she sensed would soon disappear. Her pictures were not intended to provoke change, merely to document and catalog a vulnerable part of American culture.

Laura Gilpin, another former White student based in Colorado, was doing a similar sort of work among the Navajo people of Arizona, who seemed to her to embody many of the values and virtues threatened in contemporary American life. Working on her own from 1931 to 1933, whenever she could steal time away from her commercial work, she photographed in and around the Navajo community of Red Rock, compiling a compassionate record of traditional Navajo life. Like Ulmann, she photographed with sentiment, but without sentimentality or overt political overtones. And, also like Ulmann, she often printed her work on the soft, gray platinum papers favored by White and other pictorialists. The work of both women has been overlooked in studies of the documentary strain in American photography of the period in large part because their motivation had little to do

BERENICE ABBOTT, *Exchange Place, New York*, 1933

LAURA GILPIN, *Ranchos de Taos Church*, 1930, platinum print

PAUL STRAND, *Ranchos de Taos, New Mexico*, 1931

with politics and their pictures looked so different from the sharply focused, glossy prints made by the photographers of the Farm Security Administration. Nonetheless, just as the *f*/64 photographers demonstrated that a sharp-focus approach did not have to be linked to particular subject matter, so Ulmann and Gilpin showed that photo-

graphs of documentary value did not have to be printed in a particular way.

During the thirties, the Southwest, where Gilpin worked, attracted many other photographers, painters, and writers who formed a native counterpart to the so-called lost generation of Americans who went to Europe after World War I. In the ancient Indian and Hispanic traditions of rural New Mexico, these artists discovered a rich source of folk material and an alternative to the seeming materialism of American culture without ever leaving home. In 1930, Ansel Adams published a photographic study of Taos Pueblo, one of the oldest continually inhabited villages in the country.[15] Paul Strand, whose best-known work of the twenties had been of machinery, photographed in New Mexico in 1930, 1931, and 1932 and traveled north to Colorado to photograph old mining towns. He later noted, "The New Mexico photographs continued the start that had been made in Gaspé [in 1929] and expanded it. . . . I became interested in photographing something of the last vestiges of what was the frontier in America, the ghost towns of Colorado and New Mexico."[16] Indeed, it almost seemed that, if the Flatiron Building in New York had been the photographic icon of an earlier generation of painters and photographers fascinated by the mystique of the city, the symbol for this one was the Ranchos de Taos church, an old, handcrafted adobe structure in a Hispanic New Mexico village, which was photographed by Adams, Gilpin, Strand, and others.

The impulse to explore what was American about American culture was closely linked to a sense that photography could play an important role in preserving a record of American life. Aware that the life and customs of the southwestern Indians were fast disappearing, Laura Gilpin said, "I am eager to add one more bit of accurate pictorial information about these Indians to the pitifully small amount we possess."[17] Across the continent, Berenice Abbott proposed a study of changing New York to the New York Historical Society. "The city is in the making and unless this transition is crystallized now in permanent form it will be forever lost. . . . Posterity should have a pictorial record of this era's characteristics, which typify

New York's present unique personality in regard to social and human aspects, types of people, manner of dress, architecture and interiors."[18]

Abbott's work in New York was inspired by her familiarity with the work of Eugène Atget, who for several decades had quietly and methodically photographed the changing streets of Paris. Abbott herself had been in Paris during the twenties and made portraits of the city's leading practitioners of the avant-garde. But when she came back to America it was not the abstract that attracted her. It was Atget and the impulse to record a city and a way of life before it disappeared. "Atget was not an aesthetic," she wrote in a 1929 appreciation of his work. "His was a dominating passion that drove him to fix Life."[19] On her own and then, from 1935 to 1939, with support from the Works Progress Administration's Federal Art Project, Abbott photographed the city of New York, giving particular attention to pictures that suggested the connections between structures and human life. The photographs were meant to document a rapidly vanishing past and, thus, their purpose was very different from the urban views made by photographers such as Charles Sheeler or even Alfred Stieglitz, who had earlier worked with more optimism about the future of the metropolis.

Walker Evans worked in a similar vein to Abbott, photographing Boston's Victorian buildings and the vernacular architecture of New York in the early thirties. Yet he was less interested in making a systematic documentation of the cities than in revealing the unexpected beauty of the commonplace object and in evoking a poetic spirit of place. His fascination with the beauty of everyday things linked Evans, in a sense, to Weston, but Evans was a more political photographer, imbuing his pictures with an implicit social meaning that Weston would have found distasteful. Explaining the documentary and descriptive purpose of his work, Evans wrote a friend in 1934, "American city is what I'm after. . . . People, all classes, surrounded by the down and out. Automobiles and the automobile landscape. Architecture, American urban taste, commerce, small scale, large scale, the city street atmosphere, the street smell, the hateful stuff, women's clubs, fake culture, bad edu-

ANSEL ADAMS, *Church at Ranchos de Taos,* ca. 1930/1977

WALKER EVANS, *Graveyard, Houses and Steel Mill, Bethlehem, Pennsylvania,* November 1935

cation, religion in decay. The movies. Evidence of what the people of the city read, eat, see for amusement, do for relaxation and not get it. Sex. Advertising. A lot else, you see what I mean."[20] His broad shooting script foreshadowed the directives that Roy Stryker would soon be giving to the photographers working for him at the FSA.

BEN SHAHN, *Rehabilitation Clients, Boone County, Arkansas,* October 1935

ARTHUR ROTHSTEIN, *Children in Nursery, Tulare Migrant Camp, Visalia, California,* March 1940

Stryker's project was the grandest expression of the national penchant for photographing the American scene. Between 1935 and 1943, the photographers working for him in the Historical Section of the Farm Security Administration produced 270,000 pictures that did just what Stryker's mentor, Rexford Tugwell, said they should do: they "introduced Americans to America."[21]

Stryker had studied economics with Tugwell at Columbia University and while gathering photographic illustrations for Tugwell's book, *American Economic Life,* was deeply influenced by the pictures of Lewis Hine, who had begun documenting laborers and working conditions around the country two decades before. When Tugwell became Assistant Secretary of Agriculture during the early days of the New Deal, he invited Stryker to take a job in Washington with the Resettlement Administration (renamed the Farm Security Administration in 1937). Stryker went to Washington in 1935 and gradually defined his job for himself. To document the rural problems addressed by his agency he would develop a massive picture file. His pictures would be used to illustrate agency publications, but his larger goal was "to record on film as much of America as we could in terms of people and the land." "What we ended up with," Stryker said, "was as well-rounded a picture of American life during that period as anyone could get. The pictures that were used were mostly pictures of the dust bowl and migrants and half-starved cattle. But probably half the file contained positive pictures, the kind that give the heart a tug."[22] Stryker understood the power of the photograph as propaganda. He wanted to document a particular facet of American life, but he knew that his pictures could be used to persuade as well as to record.

Arthur Rothstein joined Stryker's team first. He was followed by Carl Mydans, a journalist who had begun working with a 35mm camera, and Walker Evans, a master of the 8 x 10 view camera who considered himself more an artist than a reporter. Stryker next hired painter Ben Shahn, who was imaginative but relatively untrained as a photographer, and Dorothea Lange, who had already made an impressive series of pictures of migrant workers in California. His team eventually came to include Russell Lee; Marion Post Wolcott; John Collier, Jr.; John Vachon; Jack Delano; and Gordon Parks. Evans's meticulous prints looked nothing like Shahn's technically imperfect pictures; the photographers using view cameras made pictures that looked different from those produced with 35mm cameras. But Stryker

never cared so much about style as about content.

There was a poetry and luxuriance to the FSA vision of American life that distinguished it from the more economical view presented in such picture magazines as *Life*, which had limited space in which to report any one story. The *Life* photographers and their 35mm cameras were revolutionizing photojournalism. Earlier press photographers had relied on 4 x 5 Speed Graphic cameras with flashguns and reflector pans. Their pictures tended to look much the same: overlit foregrounds fell off to dark backdrops with relatively little detail. With the new cameras, however, journalists could capture more excitement and activity as well as different kinds of detail. At first glance, the pictures in the magazines might have seemed indistinguishable from those done for the FSA. The pictures Carl Mydans made for *Life* in Texas in 1937, for example, look as if they could belong to an FSA story, and indeed Mydans took much of what he had learned from Roy Stryker with him when he left the FSA to join the magazine in 1936. Stryker himself articulated the difference between his agency's approach and that of the magazines: "Newspictures are the noun and verb; our kind of photography is the adjective and adverb. The newspicture is a single frame; ours a subject viewed in series. The newspicture is dramatic, all subject and action. Ours show what's back of the action."[23]

Stryker's photographers, by virtue of their political charter, focused on rural and small-town American life, and their shooting scripts were often deliberately vague. Stryker would direct them to show "what keeps the town going," or how people at various income levels spend their evenings.[24] The photographer's emphasis on the vernacular and commonplace had antecedents in Charles Sheeler's studies of Shaker furniture begun in 1918, Edward Weston's photographs of the Mexican *pulquerias* from the twenties, Doris Ulmann's pictures of southern highlands crafts, and Walker Evans's own architectural studies from the days before he joined the FSA. But in the middle thirties these subjects found an even wider audience. The Index of American Design, a project begun in 1936 under the Federal Art Project of

RUSSELL LEE, *Barker Concession at State Fair, Donaldsonville, Louisiana*, 1938

JACK DELANO, *Painting on a Barn near Thompsonville, Connecticut, along Route 5*, 1940

the Works Progress Administration, employed several hundred artists to painstakingly paint reproductions of local craft objects from thirty-five states. A fascination with the regional, the local, and the primitive also found expression in the paintings of John Steuart Curry, Grant Wood, and Thomas Hart Benton.

The cities, too, attracted their chroniclers of

SID GROSSMAN, *Harlem, New York*, 1939

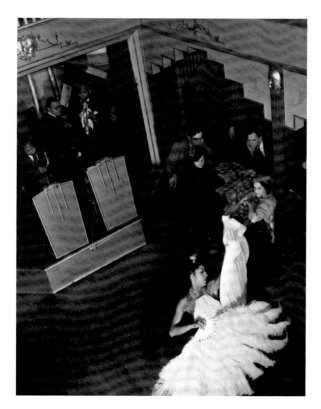

AARON SISKIND, [from the Harlem Document series], 1936

everyday life. Just as painters like George Bellows and John Sloan provided an urban counterbalance to the work of the regionalist painters, so the New York City–based Photo League produced pictures that balanced the rural emphasis of the FSA. The Photo League was founded in 1936 as an offshoot of the Film and Photo League, itself begun in 1930 as a cultural wing of the leftist Workers' International Relief. The Photo League had an open membership policy and welcomed all "honest photographers" who would use their cameras as tools to "photograph America." League members favored the straightforward style of picture-making used by Stieglitz, Strand, Abbott, and Weston and had no use for pictorialists or for the modernists who had "retired into a cult of red filters and confusing angles."[25] During the thirties, group members produced several documentaries on life in New York. Aaron Siskind and a team of younger photographers put together the Harlem Document, while Sid Grossman and Sol Libsohn collaborated on the Chelsea Document. The group lasted until 1951, though after the war its emphasis on documentary work gave way to a new interest in "creative" photography.

This emphasis on recording the American scene dominated photography in thirties America, but not all photographers took part in it. Paul Outerbridge, for example, who spent the twenties in Europe, continued to experiment with ideas borrowed from the constructivists. The photographers affiliated with the Institute of Design in Chicago, the 1938 reincarnation of the German Bauhaus, experimented with montage and cameraless images. Yet Barbara Morgan, among the most experimental of American-trained photographers, made pictures that commented on American life even as they employed such techniques as montage. In *Hearst over the People* (1938–1939), a leering, octopuslike William Randolph Hearst is superimposed on a crowd of people, suggesting the enormous power of America's wealthy elite.

But as American photography discovered and codified its own history during the thirties, it was the realist strain that was most celebrated in exhibitions and books. The American photographers highlighted in Beaumont Newhall's 1937 exhibi-

tion on the history of photography at the Museum of Modern Art included the Daguerrean portraitists Southworth and Hawes, Mathew Brady, and the great western landscape photographers of the late nineteenth century. Robert Taft's monumental book of 1938, *Photography and the American Scene*, again stressed the achievements of Brady and the western expedition workers and in its very title stressed the practical and documentary bent of photography in this country, an art inextricably tied up with broader social developments. The style that was implicitly American was straightforward and descriptive.

This resurrection of great documentary photographers of the past coincided with an increasing recognition of contemporary documentary photography as a legitimate art form. Seventy prints from the Farm Security Administration files were exhibited at the International Photographic Exhibition at the Grand Central Palace in New York in 1938 and subsequently went on nationwide tour under the sponsorship of the Museum of Modern Art.[26] Lewis Hine's long-neglected work was rediscovered by Elizabeth McCausland and Berenice Abbott in 1938, and an exhibition of his pictures was installed the following year at the Riverside Museum in New York. Other documentary workers reached an audience through books. Erskine Caldwell and Margaret Bourke-White's *You Have Seen Their Faces* came out in 1937, Paul S. Taylor and Dorothea Lange's *An American Exodus* appeared in 1939, Walker Evans and James Agee's *Let Us Now Praise Famous Men* was published in 1941.

In 1940, Ansel Adams organized the Pageant of Photography for the Golden Gate Exposition in San Francisco and, with a few exceptions (Alvin Langdon Coburn prints from David Octavius Hill negatives, two photographs by Man Ray, and Atget pictures of Paris), showed only American photography. "It is encouraging," Adams wrote in the exhibition catalog, "to observe concrete evidence that America has brought forth superior photography; photography is, in fact, a decisive American art." Singling out many of the same photographers that Newhall and Taft had praised, he wrote: "We cannot fail to be impressed by the

BARBARA MORGAN, *Hearst over the People*, 1939

magnificent daguerreotypes of Southworth and Hawes, and the historic photographs of Brady, Gardner and others of the 1850s and '60s in the eastern United States, and the exciting work of the great western photographers, such as Jackson, O'Sullivan, and Watkins. . . . The work of these hardy and direct [western] artists indicates the beauty and effectiveness of the straight photographic approach. No time or energy was available for inessentials in visualization or completion of their pictures. Their work has become one of the great traditions of photography."[27] Pictorialism was written out of Adams's and Newhall's historical surveys as an aberration, a deviation from the proper path of photography, while the work of photographers who never considered themselves to be artists was warmly embraced. Nonetheless, one wonders whether pictorialism declined in importance more from stylistic criticism or from the economic and political exigencies of the times that rendered it irrelevant.

In stressing the American subject matter and documentary intent of American photography, Newhall, Adams, and Taft were all creating a historical context for the kind of photography that predominated in thirties America. Through their books and exhibitions they created and legiti-

mated a past that stressed a particular way of seeing. The quintessential American photographers visually cataloged the world around them in a straightforward, unmanipulated style and were more concerned with documentation than self-reflection or stylistic experimentation. They were observers of the everyday world who, as William Carlos Williams wrote of Edgar Allan Poe, seemed all the more American for heeding "the local necessities, the harder structural imperatives – by standing off to *see* instead of forcing [themselves] too close."[28]

American Photographs, the one-man exhibition of work by Walker Evans at the Museum of Modern Art in 1938, was thus aptly named. Evans's precisely seen images of the vernacular world were made in and of America, and the subject matter and style of the pictures expressed the essence of American photography as it had been developed and defined during the thirties.

Lincoln Kirstein, writing for the catalog of Evans's show, was explicit about Evans's place in photographic history and about the particularly American qualities of his work. What Brady was to Civil War America, what Atget was to Paris before World War I, Evans was to the "contemporary civilization of eastern America and its dependencies," cataloging the facts of his epoch in a useful manner with careful precision, a breadth of vision, and a full awareness of the potential value of his pictures.[29]

Evans's straightforward pictures of old signs, weather-beaten buildings, unpresuming interiors,

and unself-conscious faces epitomized the thirties even as they recapitulated what seemed to be the central strains in all of American photography. His straight photographic technique, his direct way of seeing, his meticulous attention to print quality, and his preference for the 8 x 10 view camera reiterated the work of the members of Group *f*/64. His focus on vernacular architecture and commonplace things echoed a broad, newly popular strain of American photography and painting. His insistence on the poetic significance of everyday objects, his skill at giving symbolic importance to casual scenes, and his awareness of history summed up the aims of Roy Stryker and his team of Farm Security Administration photographers.

Perceiving an even broader cultural context for Evans's work, Lincoln Kirstein wrote, "The sculpture of the New Bedford shipbuilders, the face-maps of itinerant portraitists, the fantasy of our popular songsters and anonymous type-founders continue in his camera. We recognize in his photographs a way of seeing which has appeared persistently throughout the American past."[30]

With their straightforward, unself-conscious cataloging of the national scene, Evans and many of his contemporaries expressed a way of seeing that was fast becoming associated with a particularly American photographic idiom. During the thirties, this way of photographic seeing found a tradition for itself and established itself for future generations as the characteristically American style.

NOTES

1. Elizabeth McCausland, "Documentary Photography," *Photo Notes* (January 1939): 6–7.

2. Edward Weston, "Statement" (1927), in *Edward Weston on Photography*, ed. Peter Bunnell (Salt Lake City: Gibbs M. Smith, 1983), p. 46.

3. Willard Van Dyke, "Foreword," to Jean S. Tucker, *Group f.64* (St. Louis: University of Missouri, 1978), p. 8.

4. Edward Weston, "Photography Not Pictorial," *Camera Craft* 37 (July 1930): 314.

5. "683 Brockhurst," *Camera Craft* 40 (September 1933): 388.

6. Edward Weston, "Statement" (1932), in *Edward Weston on Photography*, p. 70.

7. See Ansel Adams, "My First Ten Weeks with a Contax," *Camera Craft* 43 (January 1936): 14–20.

8. Willard Van Dyke, "The Photographs of Dorothea Lange, A Critical Analysis," *Camera Craft* 41 (October 1934): 461–467.

9. John Paul Edwards, "Group F:64," *Camera Craft* 42 (March 1935): 107–113.

10. Ansel Adams, "An Exposition of My Photographic Technique," *Camera Craft* 41 (April 1934): 180.

11. Ansel Adams, [Letter], *Photo Notes* (June–July 1940): 4–5.

12. "For a League of American Photographers," *Photo Notes* (August 1938): 1.

13. McCausland, "Documentary Photography," p. 6.

14. Hank O'Neal, *Berenice Abbott: American Photographer* (New York: McGraw-Hill, 1982), p. 16.

15. Mary Austin with photographs by Ansel Easton Adams, *Taos Pueblo* (San Francisco: n.p., 1930).

16. Paul Strand, *Paul Strand: Sixty Years of Photographs* (Millerton, N.Y.: Aperture, 1976), p. 153.

17. Mildred Adams, "A Worker in Light," *The Woman Citizen* 54 (March 1926): 11.

18. Hank O'Neal, *Berenice Abbott*, p. 16.

19. Cited in Beaumont Newhall, ed., *Photography: Essays and Images* (New York: Museum of Modern Art, 1980), p. 235.

20. Walker Evans, *Walker Evans at Work* (New York: Harper and Row, 1982), p. 98.

21. Roy Emerson Stryker and Nancy Wood, *In This Proud Land: America 1935–1943 as Seen in the FSA Photographs* (Greenwich, Conn.: New York Graphic Society, 1973), p. 9.

22. Ibid., p. 14.

23. Ibid., p. 8.

24. Ibid., p. 15.

25. "For a League of American Photographers," *Photo Notes* (August 1938): 1.

26. F. Jack Hurley, *Portrait of a Decade: Roy Stryker and the Development of Documentary Photography in the Thirties* (Baton Rouge, La.: Louisiana State University Press, 1972), pp. 152–154.

27. Ansel Adams, "Introduction," in *Pageant of Photography* [exhibition catalog] (San Francisco: Crocker-Union, 1940), unpaged.

28. William Carlos Williams, *In the American Grain* (New York: New Directions, 1956), pp. 228–229.

29. Lincoln Kirstein, "Photographs of America: Walker Evans," in Walker Evans, *American Photographs* (New York: Museum of Modern Art, 1938), p. 190.

30. Ibid., p. 195.

From Protest to Affirmation: 1940–1950

NAOMI ROSENBLUM

The decade of the forties was triply divided. Its opening years reflected a backward glance at the still unsettled economic and social upheavals of the thirties, accompanied by a nervous premonition of impending troubles. Its middle years were given over to a war fought at home in defense industries and on two distant fronts, which concluded with the detonation of the atomic bomb. Its final years were spent assuaging the domestic hunger for consumer goods and in a divisive quest for internal security while asserting a sense of pride as the ranking capitalist power in the world.

The significant photographic expression of the time reflected the dissimilar sensibilities engendered by such divergent needs and attitudes. It responded also to ongoing controversies inherited from earlier times concerning concepts in the visual arts broadly termed realism, modernism, and pictorialism. In addition, during the two previous decades, professional opportunities in the fields of advertising, journalism, and science had begun to expand; by the end of the forties these jobs would be filled by individuals who were among the first to receive their training in art schools and universities. During this decade, the medium gained recognition in the art world when the Museum of Modern Art set up a separate department and curatorship for camera and other light-sensitive images.

The photographic broth that resulted from the combination of these elements was enriched by the contributions of Europeans who settled in the United States. It was flavored further by the new dye-color capabilities that had emerged in the latter part of the thirties. It boiled and simmered throughout the decade, producing a stew whose distinctive character is not easily discernible. Therefore, the most sensible course calls for look-

ing at each of these time intervals in turn and tracing the threads of documentation, photojournalism, advertising imagery, or manipulated and straight photography as they wove themselves into the main events of the decade.

A sense of the social and political climate of the opening years may be gained from the themes of two popular movies released in 1940. *The Grapes of Wrath,* an evocation of the dislocation experienced by Oklahoma farmers in the late thirties, attested to the nation's continuing preoccupation with problems that were in fact still a reality, while *The Great Dictator* – Chaplin's attempt to ridicule the presumptions of fascism – may be taken as evidence of the alarm that events in Europe had begun to awaken among many Americans. In still photography, social documentation continued to be a preeminent mode, engaging photographers working in the hinterlands and in urban centers for government agencies and on their own. Indeed, the Farm Security Administration project was not terminated until 1943, although it had languished for two years under the aegis of the Office of War Information. For the two years prior to that, its themes and approach had undergone a subtle transformation from supporting government intervention in American social policy to affirming the nation's physical and spiritual bounty – a change in emphasis that was the result of Director Roy Stryker's sensitivity to shifts in the national temper.[1] Aware of the reaction against the social concepts inherent in the project and of the boredom with still more images of the nation's poor, the FSA photographers working between 1940 and 1943 – among them Jack Delano, Russell Lee, Gordon Parks, John Vachon, and Marion Post Wolcott – celebrated the natural landscape and underscored the existence of tradi-

tional values in works that generally were less accusatory and more comforting to a nation entering upon a global conflict.

The number of publications making use of FSA images may have actually increased in the early forties; among them were Sherwood Anderson's *Home Town* and Richard Wright's *Twelve Million Black Voices*. The work eventually considered the paradigmatic expression of the ethos of the Great Depression era, *Let Us Now Praise Famous Men*, with text by James Agee and photographs taken by Walker Evans in 1938, did not appear in print until 1941. As for the FSA photographers themselves, several continued portraying social issues after the termination of their employment on the project. Dorothea Lange, for example, turned her attention to cooperative religious communities in California, to the dilemma of the Japanese-Americans interned under Executive Order No. 9066, and to the newly perceived personal and social relationships that resulted from the employment of women in basic industries.

The transformation of the documentary mode from one of examination to one of affirmation accelerated after 1943 when Stryker took on the directorship of a documentary project for Standard Oil of New Jersey.[2] The first major effort to improve the public's perception of a private corporation through photography, it employed more than a dozen photographers, among them Esther Bubley, Harold Corsini, Sol Libsohn, and Todd Webb, who spread across the nation to depict the lifestyles and artifacts of those whose existences depended to some measure on petroleum products. Although Stryker's attempts to publicize the benefits of the company's activities met with little success, he did build a unique archive of some eighty-seven thousand images of interest to those concerned with social archeology.

The Standard Oil documentation concentrated on the lives of ordinary people, whereas industrial plants and machinery became the preferred theme of Andreas Feininger. Emigrating from Europe in 1940, he specialized in documenting "the beauty, power, and excitement of the industrial scene,"[3] first for the Office of War Information and after 1943 for *Life* and other peri-

MARION POST WOLCOTT, *Post Office in Blizzard, Aspen, Colorado,* 1941/1981

ANDREAS FEININGER, *Chicago Grain Elevator on Cermak Road,* 1941

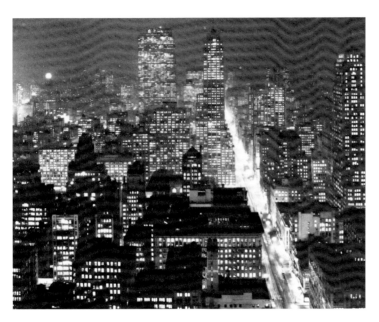

TODD WEBB, *From the 48th Floor of Empire State Building, New York,* 1946

odicals. Working largely with natural light and emphasizing formal relationships – dark/light contrasts, repetitive patterns, and geometric formations – Feininger brought his Bauhaus training to a theme that became important as the nation's factories geared up and then operated at full blast in support of the military campaigns.

Urban social documentation – what we might today call street photography – flourished in the early forties. Conceived in a more structured manner than is common now, it too had been nurtured in the documentary climate of the previous decade. One stimulus was Berenice Abbott's effort to encompass in visual form the complex character of New York City through photographs. The project, *Changing New York,* had reached the public in 1939 under the auspices of the Works Progress Administration, which continued in the early forties to sponsor projects that created work for photographers while preserving a record of the appearances and habitual activities of city dwellers.[4] Recognizing that photography had expressive as well as utilitarian dimensions, the WPA supported "creative" projects in addition to the production of useful records that publicized the need for adequate housing, play areas, and public

health facilities. Among those involved in the creative aspect were Arnold Eagle and David Robbins.

Probably the most active force in urban documentation in the early forties was the Photo League. This New York–based center offered lectures and social events, made darkrooms available, and ran a school for a small yearly fee. Imbued with a sense of mission from its origin in the thirties as the Film and Photo League – the photographic arm of radical political activists – by 1940 the League had separated from the film component, enlarged its membership, and moved closer to the political midstream while still affirming its commitment to the documentary mode. It drew sustenance from the social documentarians of the past, notably Lewis Hine (who died in 1940); provided a forum and exhibition space for Stryker and the FSA photographers; and looked first to Abbott and later to Paul Strand as a guiding intelligence.

The various projects sponsored by the League included the Chelsea Document, the Harlem Document, and the Pitt Street Document. For the most part, members photographed in the streets, taking advantage of the fact that working-class New Yorkers passed their recreational hours in public, conversing from windows, congregating on stoops and in front of stores, playing in gutters, empty lots, and public beaches to create a kind of exuberant street theater. But while the emphasis of these documentations was on people and how they lived, the young photographers who participated, among them Lou Bernstein, Corsini, Morris Engel, Libsohn, Walter Rosenblum, and Dan Weiner, were exhorted by teachers Eliot Elisofon, Sid Grossman, and Aaron Siskind to avoid turning out dull records. Mentors Robert Disraeli, Ralph Steiner, and Paul Strand urged League members to recognize that photographs convey their meanings through formal structure as well as through subject matter, expression, and gesture. Indeed, the League eventually held that social documentation was not at all a question of making random exposures in the street but required as much attention to pictorial organization as so-called pictorialist images. It lost no opportunity to make this point in its classes, meetings, and articles in its bulletin *Photo Notes.*[5]

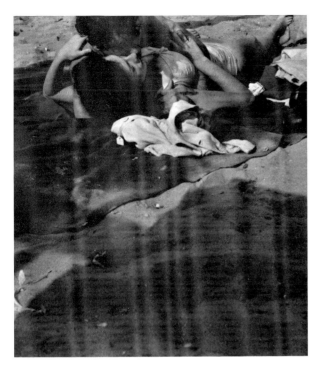

SID GROSSMAN, [Coney Island], ca. 1947

Documentary, as Evans was later to note, involves an attitude and a style.[6] Directness of vision and clarity of form were considered its hallmarks, but within these guidelines the Photo League allowed room for a range of personal expression. In the early forties, both Weegee (Arthur Fellig) and Lisette Model were invited to exhibit and lecture. Under the rubric "Murder Is My Business," Weegee exhibited highly dramatic images that were acclaimed for their authentic pungency, while Model, in her first exhibition in the United States after emigrating from France, revealed an interest in the grotesque with photographs of individuals dozing on the French Riviera or gesticulating on New York's Lower East Side. Taken in harsh light from low angles, they resonated with a kind of uneasy menace, characterized by *Photo Notes* as "the insolence of power."[7] In a series on Wall Street, Model's eccentric framing and blurred shapes diverged even further from the classic postulates of social documentation.

That a lyrical response to urban life still was possible during the forties can be seen in the street photography of Helen Levitt, Louis Faurer, and Walker Evans. Not strictly documentary in the sense then understood, their images of ordinary people seem to resonate with an intangible ardor. Levitt's photographs of children at play in East Harlem, which owe more to the example of Cartier-Bresson and the European photojournalists than to American documentary concepts, suggest that life in a ghetto can have moments of pure fantasy. A friend of Evans, and through him of Agee, Levitt worked with the writer in 1945 to prepare a book of these images.[8] Faurer, who acknowledged a visual debt to Evans,[9] worked first in Philadelphia and then in New York, transforming the artlessness of the snapshot into a style of mysterious lyricism. His images of architecture, signage, and people in the streets evoke the complexion of the city in the era before it became so thoroughly perceived as a center of commerce and confusion.

In 1941, Evans, who had been the most individualistic spirit of the FSA contingent, returned to a project that he had begun and dropped three years earlier: New York subway portraits. As a relentless but benign voyeur, he photographed underground riders in available light (at the time furnished by low-wattage incandescent bulbs rather than the fluorescents now in use) with a Contax concealed on his person. In setting aside the control he formerly had regarded as essential, Evans attempted to probe as far as was possible the inner life of those with whom he had not made personal contact. In 1946, after joining the staff of *Fortune* magazine, he returned to this concept of photography as an engagement with chance, this time working in the streets of downtown Chicago. His images of faces blinkered with sunglasses deal with "environment and machine, as well as the general contradictions . . . indigenous to the U.S.A."[10] As such, they may be said to have been seminal in forming the consciousness of the next generation of street photographers.

As a style and concept, the documentary approach attracted the interest of photographers besides those actively engaged in photographing people, notably Ansel Adams and Paul Strand. Adams, whose concern with social issues had resulted in a story on migrant workers for *Survey Graphic* in the early thirties,[11] maintained an

interest in public issues throughout his career, though he rarely worked in the documentary mode. Reality, he wrote in a personal credo, required an approach in which "simplicity was a prime requisite and control of the medium an essential element,"[12] and he applied these precepts to images of the Japanese-Americans photographed at the internment camp at Manzanar as well as to his more influential images of nature. For Strand, who had been involved since the middle thirties in creating politically engaged films, a consequence of his interest in documentary style was a preference, in virtually all future photographic endeavors beginning with his New England images of the middle forties, for a specific region and unifying theme on which to concentrate. However, for Adams and Strand, as for Imogen Cunningham, Laura Gilpin, and the Westons – Edward and Brett – the modernist concept, which involved the previsioned image on the ground glass of the view camera and full-frame processing by the individual photographer, remained the cornerstones of their aesthetic approach to the medium throughout the forties.

Support for the documentary style came from other sources, too. Beaumont Newhall, curator of the newly established Photography Department at the Museum of Modern Art,[13] included examples in a 1941 exhibition, *Images of Freedom*. Two journals, *Popular Photography* and *U.S. Camera*, with national readerships of amateurs and professionals, devoted space to popularizing the genre. Americans may have "tired of reading about the great social consciousness,"[14] but *U.S. Camera* featured the work of Stryker and the FSA, Bourke-White's southern rural portraiture, Lange's dust bowl victims, and images of the urban poor by Photo League members Elisofon, Engel, and Morris Huberland.

The documentary approach was anathema, however, to a large number of photographers organized into the Pictorial Photographers of America. This group published a journal and held regional print competitions, with points and ribbons awarded for the best images in specified categories. Aside from several sophisticated pictorialists whose work was widely reproduced,

notably Paul L. Anderson and Drahomir Ruzicka, members by and large exhibited provincial taste and adhered stubbornly to the notion that beauty of theme, of thought, and of mood were the goals of all visual art, photography included. Documentary, they held, was "lacking in imagination and similar to the 'redundant phraseology of the lawyer,' " while pictorialism represented "the imaginative and picturesque expression of the poet."[15] Nevertheless, pictorialists were forced to acknowledge the mediocre character of the images submitted to their competitions and to seek avenues for avoiding banal themes and treatments.[16] As they refused to recognize the existence of straight photography,[17] various strategies were advanced for investing images with visual interest, including photographing costumed dolls set in artificially contrived landscapes, finding natural subjects with pronounced decorative patterns, and employing montage and other manipulative techniques such as had been made popular in the thirties by Cali-

CLARENCE JOHN LAUGHLIN, *We Reached for Our Lost Hearts*, 1941

fornia pictorialist William Mortensen. It may not be altogether surprising, therefore, that this conservative group welcomed the ideas of European avant-garde theorist and educator László Moholy-Nagy. His discussion of photography and design, which appeared in the pictorialist annual of 1945, was illustrated with examples of montages, light graphics, and manipulative printing procedures produced by students attending the Institute of Design in Chicago.[18]

Another and far more significant element in the photographic scene in the early forties was the emigration of visual artists from Europe, which increased as the war expanded. American photographers were given an opportunity for direct contact with the "new vision," as European modernist theory and practice were called. These concepts and procedures had been central to the development of visual culture in Europe for some two decades following World War I but had achieved little currency in the United States other than interest in the facet called *neue Sachlichkeit* (precisionism). The establishment in Chicago in the late thirties of the School of Design – an American version of the Bauhaus – gave young graphic designers and photographers their first structured understanding of the medium's potential for manipulation. And while in Europe the roots of the "new vision" had been centered in attacks on the status quo, when transposed to the apolitical climate of middle America, the same concepts were cleansed of political and social overtones to become an opportunity for "personal enlightenment."[19] School of Design students were encouraged to think of photography in terms of effects of light, to work with cameraless techniques, to investigate unusual vantage points, to mix media, and to freely manipulate materials in pursuit of innovative statements. Exposure to the "new vision," tempered by changing sensibilities in all the arts later in the decade, was to alter the nature of expression for numbers of photographers after the war.

Another development that lent manipulative procedures merit in the eyes of photographers was the mounting interest in psychoanalytic theory and surrealist dream imagery. Emphasizing nonration-

RUTH BERNHARD, *Eighth Street Movie (Kiesler), New York*, 1946

HENRY HOLMES SMITH, [illustration for "Light Study" lecture], 1946

alist aspects of being, Ruth Bernhard and Clarence John Laughlin were among those who resorted to staged scenes as a means of capturing "a mystic and imaginary element"[20] or evoking a sense of the irretrievable past. Henry Holmes Smith, for whom Moholy-Nagy's ideas had opened up a path to the expression of subjective

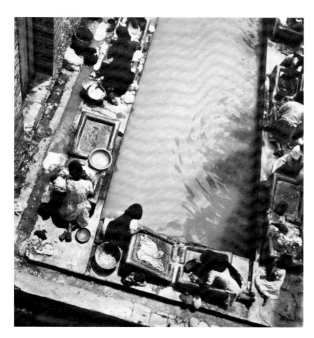

FRITZ HENLE, *Mexico: Women Washing in Taxco*, 1943/1979

realities, experimented with a mixed-media process similar to *cliché verre* to produce subjective abstractions in color. Other advocates of an experimental approach as a means to explore inner realities include Frederick Sommer, architect and friend of dadaist/surrealist painter Max Ernst, and Barbara Morgan, trained as a painter. To encompass his conviction that the worlds of mind and matter are indivisible, Sommer made straight images of nature, photographed mysterious-looking objects, and created montages and abstractions using a variety of chemical substances. Morgan was one of the earliest in the United States to experiment with moving light sources and montage, combining these techniques with straight camera work to achieve what she characterized as an expression "symbolic of Nature-Machine hybridized society." [21]

Among the surprising conduits for the visual ideas reflective of the "new vision" were the Photo League, which offered lectures and held exhibitions, the camera journals, and the popular periodicals. Endeavoring to keep its readers abreast of all developments in photography while avoiding extremes, *U.S. Camera* published letters urging

more "phantasy" in photographs and featured the work of photographers such as Feininger, Fritz Henle, Herbert Matter, and Morgan, in which design was an important element. [22] The work of several of these individuals and of other photographers recently arrived from Europe, notably Alfred Eisenstaedt, also appeared in the widely distributed news weeklies, introducing a larger public to a number of the visual strategies of modernism, with which the "new vision" was concerned. *Fortune, Life,* and *Look* featured articles illustrated with scientific images whose abstract patterns were the result of extreme magnification, enormous distance, or incredibly fast exposure, while prominent attention to decorative pattern and texture characterized images of luxury products and fashion in *Vogue* and *Harper's Bazaar.* Indeed, for nearly two decades previously, the Condé Nast publications had been instrumental, under Steichen's guidance, in modernizing photographic illustration. During the forties, this direction gained increasing authority from the work of European photographers, a development to be discussed shortly.

If any mode of photographic expression can be said to be most characteristic of the forties, it is likely to be photojournalism. In the era before television sets became household fixtures, the illustrated papers and moderate-priced weeklies, notably *Life* and *Look,* provided the public with their most vivid perceptions of national and world events. With their skillful amalgam of image, caption, text, and layout, the weekly periodicals in particular both stimulated and satisfied the desire for picture news with a human perspective.

During this springtime of photojournalism in the United States, the genres of documentation and magazine reportage appear in some respects interchangeable: both focused on exterior realities and both depended to some extent on sequences of captioned images to make their messages intelligible. Picture journals sometimes used images made in the course of government-sponsored documentary projects and hired FSA photographers experienced in the genre, notably Carl Mydans, who joined *Life* in 1936, and Arthur Rothstein, who went to work for *Look* in 1940.

The most significant differences between the

two modes involved the ultimate use of the images. Because the picture weeklies sought to convey a sense of the particularity of timely events, the visual elements always were in need of textual elaboration. Photographers turned over negatives and notes to the editorial staff who made images as malleable as words through selection, sequencing, and captions.[25] That photojournalistic reportage might reflect hidden ideologies or that readers' perceptions might be affected by omissions, by the relative size of images, by the layout, and by what pictures were used in contiguous ads were matters not easily recognized either by photographers or readers.

Nevertheless, it is undeniable that popular weeklies both reflected and promoted the shifts in ideas, priorities, and values in the United States throughout the decade. For instance, in 1940, faced with the generally isolationist sentiment in the nation, *Life* introduced a major photographic essay or shorter feature on the war in Europe into the weekly diet of celebrities, political events, science news, and typical American pastimes. Photographers whose picture stories on the bombing of England and the war in Finland signaled the change in mood included Cecil Beaton, Bourke-White, Mydans, and William Vandivert. Indeed, Beaton's image of a child victim of a German air raid, used on the cover of *Life* in September 1940, was virtually guaranteed to soften the most isolationist feeling. Shortly after American entry into the war, these magazines began to include views of fertile farms and productive factories to convince readers that the nation was capable of sustaining a conflict on two fronts. By 1944, images of middle European ghetto existence, made in 1939 by Roman Vishniac, appeared in *Life*, perhaps in preparation for the "unbelievable" scenes photographed in concentration camps by Bourke-White and George Rodgers.

During the war years, the predominant motif in reportage, especially as it was conceived by *Life*, involved the notion of the "American Century." This sense of the coming dominance of the United States in world affairs remained forceful despite picture stories of the repugnant aspects of national behavior that also appeared in the magazines.

Chief among these were the existence of internment camps for native-born Americans of Japanese descent and the outbreaks of racial violence that occurred intermittently throughout the war years. While readers may have become aware of such problems through the picture stories, American attitudes on this issue remained relatively unchanged throughout the war, with black service personnel returning to the same restricted economic and social opportunities as before. This may help explain the fact that with the exception of Gordon Parks, who worked for Stryker and for *Life*, no major black photographers found employment as documentarians or photojournalists in the decade under discussion.

The global turbulence that unfolded for nearly six years on the continents of Asia and Europe helped transform photojournalism into a sophisticated instrument. The military establishment, which formerly had not welcomed civilian photographers on the battlefield,[24] changed its

W. EUGENE SMITH, [from the Saipan series], 1944

attitude toward photography. With the picture magazines of the forties avid for material, civilian photographers who covered the battlefronts were permitted a degree of rashness that at times was life threatening.[25] Their approach to combat photography reflected attitudes that had been building since the Spanish civil war of the previous decade: they sought to portray the forces fighting for democratic values in close-up as individuals rather than from a safe distance as anonymous cogs in a fighting machine. In addition, they reacted to the savagery of war by regarding service personnel of the Allied armies and civilians everywhere as victims. Thus, on the pages of *Life* and *Look*, Americans were shown dead and wounded as well as victorious, exhausted and depressed as well as exhilarated. The sense of overwhelming catastrophe that weaves itself through much of this reportage is exemplified in an image by W. Eugene Smith of a tiny naked infant held by helmeted soldier during action on the Pacific Island of Saipan.

After the war, the continued vigor of the photojournalistic approach owed almost as much to the activities of Steichen as to the success of the picture journals. In his various roles as Director of Photography for the United States Navy, adviser to *U.S. Camera*, and Director of the Department of Photography of the Museum of Modern Art, an appointment he received in 1947, he assiduously promoted the genre. An example of the preeminence of this mode in Steichen's eyes is *U.S. Camera 1946: Victory Volume*, for which he selected the photographs to create a recapitulation of almost four years of war. He emphasized positive images of United States military power, including only a few pictures of dead servicemen, of stacked bodies at Belsen and Buchenwald, and of homeless children. There was one photograph each of black and female service personnel and none of industrial workers, despite the dedication "to all who served." Views of the devastating destruction of the two Japanese cities on which the atomic bomb had been dropped showed no evidence of the 130,000 or so civilians who had died or the countless more who were injured. In all, the preponderance of images of air and sea power in the Pacific indicated what aspect of the war the editors con-

sidered most significant and suggested how photojournalism could encapsulate such ideas without appearing to be propagandistic.[26]

Photojournalism was enshrined at the Museum of Modern Art during Steichen's tenure, although it actually had entered such hallowed precincts with the earlier decision to collect and exhibit the work of commissioned as well as self-expressive photographers. Following a number of such exhibitions during the war, mounted by both Newhall and Steichen,[27] *The Exact Instant* opened in 1949. With a 14 x 30–foot (mural size) image of an atomic explosion as its centerpiece, this show presented an extensive survey of historical and contemporary photoreportage. Steichen's support for photojournalism reached its zenith in the following decade when he mounted what in effect was a three-dimensional version of a picture magazine, which he entitled *The Family of Man.*

It has become a truism to note that the character of life in the United States changed substantially with the dropping of the bomb and the war's end. The nation, which had emerged from World War I as a principal industrial power only to find itself mired in the Great Depression of the thirties, again assumed its role as an industrial giant. Changes in economic status and world outlook enlarged opportunities for visual artists, including photographers. Jobs in magazine feature work, in photojournalism, in advertising and fashion, and in teaching opened up. The camera image became a collectible artifact, albeit in a small way, and publishers began to recognize, also to a limited extent, that photographic books other than sociological works and technical manuals might find a market. The fact that these developments took place against, and indeed were related to, a background of omnivorous consumerism and the political climate of the Cold War gave photographic activity of the late forties its special character.

While a number of photographers, among them Marion Palfi, continued to find jobs documenting social conditions, there was no question that the era of large-scale social documentation was over; in fact, the contribution of the FSA project was belittled in a debate in the United States

MARION PALFI, *New York City Gang* [from the Suffer Little Children series], 1946–1949

Congress in 1948.[28] The Standard Oil project under Stryker's directorship maintained itself until 1950, and the Photo League continued to be active but promoted a less structured approach to social documentation, which its members generally referred to as "humanist." In pursuit of this loosely conceived end, the League provided a forum and exhibition space for figures as varied in concept as Adams, Cartier-Bresson, W. Eugene Smith, and Strand and opened the pages of *Photo Notes* to articles on Atget, Moholy-Nagy, Wright Morris, Stieglitz, and Weston. In view of this breadth of interest and of the large numbers of esteemed photographers who had joined after the war, the members were astounded to find the organization listed in December 1948 as "subversive"; its subsequent shipwreck on the shoals of government-sponsored anti-Communist hysteria can only be regarded as deplorable.[29]

There is little doubt, however, that a more flexible approach to the aesthetics of photographic expression had begun to attract greater numbers of young photographers toward the end of the decade. In part, the change in direction reflected the doldrums into which documentary photography had fallen, but it was a result, also, of the expansion of educational opportunities made possible by the GI Bill – legislation providing federal funding of education for veterans, of which some eight million took advantage.[30] Seeking to make their classes attractive, art departments offered courses in photography that emphasized personal expression rather than commercial or scientific applications. Instructors came from a variety of backgrounds, including the newly renamed Institute of Design in Chicago, where the faculty was able to spread Moholy's teachings to a large number of would-be photographers, despite his death in 1946. Manipulative procedures, such as cutting the image apart, pasting it together in various configurations, combining images and handwork, creating light-generated images without lenses, appealed to the sensibilities of artist-photographers who, like the abstract expressionist painters, had abandoned depiction as a primary goal and sought to explore the realms of poetry and metaphor.

The most significant figures to embrace these concepts in terms of the authority of their work and their influence as mentors were Harry Callahan, Siskind, and Minor White. Actually, Callahan had been experimenting since 1941 with apparatus, materials, and processes to find, as he said, the means of "revealing the subject in a new way to intensify it."[31] Siskind, rejecting what he considered the lack of imaginative dimension in documentation, endeavored to expand meaning through purely photographic strategies that did not include processing manipulations; personal associations with painters of the abstract expressionist movement led him to concentrate on form, shape, and texture as he transformed his vision from documentary to metaphoric. The image as metaphor rather than depiction was central also to the work of West Coast photographers White and Wynn Bullock, both of whom found inspiration in

ARNOLD NEWMAN, *Arp*, 1949

the landscape imagery of Adams and Weston, and Stieglitz – especially the "equivalents." In embracing the mystical ideas of Gurdjieff and the Zen philosophies of the Far East, White sought to elevate photographic experience to a plane of transcendental rapture; these ideas were to gain greater currency in the following decade as a result of his roles as an influential teacher and as editor of *Aperture* magazine. Others whose approach was both more abstract and more decorative were Carlotta Corpron, who worked with light modulation, and Lotte Jacobi, who produced nonobjective images using moving light sources.

In actuality, however, the number of individuals who were in a position to regard photography as a self-motivated means of personal artistic expression was relatively small. Most photographers, aside from the vast numbers for whom snapshot and photograph were synonymous terms,

were professionals engaged in some practical application of the medium. Notable among those who chose to make their creative energies economically viable by turning to advertising, fashion, and publicity fields were Louise Dahl-Wolfe, Toni Frissell, Leslie Gill, Frances Laughlin Gill, Irving Penn, and John Rawlings. Joined by numbers of European emigré photographers, notably Erwin Blumenfeld, Horst P. Horst, and André Kertész, these individuals gave American still-life, fashion, and celebrity images a distinctive appearance, inspired in some instances by the clarity of form and texture associated with *neue Sachlichkeit* and in others by the iconography of surrealist dream imagery. The distinctive portraiture of the period also was produced in response to publicity needs, with the work of Philippe Halsman and Arnold Newman, both of whom specialized in the genre, adhering closely to the design concepts that characterized luxury-product advertising in general, especially as it appeared in *Vogue* and *Harper's Bazaar*. In this connection, one might cite the role of Alexey Brodovitch, who exercised a significant influence on graphic and photographic concepts both in his role as art director of *Harper's Bazaar* and as an eminent teacher of graphic design.

Probably the most significant development in this area of photographic activity was the expanding use of color materials throughout the forties. Originally pushed as a means of counteracting the buying slump caused by the Depression,[32] by 1949 color was widely used in both luxury and popular magazine advertising and feature sections, with the fashion magazines continuing to exert the leadership they had assumed in the previous decade.[33] As a result of the way Dahl-Wolfe, Penn, and Frissell, for instance, handled color and light, fashion images of the era still retain a strong visual interest despite the dated clothing; in contrast, the handling of color in photographs of nature and the environment, exemplified by those commissioned of Adams and Weston by Eastman Kodak Company, seem uninspired. In addition to the fact that color film was expensive, prints were difficult to obtain and dyes were notoriously unstable, so that photographers other than those engaged in commercial work appear to have been hesitant to

investigate the coloristic potentials of the material.

After the war's end, the mounting interest in photography as visual illustration and as personal expression was reflected in the greater diversity of photographic publications. The documentary idiom continued to find some support among publishers, and, as might be expected, photojournalistic images also appeared in book format, notably *Naked City*, in which full and partial bleeds and dark, rich ink enhanced the sense of drama inherent in Weegee's photographs. Works of an entirely different spirit also were brought out: *Inhabitants* and *The Home Place*, both with text and images by Wright Morris, and *Time in New England*,[34] a collaboration between Nancy Newhall and Paul Strand, endeavored to fuse word and image so that each served to reinforce the overall theme, which in turn reflected continuing interest in the regional diversity and history of the United States. Other books, notably Beaumont Newhall's *History of Photography* (and also Newhall's appointment in 1949 to the directorship of the newly opened

museum at the George Eastman House in Rochester), signaled a commitment to the study and preservation of historical camera images that previously had been lacking.[35]

The decade may be seen as one that started with a firm preference for the documentary image and ended with the encouragement of a many-sided view of the medium's potential. This variety is perhaps best indicated by *In and Out of Focus*, a survey exhibition of contemporary camera expression organized by Steichen for the Museum of Modern Art in 1948. Comprising two hundred fifty works by eighty photographers, the exhibition embraced images made as personal expression and on commission for advertising, fashion illustration, and scientific purposes; it included works conceived as aesthetic statements, as documentation, as photojournalistic reportage, as subjective language. The title, the exhibition itself, and the critical articles about it seemed to suggest that henceforth no single genre of photography would dominate the scene as pictorialism and documen-

WRIGHT MORRIS, *Front Room Reflected in Mirror*, 1947

PAUL STRAND, *Bellrope, Massachusetts*, 1945

From Protest to Affirmation: 1940–1950

tary had in the past – that images recorded with light-sensitive materials would encompass the same spectrum of styles and meanings as other visual arts. Perhaps most significant was the unstated acknowledgment that the terms "high" and "popular" art were not applicable to a medium of such varied function as photography, and that in the future the products of self-expression and commercial patronage would be treated similarly.

Another change that may have been less visible at the time concerned the increasingly diversified role of women in photography. The notable women photographers of the era did not wish their work to be judged on the basis of gender, but they did wish for equal access to and payment for commissioned work not only for themselves but for less well recognized women in the field. In 1940, a conference organized in New York City set forth more than twenty different photographic specialties theoretically open to women;[36] in addition to positions behind the scenes in museums, libraries, archives, and scientific and health institutions,

after the war teaching jobs in photography also became available, albeit on a limited scale. Despite the highly visible work of Bourke-White and Lange, many women, Abbott among them, continued to feel, with justification, that women photographers had not yet reached parity with their male colleagues.

There can be little question that *In and Out of Focus* reflected the tenor of the times and anticipated the future. Having called to mind the motion pictures that seemed to characterize the opening years of the decade, we might turn again to the cinema for an emblem of its closing. *Rashomon*, a Japanese film released in 1950, affirmed that a uniform approach to experience and history no longer was possible, that "truth" was to be regarded as the function of a multiplicity of personal investigations and viewpoints. In photography, the manifold versions of reality reflected in *In and Out of Focus* are still evident, suggesting that the decade of the forties ended as the spawning ground for concepts about photographic expression that would endure for the rest of the century.

NOTES

1. For a discussion of developments in the Historical Section of the Farm Security Administration from 1941 to 1943, see F. Jack Hurley, *Portrait of a Decade: Roy Stryker and the Development of Documentary Photography in the Thirties* (Baton Rouge, La.: Louisiana State University Press, 1972), pp. 147–175.

2. For the background and accomplishments of the Standard Oil of New Jersey photographic project, see Steven W. Plattner, *Roy Stryker: U.S.A., 1943–1950: The Standard Oil (New Jersey) Photography Project* (Austin, Tex.: University of Texas Press, 1983); also Nicholas Lemann, *Out of the Forties* (Austin, Tex.: Texas Monthly Press, 1983).

3. Andreas Feininger, "Introduction," *Andreas Feininger: Industrial America: 1940–1960* (New York: Dover Publications, 1981), p. i.

4. See Checklist, "NYC: Work and Working: WPA Photographs," Surrogates' Courthouse, New York, 4 September–17 October 1980; this exhibition has been one of the few to explore the nature and extent of urban images made in New York City under the auspices of the WPA.

5. "A Letter from Ansel Adams!" *Photo Notes* (June–July 1940): 4, reprint edition, Rochester, New

York, n.d. See also comments on the aesthetics of documentation of Robert Disraeli, "The Farm Security Administration," *Photo Notes* (May 1940): 2–3; Aaron Siskind, "The Feature Group," *Photo Notes* (June–July 1940): 6–7; "Ralph Steiner at the League!" *Photo Notes* (September 1940): 1–2; Paul Strand, "Two-Dimensional Documentary," *Photo Notes* (March 1948): 5.

6. Leslie Katz, "Interview with Walker Evans," *Art in America* (March–April 1971): 87.

7. Elizabeth McCausland, "Lisette Model's Photographs," *Photo Notes* (June 1941): 3.

8. *A Way of Seeing: Photographs of New York by Helen Levitt with an Essay by James Agee* (New York: Horizon Press, 1965). The book waited twenty years for publication.

9. See Louis Faurer, "Narrative of My Career," *Louis Faurer: Photographs from Philadelphia and New York, 1937–1973* (College Park, Md.: Art Gallery, University of Maryland, 1981), p. 9.

10. "In and Out of Focus: Walker Evans" *U.S. Camera 1949* (New York: U.S. Camera, 1948), pp. 12–13 [3 illus.].

11. Paul S. Taylor, "Mexicans North of the Rio Grande," *Survey Graphic* 19, no. 2 (May 1931): 134–

140; illustrated with eleven photographs by Adams.

12. "Ansel Adams: A Personal Credo," in Vicki Goldberg, ed., *Photography in Print* (New York: Simon and Schuster, 1981), p. 378.

13. Announced in *Bulletin of the Museum of Modern Art* 2; no. 8 (December–January 1940–1941), which devoted the entire issue to the new department.

14. "Letters," *U.S. Camera* 14 (February 1941): 8.

15. See F. R. Fraprie, "Letter," *Photo Notes* (October–November 1940): 5; Arthur Hammond, "How to Raise the Standards of Pictorial Photography," *American Annual of Photography 1945* (Boston, 1944), p. 48.

16. Hammond, p. 43; F. R. Fraprie, "Our Illustrations," *American Annual of Photography 1945*, p. 168.

17. Christian A. Petersen, *Pictorialism in America: The Minneapolis Salon of Photography, 1932–1946* (Minneapolis: Minneapolis Institute of Arts, 1983), p. 16.

18. L. Moholy-Nagy, "Photography in the Study of Design," *American Annual of Photography 1945*, pp. 158–164.

19. Charles Traub, ed., with essay by John Grimes, *The New Vision: Forty Years of Photography at the Institute of Design* (Millerton, N.Y.: Aperture, 1982), p. 10.

20. Ruth Bernhard, quoted in *U.S. Camera 1943* (New York: U.S. Camera, 1942), p. 180. The possibility of exploring the irrational with a camera had been recognized in the United States in 1940; see Rolf Tietgens, "Photography Beyond Reason," *U.S. Camera* (February–March 1940): 47–51.

21. Barbara Morgan, "Learned Experiences – Working Thoughts," *Aperture* 11, no. 1 (1964): 35. Morgan began to work in this vein in 1935.

22. "Letters," *U.S. Camera* (February–March 1940): 1; Andreas Feininger, "Truth and Falsehood," *U.S. Camera* (February 1941): 30; Fritz Henle, "Pattern and Photography," *U.S. Camera* (March 1941): 45.

23. Wilson Hicks, *Words and Pictures* (New York: Harper and Brothers, 1952), p. 42.

24. Jorge Lewinski, *The Camera at War: A History of War Photography from 1848 to the Present Day* (New York: Simon and Schuster, 1978), p. 63.

25. See Tom Maloney, "Wonderful Smith," *U.S.*

Camera 1946: Victory Volume (New York: U.S. Camera, 1945), p. 372, for a tribute to Smith's intrepidness.

26. In the dedication, *Victory Volume*, p. 5, the war is referred to as the "greatest."

27. Newhall mounted *War Comes to the People* in 1940 and *Image of Freedom* in 1941; Steichen directed *Road to Victory* in 1942 and *Power in the Pacific* in 1945.

28. Congressmen from western states held that FSA images had demeaned their constituents; see Jacquelyn Judge, "F.S.A. Attacked," *Photo Notes* (Fall 1948): 5.

29. After the Photo League found itself on the Attorney General's list of subversive organizations, it attempted without success to obtain an explanation from federal authorities. As photographers grew fearful of associating with so-called subversive bodies, membership diminished rapidly and the League was terminated in 1951.

30. Geoffrey Perrett, *Days of Sadness, Years of Triumph* (New York: Coward, McCann and Geoghegan, 1979), p. 68.

31. "Harry Callahan: Statement," in Vicki Goldberg, ed., *Photography in Print*, p. 420.

32. Leonard Sipley, *A Half Century of Color* (New York: Macmillan, 1951), p. 86.

33. "Color Photography in Current Magazine Illustration," *U.S. Camera 1942* (New York: U.S. Camera, 1941), pp. 15–24.

34. The collaboration began in 1946, but difficulties with the original publisher delayed the appearance of the work until 1950.

35. That the commitment was undertaken by both the academic and industrial communities is seen by the fact that the museum was to be under the joint auspices of the Eastman Kodak Company and the University of Rochester. See Jacob Deschin, "Eastman Museum," *New York Times*, 13 November 1949, and "Eastman House Made a Museum for Photos," *New York Times*, 10 November 1949.

36. Institute of Women's Professional Relations, *Proceedings of the Conference on Photography: Profession, Adjunct, Recreation* (New London, Conn.: Institute of Women's Professional Relations, 1940).

Photography in Transition: 1950–1960

HELEN GEE

The fifties are marked by three major photographic events: the founding of *Aperture* magazine, the opening of Edward Steichen's exhibition *The Family of Man*, and the publication of Robert Frank's *The Americans*. While these events had an enormous influence on the subsequent development of photography, of equal importance in determining its direction was the climate in which these events occurred. Photography, tied irrevocably to the world, is a barometer of change, both sociopolitical and cultural. In order to place photography of the fifties in its proper historical perspective, it must be seen in the context of the times.

During the first half of the decade, the mood of the country was bleak. There was a feeling of disillusionment, a growing realization that victory in World War II had failed to bring lasting peace. Our dream of "one world" was shattered when Russia, our former ally, exploded its first atomic bomb, raising fears of an even more devastating conflict. The Cold War seemed only a prelude as the nation prepared for the worst. Schoolchildren ducked under desks in practice drills, and bomb shelters vied with barbecue pits for backyard space.

In 1950, American troops were sent to Korea to "forestall" Soviet expansionism. Once again the face of General Douglas MacArthur, in dramatic half-profile, appeared in the press, along with growing lists of casualties as the weeks and months dragged on. *Life* magazine, "eyewitness to the world," sent correspondents to the combat areas, and, in an issue published on Christmas Day, a photo essay by David Douglas Duncan brought the horror of the war back home. The faces of weary GIs – fighting not even for villages but for hillocks, winning one day, losing the next – shook the nation.

Meanwhile, Senator Joseph McCarthy, Chairman of the House Un-American Activities Committee (HUAC), was fighting a war of his own. Citing a "danger greater than any threat from Communist Russia," he warned of radicals right here at home, lurking in our schools, factories, offices – even in our churches. No one was beyond suspicion as he conducted the investigations that were to ruin lives, wreck careers, endanger the democratic process, and cast a pall over the entire decade. Academic life suffered as teachers, guilty merely of association with suspected "fellow travelers," were fired. Libraries were searched for "subversive" material, and books, including Thoreau's *Walden*, were seized and, in some instances, burned.

Photography also came under attack. New York's active and influential Photo League, which included among its members many of the country's leading photographers, became HUAC's prime target. The League's advocacy of social documentary photography made it particularly vulnerable and an easy mark. In 1947, it was placed on the attorney general's list of "subversive" organizations and in 1951, no longer able to survive the stigma, it folded.

The film industry suffered even greater scrutiny. The infamous jailing of the Hollywood Ten and the blacklisting of hundreds of writers, actors, directors and cameramen, many of whom would never work in the industry again, was viewed by the photographic community with increasing alarm: anything but the most benign photographic imagery might be open to question. The inhibiting effects of the witch-hunt, particularly on documentarians, was expressed by Lisette Model, who, in reminiscing on the period many years later, exclaimed, "It was terrible. You didn't know *what* to photograph."

Sid Grossman, one of the founders of the Photo League and the director of the League's teaching program at the time of its dissolution, claimed that he no longer felt free to photograph on the streets. Harassed by the FBI, living in fear of "the knock on the door," he sought refuge on Cape Cod, where his work changed radically. He turned from photographing people (fun-loving Coney Island beach-goers had been a favorite theme) to photographing quiet, contemplative scenes of sand and sea — a change that appears to be as psychological as it was geographic.

Aaron Siskind's work had altered even more dramatically. While active with the Film and Photo League, the predecessor of the Photo League, Siskind produced important documentary work of Harlem. But early in the forties, on discovering beauty in "shapes of rocks and bits of string," he turned to the semi-abstract imagery he was to pursue over a lifetime. Siskind was close to the abstract expressionist painters, and the change in his work seems to have been more related to the influence of this new aesthetic than to the political tenor of the times. As such, it reflected the shift in postwar art from public to private concerns.

Abstract expressionism replaced the social realism of the Depression years, and by the early fifties the painters of the vanguard New York School had already found an audience and a ready market. Willem De Kooning, Franz Kline, and Mark Rothko were no longer looked upon as rebels. Even Jackson Pollock, who had been vilified for his "spilled ink and spattered paint," was featured in *Life* with a somewhat tongue-in-cheek article titled, "Is He Our Greatest Painter?"

If nonrepresentational painting was puzzling, at least it was nonthreatening. The abstract expressionists — once described by Robert Motherwell as "apolitical, like cats" — were spared the attacks made on the WPA painters and on the FSA photographers. And the Club, their famous meeting place, was spared the fate of the Photo League.

Photographers, tied as they were to the "real" world, turned to less controversial material. The humanist documentary tradition continued to dominate, but emphasis now shifted to the more

AARON SISKIND, *New York 6*, 1951

"positive" aspects of life. Adverse social commentary became largely a thing of the past.

By mid-decade the country had recovered its equilibrium. The Korean war was over, and though the Cold War continued, it showed little sign of accelerating. Congress had finally censored McCarthy and dismissed him from HUAC. Eisenhower's benign presidency assured us that all was well, and, for the first time since Korea, the mood of the people matched the official optimism of the White House.

The opening of *The Family of Man* at the Museum of Modern Art in January 1955 – at mid-decade – could not have been more timely. A public weary of national and international conflict responded wholeheartedly to Steichen's affirmation of "the essential goodness of man." In placing "human consciousness rather than social consciousness" at the center of his thinking, as he wrote in the foreword to the book accompanying the exhibition, Steichen was fully in step with the

times. The enormous public response could be measured by the extraordinary number of visitors, averaging three thousand a day, who viewed the exhibition during its New York run.

The unusual installation, much like a three-dimensional magazine spread, seemed tailor-made for a public that was accustomed to seeing photography in the big picture magazines like *Life* and *Look*. Five hundred and three images, greatly enlarged and dramatically displayed (some blow-ups were as large as ten feet), created the overall effect of a giant photo essay. Arranged sequentially, the photographs led the viewer along man's journey through life, illustrating how – all over the world and in much the same way – man loved, worked, played, procreated, worshiped, and died. Repeated throughout the exhibition, reflecting its essentially optimistic mood, was the portrait of a Peruvian piper, merrily playing a tune.

Famed photographer Barbara Morgan provided a euphoric description of the installation in an issue of *Aperture* devoted to *The Family of Man*, saying, "The Birth bower is an open-sided circle suggesting emerging from the womb, the Death theme uses an open-ended tunnel, the rooms that lead to the H-Bomb are three-sided cells, Religion and Awakening Love are carried on running walls and a corridor, in keeping with the universals that keep life and hope continuing. In the Fun room pictures of eating, dancing and music are hung high. 'High spirits' literally 'raise the roof.' "

Not everyone shared this enthusiasm for the exhibition as a whole, however. In an article titled "One Family's Opinion," in this same issue of *Aperture*, George and Cora Wright voiced the silent dissatisfaction of a significant segment of the photographic world: "I doubt that photographers would question the basic thinking behind the show if it had been designed for the lobby of the U.N. building. . . . Is it the function of a museum to hang a show which documents a particular social theme no matter how valid the theme is? Even if 'men are all men,' shouldn't a museum use its space to educate the public about photography as it does about the other arts?"

The Wrights also questioned the validity of using single images from a body of work in order to illustrate a theme. "Any really great photographer, like a great painter, creates his own visual universe. . . . You can distinguish a Gene Smith from a Cartier-Bresson without a signature. You can instantly recognize an Adams, a Weston, a Laughlin print, or that of any mature worker whose previous work you've seen. They are all pointing lenses at the same universe but each selects the area or aspect which is most real to him. When we see a group of pictures made by these men, we enter his subjective world to look at reality through his eyes. But mixed up with others in a show, he surrenders his individuality."

Yet the Wrights conceded, as did most of its critics, that the exhibition was "overwhelming," and, even if they disagreed with everything it stood for, they were happy that it had been undertaken. The Wrights concluded, "The show's like a magazine essay . . . a contemporary use of photography." Jacob Deschin, the camera editor of the *New York Times*, made a similar point, referring to *The Family of Man* in a fairly tepid review as "an editorial achievement rather than an exhibition of photography in the usual sense."

Assuming the role of editor as well as curator, Steichen had decided on the size of the prints and on their quality (they were made from the photographers' negatives by a large commercial lab), and had exercised full control over the context in which they were used. Yet there were no murmurs of protest, not even from those photographers who were to become vociferous critics later on. And if one is to damn Steichen, then one must necessarily damn the entire photographic community, as nearly every photographer, both known and unknown, had submitted his or her work. One might also damn, and with better reason, the overblown installation, the florid prose of Carl Sandburg's introduction, and the simplistic theme. Yet one must still credit Steichen for the quantity of beautiful images in the exhibition.

It is also regrettable, particularly in the light of present-day criticism, that Steichen's ambitious undertaking (he screened over two million photographs in his worldwide search for work) has overshadowed the important contribution he made

during his many years at the Museum of Modern Art with his smaller, more modest exhibitions.

Whatever the show's failings, it had succeeded on one important level. This was summed up in a single line in the *New York Herald Tribune*: "It can truly be said that with this show, photography has come of age as a medium of expression and as an art form."

The enthusiasm with which *The Family of Man* was received around the world – in Tokyo, Paris, Berlin, and even in Moscow – did not go unnoticed at the state department. In the politics of the Cold War, in the battle for the "minds and hearts of men," art served as a weapon. Exhibitions of abstract expressionism were circulated abroad, demonstrating to the world, and to European intellectuals in particular, that America was no longer a cultural backwater, that free people in a free society were free to think and work as they chose. (Yet politically suspect artists were excluded from these traveling shows.)

None of these painting exhibitions achieved the phenomenal success of *The Family of Man*. In an international tour covering over thirty countries, the exhibition was seen by nearly nine million people, more than had attended any kind of exhibition ever. In this respect, *The Family of Man* is thought to have benefited American diplomacy as much as it did photography.

Throughout the fifties, photojournalism continued to dominate the photographic world. Despite the growing competition of television, the big picture magazines were still a major source of entertainment and news. For millions of American families, reading *Life* and *Look* was as much a part of the weekly household ritual as going to the movies. *Life*'s early prospectus "to see the world, to eyewitness great events . . . to see strange things – machines, armies, multitudes, shadows in the jungle and the moon" still lived up to its promise.

Photojournalists were seen as romantic figures, freewheeling characters who roamed the world, risked their lives in wars, and hobnobbed with heads of state and Hollywood stars; they could go everywhere and do almost anything. Few, however, actually lived up to this image. They were, for the most part, a hardworking lot

W. EUGENE SMITH, [from the Ku Klux Klan series], ca. 1951–1958

who went where they were sent, performed frequently dull assignments, and had little to say about the use of their work. Some complained of being reduced to mere shutter-clickers who, if they did indeed risk their lives, would often see their stories killed or mutilated by the editors.

W. Eugene Smith, who by the fifties was already something of a legend, fought against this editorial interference during most of his years at *Life*. Railing against a bureaucratic system that rarely included the participation of the photographer in the presentation of his work, he won the respect and admiration of a whole generation of photographers. Smith fought for a say in every stage of the editorial process, from the initial

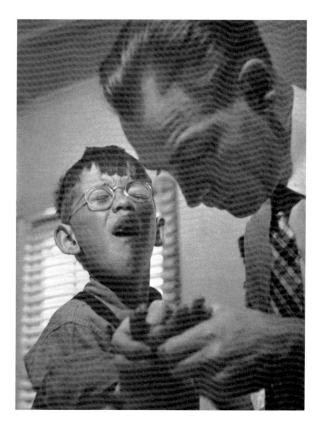

W. EUGENE SMITH, [from the Country Doctor series], 1948

selection of his photographs to the final layout on the page. Though his single-handed struggle met with varying degrees of success, Smith did win the right to choose his own assignments, a significant concession on the part of *Life*. Yet this was not entirely gratuitous: the editors found that when Smith was deeply concerned with his subject, he did his finest work.

His "Country Doctor," a photo essay published in *Life* in 1948, represented a turning point. In striving for greater depth – revealing the *person* behind the doctor, not merely his work – Smith went beyond the simple, narrative function of the picture story, thus expanding its creative and expressive possibilities. Over the years, the photo essay had been reduced to little more than a formula, with the "opener," the "stopper" (a photograph that peaked the action), and the "closer" usually determined in advance by the editors. Smith rejected this mechanistic approach. In

introducing the element of subjectivity – using not only what he saw, but how he felt – Smith brought new layers of meaning to this previously superficial form of photo reportage.

Unlike Cartier-Bresson, Smith depended not on the "decisive moment" of instantaneous revelation but on a kind of "knowing" that called for exploring a subject in depth. He spent weeks photographing Maude Callen, the central figure in his 1951 photo essay "Nurse Midwife." (His preparation for the assignment included taking a course in midwifery.) Even more months were spent with Dr. Albert Schweitzer in Africa while working on "A Man of Mercy" (1954), in order to arrive at what he saw as "truth."

But Smith's truth did not always correspond with what *Life*'s editors regarded as fact. In 1951, when given the choice assignment of photographing Fascist Spain (at a time when few newsmen were allowed entry), he returned after almost a year with an eloquent series of photographs showing the harvesting of the crops, religious rituals, and other aspects of life in a centuries-old village. But, much to the disappointment of the editors, Smith had ignored what they believed should be the focus of the story: life in Generalissimo Franco's police state. They were mollified, however, when the "Spanish Village," which became his most famous photo essay, also won critical acclaim.

Although Smith's myriad problems – his troubles at the magazine (he quit in 1955), his financial difficulties, and an erratic personal life – all contributed to his legendary status, fundamentally he was revered for the quality of his work. The idealistic humanism central to the period is seen at its finest in the work of W. Eugene Smith.

By the late fifties, the great era of photojournalism was drawing to a close. Television was taking over: in 1946 there were seven thousand sets in use, fifty million in 1960. The picture magazines, already in trouble, began to founder. *Collier's* failed in 1957, *Coronet* in 1961, and *The American Weekly* in 1963. *Life* and *Look* managed to survive, at least until the seventies.

Yet the rest of the publishing field was booming. Magazines of every description – on sports, art, homemaking, gardening, mechanics, and

every imaginable hobby – appeared on the stands, providing photographers with an abundance of work. Women looked to magazines for advice on how to raise a family, how to keep a husband happy, and how to dress. *Vogue, Harper's Bazaar, McCall's, Good Housekeeping, Ladies' Home Journal*, and scores of others provided the answers. Advertising stimulated an appetite for "the new." Hemlines went up and then went down. Cars sprouted longer and longer fins. Supermarkets displayed a dizzying array of goods. A burgeoning economy brought within reach all the extravagances of the American dream.

Color, important in the glamourizing and marketing of this avalanche of goods, found its widest use in advertising. Although a number of artist-photographers had begun to experiment with color, among them Harry Callahan and Eliot Porter, most still preferred black and white. In 1957, a lecture by Steichen on experimental color drew record crowds but did little to dispel the prejudice long surrounding its use. Documentary photographers claimed that color lessened the impact of their statements; photojournalists found the film too slow; artist-photographers were put off by its identification with the commercial world. Even in fashion, where color was most frequently used, Richard Avedon made black-and-white photography his aesthetic choice. A few innovative art directors encouraged experimentation (Bert Stern's Smirnoff's Vodka ads, Irving Penn's DeBeers Diamonds, Ernst Haas's New York cityscapes), yet most color work remained unimaginative and slick. A quip attributed to a leading art director was "Use any color so long as it's red."

In a 1955 *Popular Photography* poll conducted to determine "The World's 10 Greatest Photographers," all of those chosen, with the exception of Ansel Adams, worked within the structure of the magazine field. The top ten, according to the 243 "eminent critics, teachers, editors, art directors, consultants and working photographers" polled, were Richard Avedon, Alfred Eisenstaedt, Ernst Haas, Philippe Halsman, Yosuf Karsh, Henri Cartier-Bresson, Gjon Mili, Irving Penn, W. Eugene Smith, and Ansel Adams. The exclusion of other artist-photographers attests to the focus of

the period; they were certainly not unknown nor had they been overlooked.

Even on an international level, the photography world was small. Everyone knew what everyone else was up to. A photographer in New York was as aware of the work of Brassaï in Paris and Bill Brandt in London as that of John Rawlings on Madison Avenue. Various periodicals – the Swiss magazines *Camera* and *Du*, the George Eastman House publication *Image*, and the American Society of Magazine Photographers' journal *Infinity* – kept photographers informed. The mass-circulated magazines – *Popular Photography, Modern Photography*, and *U.S. Camera* – published a wide spectrum of work along with their articles on technical matters. And the book version of *The Family of Man*, a bestseller, served as a virtual "Who's Who."

Despite a prodigious amount of photographic activity, photographers working outside of the publishing mainstream found the outlook bleak. Most often, the sole reward for years of uncompromising devotion to a personal vision was inner satisfaction and the esteem of one's fellow artists. Harry Callahan, in addressing the inclusion of several of his photographs in the *1953 ASMP Picture Annual*, said wryly, "None were done on assignment."

For Callahan, Berenice Abbott, Aaron Siskind, Lisette Model, and others outside the mainstream, teaching provided an alternative to the strictures of the commercial world. But universities had not yet incorporated photography into the curriculum and, thus, even teaching positions were scarce. Among the few institutions providing photographic education were the Rochester Institute of Technology, the Institute for Design in Chicago, Brooklyn College, the New School for Social Research in New York, the San Francisco Art Institute, and Indiana University, where Henry Holmes Smith introduced the first university course in the history of photography.

Another aspect of photographic education had emerged with the establishment in Rochester in 1947 of the George Eastman House, and its influence was evident. Beaumont Newhall, who served as curator before being appointed director in 1958,

WYNN BULLOCK, *Child in the Forest*, 1951

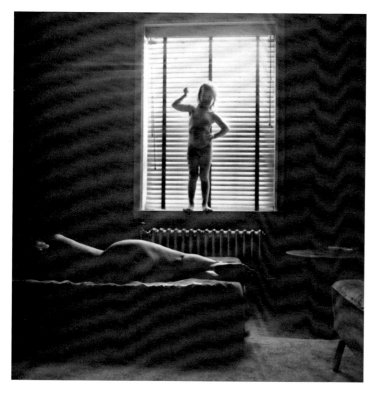

HARRY CALLAHAN, [Eleanor and Barbara], 1954

established a program for the exhibition and preservation of photographic art that would serve as a model to the field. Among the few museums exhibiting photography, aside from the Museum of Modern Art, were the Cincinnati Museum of Fine Art, the Art Institute of Chicago, and the San Francisco Museum of Fine Art.

Fine-art photography found yet another voice in *Aperture*, the quarterly magazine launched in 1952. Though its readership was limited to a dedicated few, it provided a much-needed critical forum for the aesthetics of photography, as had Alfred Stieglitz's *Camera Work* in the past. Minor White, *Aperture*'s guiding spirit and editor for twenty-four years, was ideally suited both in personality and by conviction to go "against the grain." *Aperture* became as much a vehicle for his off-beat views as a showcase for many fine-art photographers, such as Manuel Alvarez Bravo, Wynn Bullock, Paul Caponigro, Imogen Cunningham, Nathan Lyons, Aaron Siskind, and Frederick Sommer.

A treatise on the "reading" of a photograph – an aesthetic and philosophic concept developed by White – might appear along with a smattering of Zen or a bit of the Tao. Unifying what at times seemed like a hodgepodge was White's belief in photography as a means not only of personal expression but of personal growth. The single-mindedness with which he pursued this vision – as teacher, photographer, and editor – placed him at the forefront of creative activity. And *Aperture*, undersubscribed and undercapitalized for most of its years, not only survived (an irony, considering the demise of the picture magazines) but developed into a vital force in the field of creative photography.

White was hardly alone in his involvement with oriental thought. The publication of Eugen Herrigl's *Zen in the Art of Archery*, as well as the teachings of D. T. Suzuki, won converts among artists and intellectuals, particularly on the West Coast, where the cosmic scale of nature seemed to induce a cosmic view. Its influence on the East Coast was minimal, but it was of special interest to the abstract expressionists, who saw a correlation between their own aesthetic and the intuition and

spontaneity that was central to Zen Buddhist thought. Happenings, method acting, and modern jazz were all manifestations of this new emphasis on improvisation.

If there was anything that could be described as an underground, it was found at Limelight (1954–1961), a photography gallery and coffee-house in Greenwich Village that was the primary exhibition space for photography in New York aside from the Museum of Modern Art. Louis Faurer, Robert Frank, Roy deCarava, Garry Wino-grand, Duane Michaels, Bruce Davidson, and Diane Arbus were among the many young photog-raphers who frequented Limelight, as did others who were longer established, such as Eugene Smith and Lisette Model. What bound these pho-tographers into a kind of community was their sense of themselves as artists, of going against the mainstream, of finding fulfillment in personal work. Many were busy professionally yet still found time for creative work. Museum exhibition, however limited, supported their efforts, as did an increasingly sophisticated attitude on the part of the public as to what constituted photographic art. Steichen's espousal of personal photojournalism gave street photography, which most of these young photographers were involved with, heightened status. A street scene by Helen Levitt could be as much appreciated for its aesthetic value as a pepper by Edward Weston or a moon-rise by Ansel Adams.

While most documentary photographers looked to Smith and Cartier-Bresson, there was something new in the air – a spirit of experimenta-tion, a moving away from the limitations that straight photography imposed. Graininess, blurs, and unconventional framing began to be used as artistic devices, albeit tentatively, by these young photographers. The dialogue fostered by *Aperture* was pursued on a one-to-one basis at Limelight, and with such intensity that Ralph Hattersley was led to remark, "Photography has become the clos-est thing to a religion that any of us ever had."

Though photographers had never looked to Europe as painters had in the past, there was con-siderable interest in French photography, particu-larly in the work of Cartier-Bresson, whose

PAUL CAPONIGRO, *Ice, Nahant, Massachusetts,* 1958

influential book *The Decisive Moment* was pub-lished to wide acclaim in 1952. The Museum of Modern Art presented two important exhibitions: *The Roots of French Photography,* organized by the George Eastman House, in 1949; and in 1951, *Five French Photographers* – Brassaï, Izis, Robert Doisneau, Willy Ronis, and Cartier-Bresson.

The romantic appeal of everything French in this most French of American decades encom-passed not only photography but film, literature, and, of course, fashion. Paris was still the un-rivaled center of *haute couture.* Existentialism and the writings of Jean-Paul Sartre, Albert Camus, and Simone de Beauvoir were standard intellec-tual fare. Even the coffeehouses that sprang up in New York and San Francisco were patterned after Parisian cafes.

The coffeehouse was where it was happening – poetry readings, folk singing, jazz. In New York, photographers met at the Limelight; painters (evi-dently preferring harder stuff) met at the old Cedar Bar. In San Francisco, a group of obscure poets called Beats titillated audiences in the cof-feehouses of the Bay Area with their strange, uninhibited verse. It was not until the police raided the City Lights Bookstore and seized Allen Ginsberg's *Howl* that the Beats made national news. At first dismissed as a curiosity – just

ROBERT FRANK, *Newburgh, New York* [from *The Americans*], 1955–1956

another one of those California cults – the movement began to attract a youthful following, causing wide concern. Everything "beat" stood for – sexual freedom, rejection of materialism, communal living – was antithetical to the values of Middle America. Cracks in the monolithic structure of American society had already appeared, evidenced in a rise in juvenile delinquency and in the growing disaffection of the young.

Social protest, virtually nonexistent during the McCarthy years, became a disturbing reality. Pacifism, agitation to ban the bomb, and the civil rights movement shook a nation grown unaccustomed to dissent. Police dogs snapping at the heels of schoolchildren flashed across television screens.

In 1955, Robert Frank set off on his now legendary journey through America, made possible by a Guggenheim grant. But the America Frank saw was not an America of protest; neither was it the America pictured in *Life*. It was not the America of "togetherness," suburbia, split-level houses, and well-kept lawns, nor the America of the Hula-Hoop, tail-finned cars, and Marilyn Monroe. It was not "America the beautiful," replete with rolling hills and open plains. Rather, Frank saw and captured with his camera a land of "quiet desperation," suffering, in the midst of plenty, from an impoverishment of the soul.

Struck, too, by the lingering effects of McCarthyism, Frank remarked, years later, "Seeing those faces, the kind of hidden violence – the country at that time – the McCarthy period – I felt it very strongly."

But it is a sense of loneliness that most of the images in *The Americans* convey. While alienation was not a new theme, it having become current in literature, Frank made it visible. In his introduction to Frank's book, Jack Kerouac described the image of men in a public urinal as "the loneliest picture ever made." Just as lonely is the image of an infant lying on the floor of a tavern, a jukebox as its nursemaid. There are also few images that convey a sense of violence as forcefully as Frank's photograph of a cross marking the scene of a crash on a lonely stretch of highway. Or that of the dead, concealed beneath a blanket, lying by a roadside.

The outrage following the publication of *The Americans* in the United States in 1959 centered on what many critics, even those more favorably disposed toward Frank, claimed to be its one-dimensional view. Had Frank chosen a less inflammatory title (*Some* instead of *The* Americans, as one writer suggested), he might possibly – but only possibly – have defused much of the adverse criticism. Described as "sad . . . sick . . . nihilistic," the book was said to show a "lack of love for one's country" – a love that even the dissenting Beats professed. And what seemed even more outrageous was the fact that this acerbic view of America was made by someone relatively new to its shores. Patriotism ran high in the fifties; the national self-criticism that marked the sixties had not yet set in.

Yet Frank had his supporters. H. M. Kinzer, writing in *Popular Photography*, which had devoted several pages to various reviews of the book, defended his approach. Kinzer saw no particular virtue in Frank's covering "the vast and smiling middle-class" and "the champagne and Jaguar stratum" just for the sake of a more rounded view. Charles Reynolds concluded his review of *The Americans* in *Popular Photography* with the statement (all the more important for its having been said at a time when photographers were still skirting social and political issues), "An artist with a strong viewpoint, however limited, is better than one with no viewpoint at all."

In addition to attacks on content, there were also attacks on his style: Frank's use of grain, blurs, and "drunken horizons" contributed to what was derisively referred to as the "snapshot" quality of his imagery. Yet some of these same artistic devices could already be found in the work of Louis Faurer, Ed Feingersh, Garry Winogrand, and others engaged in a search for a new photographic vocabulary outside of current conventions.

The work of William Klein, who explored New York around the same time that Frank explored the hinterlands, was actually more radical. And Klein also produced a disquieting book. Self-published in France in 1956 under the improbable title *Life Is Good and Good for You in New York: William Klein Trance Witness Revels*, it raised none of the uproar that Frank's book did; attacking New York was not like attacking apple pie and the flag. Yet the images were far more abrasive. The distortions, erratic framing, and exaggerated blurs made *The Americans* appear relatively conservative.

But Frank was the more subtle and sensitive photographer. The tension in Klein's photographs, regardless of where they were taken – in Tokyo, Rome, or New York – was always the same. And

ROBERT FRANK, *City Fathers, Hoboken, New Jersey* [from *The Americans*], 1955–1956

while Klein did have some influence on the underground, it was minimal, partly because he was less visible, having left America to live in France.

Frank's work was also distinguished by the tentative quality of its style. Frank saw not the "decisive moment" but what he called "the moments in between." Though one may marvel at the perfect configuration of chance elements that marks the work of Cartier-Bresson, it is the artless, shooting-from-the-hip quality of Frank's imagery that is somehow truer to life. One feels the sense of recognition that goes beyond the familiar object and touches a deeper core.

While Frank's vision was not all-encompassing, he touched on a certain malaise. He recognized the ills that were to surface in the sixties, when the country erupted in political and social dissent. Frank saw beneath the surface, and that is where his genius lies.

Public Places/Private Spaces: 1960–1970

TERENCE PITTS

Experimentation, rebellion, alienation, social criticism, tradition: these are the contrasting faces that the photography of the sixties presents us. Even from our perspective two decades later, the sixties still – perhaps fortunately so – defy easy definition. There was no Photo-Secession, no Group *f*/64, no Farm Security Administration, and no Stieglitz or Weston dominating the sixties.

HARRY CALLAHAN, *Chicago*, 1961

The sixties have often been characterized as the decade of the ill-defined photographic style called the snapshot aesthetic. But if anything, we ought to remember these years as the decade in which photographers grappled with the meaning and definition of their own medium. As the French political philosopher Louis Althusser put it in the middle of the decade: "Our age threatens one day to appear in the history of human culture as marked by the most dramatic and difficult trial of all, the discovery of and training in the meaning of the 'simplest' acts of existence: seeing, listening, speaking, reading – the acts that relate men to their works." [1]

For the more than one hundred and twenty years of its existence, photography had been considered as the simplest and most direct way of relating the world to people; and looking at photographs had been considered as simple as looking at the world itself. Only slowly did it become apparent that photographs mediated between reality and the viewer, and that they therefore probably had some form of syntax. The German critic and philosopher Walter Benjamin had raised this issue in the thirties, particularly in his now-classic essay of 1936, "The Work of Art in the Age of Mechanical Reproduction." And in the late fifties, the French structuralist and semiotician Roland Barthes had begun to decode the syntax of advertising and journalistic photographs in some of his essays. The slowness with which this concept reached a broad audience can be witnessed by the fact that Vance Packard's highly popular 1957 book, *The Hidden Persuaders*, exposing misleading practices in advertising, failed to make any mention whatsoever of photography in spite of the obvious role that photography plays in commercial persuasion of all types.

For whatever complex web of reasons, the issue finally surfaced in a large way in the sixties. As Henry Holmes Smith put it in "Photography in Our Time," a 1961 essay reviewing the prospects for photography in the coming decade: "Before I can make any estimate of photography's present state and future prospects, I need to know what a photograph should look like and I am not at all certain that I do."[2] What had once seemed obvious to anyone had become totally muddied. Photographers like Robert Heinecken emerged who didn't even use cameras, while painters like Richard Hamilton, Chuck Close, and Andy Warhol began to make paintings that looked like canvas-sized photographs.

The traditional and the experimental seemed to be not only coexisting – however fractiously – but flourishing simultaneously. Photographers like Wynn Bullock, Minor White, Paul Caponigro, Ansel Adams, Frederick Sommer, and Brett Weston were carrying on and individually adapting the long-standing American tradition of an artistic photography rooted in finely crafted prints and beautiful, spiritually elevating subjects. At the same time, other photographers were striking out in new directions that denied most, if not all, photographic tradition, and their work has defined areas of formal and social concern that are still being explored and debated today in the eighties.

The most strenuous debates were over what ought to be the role of traditional craftsmanship and technical proficiency, and, perhaps more important, what photographs could mean. If photographs were to be "read," were their meanings universal or ultimately personal and subjective? Were they "equivalents" of the photographer's inner state or "expressions" of the photogapher's "vision"? Were they the "faithful witness" to history, were they reflections of contemporary culture, or were they as artificial and untrustworthy as any other medium of communication? As Nathan Lyons reported in 1966, the controversy concerning what constituted the meaning of reality in pictures had "fragmented the photographic community into reverently biased schools of thought,"[3] the scars of which are still apparent today.

FREDERICK SOMMER, *Dürer Variation #2*, 1966

Beginning in the early fifties, with the founding of *Aperture* magazine, Minor White, Henry Holmes Smith, and others had addressed the issues of "reading" photographs, attempting to develop meaningful categories of imagery, improve the level of photographic education, and create possible methods for the criticism of photographs. During the sixties, attempts to construct a basis upon which to look at, understand, discuss, and judge photographs reached an even broader audience in the exhibitions and catalog essays of Nathan Lyons, John Szarkowski, and others.

It was a decade of cultural uncertainty, "countercultures," and growing social protest, and as America vacillated between tremendous national confidence and abysmal national disgrace, it is not surprising that many photographers believed that the times demanded fresh, new approaches to their medium. In his 1961 essay, Henry Holmes Smith suggested that photographers needed to be freer to explore their medium in completely new ways and that the time was ripe

for photography to take a closer look at society: "As to certain potentialities unexplored or only partly explored: the first is to face squarely the embarrassments of the human predicament. No other medium is so open in its candor, so able to emphasize the peculiarly relevant detail, underline an essential vulgarity, make us aware of some shocking crudity . . . Possibly we are now ready for more surgical detail from the everyday world."[4]

No prophet could have hoped for a truer prophecy. Within the next ten years, in a tremendous outburst of energy, some of the most controversial, yet exciting, new photography of the postwar era arose from a rejection of traditional subject matter, traditional camera aesthetics, traditional definitions of photography, and traditional notions about the role of the photographer. Some of the most prominent new arenas of photography in the sixties were found in popular culture, the routine moments and banality of much of contemporary life, and the extremes of the socioeconomic ladder, as photographers began to look beyond the facade of what John Kenneth Galbraith called "the Affluent Society," where "wealth is the relentless enemy of understanding,"[5] toward the vast territory that Lee Friedlander termed the "American social landscape."

The distinctive new style that evolved simultaneously was often likened to the snapshot. The growing desire to respond to the manifold realities of the modern environment required a new type of photographic realism, and it was logical that the new aesthetic be derived from the very heart of popular culture. In adopting – whether purposefully or not – stylistic aspects of nonart photography as found in family albums, amateur snapshots, news photographs, postcards, advertisements, and other popular manifestations of the medium, photographers of the sixties did what earlier generations of American artists had done when American art seemed in need of replenishment and reinvigoration: they took the expressive potential of image-making at the vernacular level and redeployed it to their own communicative and aesthetic ends. As photographer and teacher Lisette Model put it, the snapshooter simply disregards the differences between the three-dimensional world and the two-dimensional photograph, thus giving "his pictures an apparent disorder and imperfection, which is exactly their appeal and their style. The picture isn't straight. It isn't done well. It isn't composed. It isn't thought out. And out of this imbalance, and out of this not knowing, and out of this real innocence toward the medium comes an enormous vitality and expression of life."[6]

With a frequently undisguised irony, a number of photographers took the most innocent and unself-conscious style of photography and deliberately adapted it in ways that consciously referred to the artifice of the medium. In the style of the sixties, the glare of a bare light bulb, the unfocused nature of a scene hastily responded to, or the unnoticed intrusion of an unwanted object on the periphery of the composition suggested that picture-making was, for some photographers, simultaneously a very visual art and a gut-level reflex to the compelling power of the subject – thus uniting two of the seemingly most opposed traditions in photography: the documentary photograph and the art photograph. In much the same way that the stream-of-consciousness writing of New Journalism and the deliberately apparent camera techniques of *cinema verité* seemingly placed the reader/viewer in the shoes of the writer/filmmaker, this new photographic style emphasized the primacy and authenticity of the photographer's experience over the reporting of pure facts.

In addition to hinting at the urgency of the subject matter, the snapshot aesthetic, which inevitably involved a great deal of serendipity, presented the photographer with new formal and purely visual possibilities. One thinks immediately of the many visual puns that appear in the landscapes and urban scenes of Lee Friedlander or Garry Winogrand and of the series of "self-portraits" in which Friedlander appears in the form of his own reflection, shadow, or mirrored image, with camera poised to eye in the act of making the very photograph that the viewer is looking at.

What all of this led to was a growing sense that in addition to having a syntax of some sort, perhaps photography was also distinctly *different* from other image-making practices, a notion that

opened a discussion of just what was peculiar to photography. In a 1966 book, *The Photographer's Eye*, John Szarkowski suggested five elements that might "contribute to the formulation of a vocabulary and a critical perspective more fully responsive to the unique phenomena of photography": The Thing Itself (meaning the actuality of the world), The Detail, The Frame, Time, and Vantage Point.[7] In turn, the construction of a theoretical approach to photography like Szarkowski's required a historical approach that meant a reexamination of the entire history of photography from a new perspective, which is exactly what Szarkowski accomplished in *The Photographer's Eye*.

Two other important reevaluations of the history of photography also appeared in the sixties, both locating photography's central role in the evolution of the mainstream fine arts, principally painting and printmaking, since its invention in 1839. Aaron Scharf's *Art and Photography* and Van Deren Coke's *The Painter and the Photograph* not only demonstrated the widespread relationship between photography and the other arts but also suggested the many subtle ways in which photography had altered our visual conception of the world.

Looking backward from the perspective of the sixties, one could see that earlier photographers like Walker Evans, Weegee, W. Eugene Smith, and Lisette Model, all of whom were still working to one extent or another in the sixties, had each provided different directions that artists could take in a socially oriented photography. But the one photographer whose style met the needs of the sixties more than any other was Robert Frank, whose influential book *The Americans* began appearing in American bookstores in January 1960.

The photographs in *The Americans*, which Frank made during 1955 and 1956, explored not only the dramatic potential of anonymous people, public places, and the pervasive new symbolism of contemporary America but also the no-man's-land between subjective vision and objective reality. Frank was a 1947 émigré from Switzerland, and it was as much his perspective as a stranger in a very strange land as his visual genius that allowed him

to so successfully depict the varied and often bizarre face of American culture and to interweave such sensitive issues as racism, poverty, wealth, religion, and power into a remarkable social portrait of our country. *The Americans* still stands as one of the most remarkable photographic books ever produced. Through the careful sequencing of images and the repetition of powerful iconographic elements, Frank created a book in which the impact and meaning of individual images remain in a state of continual flux, seemingly defying any tendency toward entropy.

In addition to its radical and innovative content, *The Americans* was bursting with a concentration of new stylistic and expressive photographic effects perfectly attuned to the times. As Jonathan Green has said: "Frank's photographs are alternately elegant or graceless, luminescent or grim, immaculately focused or fuzzy, apparently casual or excessively mannered. Their shape is dictated by an unswerving commitment to accuracy of feeling and description."[8] Realizing that the work he had done for *The Americans* meant a break with his commercial career (and his source of livelihood), and also perhaps anticipating the widespread negative reaction that the book would cause, Frank had written that since photography is "presumed to be understood by all — even children . . . only the integrity of the individual photographer can raise its level."[9]

Frank's style broke the ground for an entirely new, personal form of social documentary photography that, even when most concerned with social realities, constantly stressed subjectivity as well as a keen interest in the facades and surfaces of the world. Frank's 1955 statement that "to produce an authentic contemporary document, the visual impact should be such as will nullify explanation"[10] implied the dilemma that photographers faced in trying to retain the visual nature of their images and their own subjective identity as artists when they turned toward social themes as subjects.

Like children seeing the empire's nakedness for the first time, Diane Arbus, Lee Friedlander, Bruce Davidson, Garry Winogrand, Larry Clark, Danny Lyon, Richard Avedon, and other photog-

GARRY WINOGRAND, *New York City*, 1969

LEE FRIEDLANDER, *TV in Hotel Room, Galax, Virginia*, 1962

raphers began to examine aspects of America that seemed to be invisible to the gaze of all too many Americans: madness, death, loneliness, urban decay, poverty, racism, the uncertain cultural terrain of television, and the lives of criminals, eccentrics, and social misfits.

In 1966 and 1967, the photographs of Garry Winogrand, Diane Arbus, and Lee Friedlander comprised one of the landmark exhibitions of the decade: *New Documents,* curated by the Museum of Modern Art's John Szarkowski. For Szarkowski, a compelling aspect of the work of these three photographers was that their work was simulta-

neously social and personal. Szarkowski wrote that "their aim has not been to reform life, but to know it. . . . They like the real world, in spite of its terrors, as the source of all wonder and fascination and value."[11] Implicit in these "new documents" was a critique of the traditional notion that photography created an "objective," truthful image through the oversimplified equation of image and subject, whereas in the work of these photographers the meaning of an image was affected not only by the visual presence of the subject itself but also by the subjectivity of the photographer and by the conventions of photography.

For Lee Friedlander, the camera became the ultimate tool of democratic vision. It rejects nothing and is capable of recording everything that falls within the realm of its lens with equal importance – or equal unimportance. His deadpan, often sly urban views reflect a chaotic, disjointed, surreal America. Yet at the same time, in some of Friedlander's photographs, modernistic epiphanies appear in unlikely places when nobody seems to be looking, in the dusty abandon of neglected shop windows, for example, or in the serendipitous concurrences that happen on public streets.

With Garry Winogrand, the democracy of photography began to verge on anarchy. At first, many of his photographs appear to be the random, accidental images of a photographer making his way through a crowded party or a busy public arena, shooting pictures continually and almost heedlessly. But his beautifully balanced public dramas have the same kind of filled-frame coherence as a Jackson Pollock painting or one of Frederick Sommer's dense, centerless, horizonless desert landscape photographs. An extraordinarily compulsive photographer, Winogrand frequently used the camera like a machine gun, in search of events and coincidences that the eye rarely notices. His now-notorious statement, "I photograph to find out what something will look like photographed,"[12] represented a direct turnabout of the fiercely held position that the photographer had to have a certain type of control over his subject matter.

But while Winogrand and Friedlander kept a cool, often amused distance from the world, it was

Diane Arbus's obsessive descent through the social and economic caste system of America that provided the most "surgical" and yet most personal view of the sixties. Although most widely known for her photographs of transvestites, giants, midgets, and other types of "freaks," as she called them, Arbus's most powerful photographs painfully depict the gap that exists between inner and outer lives, between what appears to be the subject's self-perception and the actual public image of more or less ordinary people. "If you scrutinize reality closely enough," she said, "if in some way you really, really get to it, it becomes fantastic. You know it really is totally fantastic that we look like this and you sometimes see that very clearly in a photograph."[13]

Ultimately, her photographs of socialites, adolescents, young patriots, and senior citizens suggest that no one is really ordinary.

Like many photographers of this and the previous decade, Harry Callahan found himself fascinated with the visual opportunities that he found all around him on city streets. But unlike most of his contemporaries, Callahan's images create an intimate, personal world more than a social one. He viewed the self-absorbed pedestrians of Chicago, Providence, and New York with the poetic empathy of an inveterate fellow loner, and his bemused photographs of the surrealistic window displays and the mélange of architectural styles that he encountered evoke the spirit of the Parisian photographer Eugène Atget.

Pursuing another kind of street photography, Aaron Siskind used the city for his own personal ends, photographing graffiti and other symbolic traces of modern urban life almost as if discovering cave paintings of universal or archetypal significance. In the sixties he began traveling – notably to Mexico and Rome – and extending his visual language into photographs made in nonurban settings, such as Mexican villages, remnants of the ancient world, and nature itself.

The more traditional, humanistic form of social documentary photography was also much in evidence during the sixties. Although still very much a presence, W. Eugene Smith produced relatively little during the sixties. In 1961 and 1962

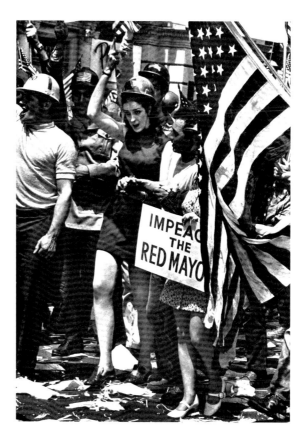

W. EUGENE SMITH, [from the Protest in the 1960s series], 1969

he was in Japan, working on a lengthy commission for Hitachi, Ltd., and from 1966 to 1968 he photographed for the Hospital for Special Surgery in New York City.

The first of several publications and related exhibitions organized by Cornell Capa under the title of *The Concerned Photographer* appeared in 1968, surveying as much as six decades of images made around the world by five photojournalists – Dan Weiner, Leonard Freed, Robert Capa, David Seymour, Werner Bischof – and the not-so-journalistic André Kertész.

A number of other young photographers, whose work resembles that in the social documentary vein, seemed to fall into an undefined space between photojournalism and the "new documents" – photographers like Bruce Davidson, Larry Clark, Mary Ellen Mark, Ralph Gibson, and Danny Lyon. Some of their subjects were typical of traditional American social documentary pho-

tography: people whom the American Dream had passed by – America's rural and urban poor, and its racial and ethnic minorities. But they were also champions of a new postwar breed of American outsiders, those who had deliberately left the mainstream of American life and were rebelling against the traditional values and definitions of success – outsiders such as motorcycle gangs, convicts, drug addicts, and dropouts of all types. Frequently, these photographers rejected the traditional role of the documentary photographer as objective, albeit usually sympathetic, viewer,

and they became part of the group that they were actively photographing. This increased level of access and trust that they were granted led to a more sympathetic photographer/subject relationship and to more sustained photo essays resulting in a number of book-length publications.

Richard Avedon's book *Nothing Personal*, with text by James Baldwin, portrayed a wide spectrum of American society, from the Daughters of the American Revolution to inmates at a mental asylum. Danny Lyon, who has a particular sensibility for the situation of poor and disaffected youths,

DANNY LYON, *The Line, Ferguson Unit, Texas* [from the Conversations with the Dead series], 1967–1969

BRUCE DAVIDSON, [from the Welsh Miners series], 1965

ROY DECARAVA, *Three Men with Hand Trucks, New York*, 1963

LARRY CLARK, [from the Tulsa series], 1963–1971

photographed the civil rights movement, the poor of Chicago's Uptown section, convicts (*Conversations with the Dead*, 1971), and Chicago's motorcycle gangs (*The Bikeriders*, 1968). Mary Ellen Mark created some powerful photo essays centered largely around the lives of women, in Northern Ireland, in Appalachia, in the Women's Army Corps, inside drug treatment centers. Bruce Davidson in particular seemed to carry on the somewhat romanticized, committed photography of W. Eugene Smith, especially in his photo essays "The Clown," "Brooklyn Gang," and "Los Angeles," which depicted the conditions of poverty and the alienating trends of modern urban life. In 1970, he published *East 100th Street*, an intimate portrait of New York's Harlem.

The photographs of Roy DeCarava are some of the most poetic documents of urban life in the sixties. His mysterious images of jazz musicians, New York street scenes, and people at work are frequently so dark or so close in that their subjects are reduced to a single, significant detail. Larry Clark's book *Tulsa* (1971) portrayed a painfully and graphically powerful insider's view of a group of young drug addicts in Tulsa, Oklahoma. Ralph Gibson's work in the late sixties concentrated on Hollywood's Sunset Strip, where he made a series of harsh, often uncomplimentary images of what Thomas Garver called the "complex narcissistic rituals of dancing, eating, and dress."[14]

For a photographer like Emmet Gowin, however, the exploration of rituals was a far more personal undertaking. Gowin, whose early stylistic models included Robert Frank, Frederick Sommer, and Harry Callahan, made pictures of his wife, family, and friends in rural Virginia. His photographs are, in a very real sense, a coming-to-terms with his own identity, his family's rural roots, and the familiar yet ever mysterious moments of everyday life.

And right at the end of the decade, Judy Dater began a series of intense portraits, mostly of women — portraits that reflected upon the realities and fantasies of gender and on the emergence of Northern California as a distinctly new cultural force in what would become known as the "love generation."

EMMET GOWIN, *Edith, Danville, Virginia*, 1967

RALPH GIBSON, *San Francisco*, 1960

AARON SISKIND, *Chicago 56*, 1960

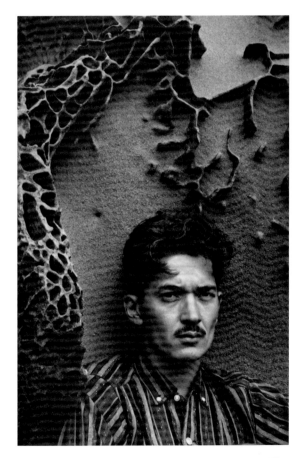

MINOR WHITE, *Bill LaRue, Shore Acres, Oregon* [from the Second Movement series], 1960

Far from the urban streets of America's cities, photographers like Minor White, Aaron Siskind, and Paul Caponigro were seeking out natural arenas and more personal spaces where they could pursue the mysteries of nature, purely expressive images, and goals of the spirit. Following photographic avenues opened up by Alfred Stieglitz, who, in photographs of clouds that he called "equivalents," found expressions in nature that could stand as the visible equivalents of the conditions of the inner self, these photographers faced what Henry Holmes Smith described as a "central problem for photography," namely, "how to strike a balance between depiction . . . and allusion through which the shapes of art and nature [are] now capable of generating new meanings."[15]

As West Coast photographers such as Edward Weston, Ansel Adams, and Wynn Bullock had already shown, black-and-white photography was well suited for developing an expressive language of nature that often focused on the more intangible aspects of the natural world: light and darkness, rhythms, reflections, and the abstractions and anthropomorphisms found in nature. Through the use of large-format cameras and carefully controlled printing, they could give both the ageless aspects and — perhaps more especially — the transitory effects of nature a transcendent semblance that referred to a spiritual or highly personal meaning "behind the landscape."

For this group of sixties photographers, the commitment to nature as subject matter was more than just a personal quest, it represented a humanistic — and sometimes even a political — stance. Throughout the sixties, an American counterculture was in the making, to paraphrase the title of Theodore Roszak's 1969 book.[16] This counterculture was an alternative to the perceived failures of science, technology, bureaucracy, and urbanization — failures that included depersonalization, worldwide militarization, and continued political and economic crises. Nature was a major component in the effort to develop or recover alternative, more "natural," consciousnesses (through mysticism, meditation, and so on) and a renewed intuitive, instinctive, humanistic approach to life. In a 1968 issue of *Aperture*,

Minor White discussed the role of photography in relation to the realities of war abroad and threatening riots at home: "Compared to the insanity of mankind, not-man looks pretty sane. For the continuation of mankind on earth it is essential that a few people in the world realize that war, civil and otherwise, is mass insanity. . . . [The photographer] takes his stand, aware of the futility of action. In full consciousness of the insanity of the world, he makes his action; his photograph, a prayer. He turns his camera on rocks, water, air, and fire, not to escape but to be in life, but not of it. He acts to bring about the concentration of something without which man will blow out his heart."[17] In saying this, White echoed a controversial but oft-repeated statement that Ansel Adams had originally written to Edward Weston in 1934: "I still believe there is a real social significance in a rock – a more important significance therein than in a line of unemployed."[18]

An articulate writer and teacher and the longtime editor of *Aperture* magazine, White was more or less the spokesperson – or guru, in some people's eyes – of photography as an evocative tool for personal and spiritual growth. He was probably also the most complex individual of this group, using his own photographs singly, or in carefully arranged sequences, or in combination with his own poetic texts, as a medium for exploring and meditating on the depths of his own personality. The title of his 1969 monograph, *Mirrors Messages Manifestations*, reflects what he thought photography was capable of revealing. White, through the pages of *Aperture* magazine and through his personal teachings, was one of the major forces behind the attempt to elevate the receptivity of the public to a photography that required concentration, even "reading."

Where Minor White turned his camera inward, so to speak, photographers like Paul Caponigro were using their cameras more for an understanding of the mysteries and essences of nature. In writing about his landscape photographs, Caponigro described his goal as a photographer: "It seemed to me that I was exploring two separate worlds, and that somehow I must unite the two. Through the use of the camera, I must try

WYNN BULLOCK, *Sea Palms*, 1968

PAUL CAPONIGRO, *Stone and Tree, Avebury, England,* 1967

to express and make visible the forces moving in and through nature. But the limitations imposed by the technical aspects of the medium were still restrictive, cutting me off from a sense of rapport with the constant flow of nature. Through the camera I brought back only hints, intimations of the possibilities for capturing in silver the elusive image of nature's subtle realms. My concern was

to maintain, within the inevitable limitations of the medium, a freedom which alone could permit contact with the greater dimension – the landscape behind the landscape."[19] His photographs suggest the existence of the macrocosm within the microcosm, and they depict the transitory and manifold aspects of nature: mists, clouds, reflections in water, the forms of ice crystals, and the mathematical precision of sunflowers. In the late sixties he also began an ongoing study of the monolithic stone monuments of the British Isles, particularly Stonehenge, a study that Peter Bunnell described as attempts to understand and symbolize the ancient stonebuilders' relationship to nature. [20]

During the sixties there was also, for the first time since the twenties, a concerted effort to seek alternatives to traditional black-and-white photog-

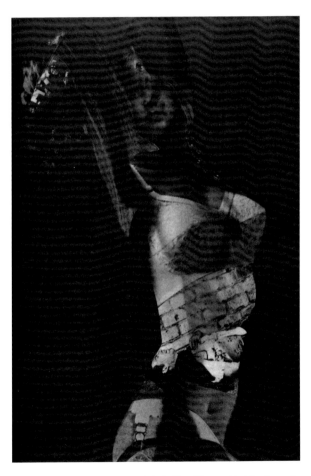

ROBERT HEINECKEN, *U.C.B. Pin Up*, 1968, black-and-white film transparency over magazine collage

raphy. The definition of a photograph as the image resulting from the straight printing on gelatin silver paper of a basically unmanipulated camera negative represented a tradition that had dominated art photography since approximately the middle twenties, when gelatin silver papers finally became the standard. Now, even dependence upon the camera, which seemed so essential to photography, but which Robert Heinecken said resulted in "dull illusionism," was questioned.

Pop art, happenings, and the beginnings of conceptual art were all contributing to a new idea-oriented approach to art that refused to be media bound, and Heinecken suggested some of the ways in which photography could be broadened: "The manipulation of time and space; experiments with various interpretations of motion and speed; the possibilities of repetition and changing images; the viewing condition of the print; the surface on which the image is formed; the reassembling of photographic images; the montage; and the multiple possibilities of combining photographs with other media and materials."[21]

For a photographer like Robert Heinecken, who, as William Jenkins has noted, "seldom operates a camera and probably could pursue his art [as a photographer] perfectly well if he never did,"[22] photography meant working with photographic images that were already at hand – *appropriating* them, in the phrasing of the eighties. As photographer cum semiotician, Heinecken's most frequent practice has been to estrange and then reconstruct in a variety of ways existing images from newspapers, newsmagazines, pinup calendars, and pornography magazines, exploring the relationships between sex, gender, violence, news, power, and photography. More than any other photographer of the sixties, it was Heinecken who truly took Marshall McLuhan's dictum seriously that "the medium is the massage," and much of his work from this period seems to be trying to explore and make obvious the media's attempt, particularly news and advertising photography, to seduce the viewer/consumer through the clichés and stereotypes of a very unreal reality. As William Jenkins put it: "After looking at the scores of modified magazines Heinecken has produced . . . ,

one is far more impressed by the homogeneity of printed media than by its variety. Fashion, sports, home decorating and sex inexplicably melt into a magma of contemporary culture."[23]

For other photographers, freedom from the traditional approach to photography opened up to interior and even more personal spaces. For a photographer like Jerry Uelsmann, the technique of combination printing (creating a single, apparently seamless image from portions of several unrelated negatives) allowed him to make complex, often paradoxical images that dealt with dreams and psychological issues, with surrealistic humor and fantasies. In an ironic way, Uelsmann's daring and well-crafted combination prints harked back to nineteenth-century photographers O. J. Rejlander and H. P. Robinson at the same time that he was helping to open photography up to entirely new possibilities for a highly personalized, symbolic iconography.

Henry Holmes Smith, who was one of Uelsmann's principal teachers, and whose role as an educator and historian of the times has already been discussed, was, like Heinecken, another photographer without a camera. Smith created "light modulators," using László Moholy-Nagy's term, by mixing liquids like oils and syrups on plates of glass. By shining light through these plates onto sheet film, Smith produced abstract negatives that he could then print in either black and white or in endless color permutations.

Todd Walker, a former commercial photographer who had studied at the Art Center School in Los Angeles, began to explore the possibilities of photography from a highly process-oriented perspective. In the late sixties he began printing some of his photographs of nudes (images that he uses and reuses like stock photographs) in collotype, photolithography, and Sabattier-altered gelatin silver prints.

By the end of the sixties, the image and the practice of photography, which had seemed so

JERRY UELSMANN, *Small Woods Where I Met Myself,* 1967

straightforward at the beginning of the decade, had shattered into pieces like a broken plate of glass. But in a very real sense, that broken plate of glass was like a broken hologram (the prophetic imaging invention of the sixties), for each fragment continued to contain a whole reference – albeit each from a different point of view – to the image that had once projected from the now irretrievably lost whole plate. For no matter how experimental or untraditional photography seemed, the *tradition* of photography continued in the role of the sacrificial parent, as the locus for all departures, rebellions, and renascences.

Traditional photography has, of course, survived, and so have all of the major trends that flourished in the sixties. But from the perspective of the eighties, the rebellious offspring of the long tradition of photography that went in such differing directions in the sixties seem to have emerged into genres of their own, with histories and traditions of their own – histories and traditions that were largely born in the sixties.

1. Louis Althusser, *Reading Capital* (London: NLB, 1970), p. 15. The original French edition was published in 1965.

2. Henry Holmes Smith, "Photography in Our Time: A Note on Some Prospects for the Seventh Decade," *Henry Holmes Smith: Collected Writings, 1935–1985* (Tucson: Center for Creative Photography, 1986), p. 68.

3. Nathan Lyons, *Toward a Social Landscape* (New York: Horizon Press, 1966), p. 5.

4. Henry Holmes Smith, "Photography in Our Time," p. 70.

5. John Kenneth Galbraith, *The Affluent Society* (Boston: Houghton Mifflin, 1958), p. 1.

6. Lisette Model, [untitled statement], *The Snapshot* (Millerton, N.Y.: Aperture, 1974), p. 7.

7. John Szarkowski, *The Photographer's Eye* (New York: Museum of Modern Art, 1966), p. 8.

8. Jonathan Green, *American Photography: A Critical History – 1945 to the Present* (New York: Harry N. Abrams, 1984), p. 91.

9. Robert Frank, "A Statement . . . ," *U.S. Camera 1958* (New York: U.S. Camera, 1957), p. 115.

10. Ibid.

11. John Szarkowski, "New Documents" [unpublished wall label], 1966. Exhibition files, Museum of Modern Art, New York.

12. Quoted by Janet Malcom, "Photography," *The New Yorker* (4 August 1985): 80.

13. *Diane Arbus* (Millerton, N.Y.: Aperture, 1972), p. 2.

14. Thomas Garver, *12 Photographers of the American Social Landscape* (Waltham, Mass.: Rose Art Museum, Brandeis University, 1967), unpaged.

15. Henry Holmes Smith, "New Figures in a Classic Tradition," *Henry Holmes Smith: Collected Writings, 1935–1985*, p. 94.

16. Theodore Roszak, *The Making of a Counterculture* (New York: Doubleday, 1969).

17. Minor White, "A Balance for Violence," *Aperture* 13, No. 4 (1968): 1.

18. Ansel Adams to Edward Weston, 29 November 1934, Edward Weston Archive, Center for Creative Photography.

19. Paul Caponigro, *Landscape* (New York: McGraw-Hill, 1975), unpaged.

20. Pete Bunnell, "Introduction," *Paul Caponigro Photography: 25 Years* (La Jolla, Cal.: The Photography Gallery, 1981), p. 6.

21. Robert Heinecken, "Manipulative Photography," *Contemporary Photography* 5, no. 4 (1967): unpaged.

22. William Jenkins, "Introduction," *Heinecken*, James Enyeart, ed. (Carmel, Cal.: Friends of Photography, 1980), p. 11.

23. Ibid., p. 15.

From Social Criticism to Art World Cynicism:

1970–1980

CHARLES DESMARAIS

Were it not for the clock and the calendar, one could make a fair argument that the seventies never happened. Certainly, the decade never took on its own cohesive identity as a cultural era. In fact, the political/cultural/social movement we think of as the The Sixties actually came to full flower (so to speak) in the early seventies. And the new conservatism represented by "the Silent Majority" and "the Reagan Revolution" appeared late in the seventies, not when Ronald Reagan was inaugurated in 1981.

The art of photography, subject to the same social forces and analyses, underwent the same kind of radical reconstruction – so quick you hardly saw it happen – as the rest of our social structures. Launched by a good-hearted humanism and a youthful glee in experimentation, the decade revealed a previously unknown critical audience and a viable, if precarious, commercial market, only to end in a cynical critique of the very idea of originality or quality. Paradoxically, this decade with no character of its own, no tidy intellectual construct to hold it together, also saw some of the most profound changes the medium had yet undergone.[1]

Surely the most significant of these was the acceptance by the publishing and museum establishments of photography as a medium for serious expression. Prices, galleries, and individual artists may have had their ups and downs during the decade, but once the major communication lines were accessible, photographers could share ideas among themselves and with a wide audience. Photography has not been the same since.

The End of the Sixties: Setting the Stage

As America entered the seventies, Richard Nixon was at the height of his powers, the Vietnam war dragged on, and the Ohio National Guard had not yet made its fateful assault on Kent State University student protesters. Young men were wearing their hair longer than ever before in this century, and the memory of the "Woodstock Music and Art Fair" was but eighteen weeks old.

In photography the dominant artists were classic formalists whose work had survived, despite the deprivations of an art world that did not need them, in little magazines, coffeehouse galleries, and a few adventurous universities and museums. Among themselves they had sustained a tenuous network of contacts and launched a few fledgling training programs to foster the early growth of a new field of the visual arts.

For the most part, these mature artists were, despite the conservative look of their pictures, rebels. Their isolation had made them proudly individualistic, and their activity as artists had sharpened their social-critical skills. Now, as the curtain rose on a new decade, they and their friends, colleagues, students, and acolytes formed the backdrop against which photography's new role as an art medium would be played.

One of the most articulate of the established photographers was artist/theorist/guru Minor White. White's *Aperture* magazine had, for nearly twenty years, been the only serious and consistent journal in the field. He used the magazine to explain and promote work he believed strove for

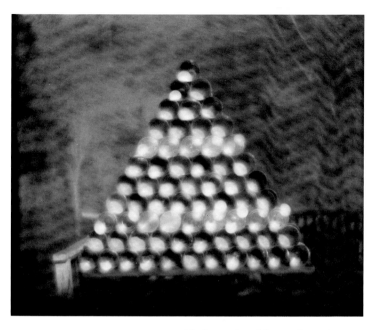

LINDA CONNOR, untitled, 1976, gold-toned printing-out-paper print

KENNETH JOSEPHSON, *Chicago*, 1970

BARBARA CRANE, *Bicentennial Polka* [from the Baxter/Travenol Lab series], 1975

WILLIAM LARSON, [from the Transmissions series], 1975, electro-carbon print transmitted by the Graphic Sciences Teleprinter

the kind of "equivalence" Alfred Stieglitz had sought – work that dealt in spiritual metaphor and mysticism. Among the younger artists White had taught and helped bring to prominence in the sixties were Paul Caponigro and Jerry Uelsmann, both consummate craftsmen with an eye on the cosmos, but with wildly different technical approaches and visual sensibilities.

At the end of the sixties, White curated two influential exhibitions at the Hayden Gallery of the Massachusetts Institute of Technology, *Light*[1] (1968) and *Be-ing Without Clothes* (1970). While controversial because the work of the individual photographers seemed to be subordinated to White's themes,[2] these exhibitions and their catalogs pointed to a "new equivalence" compatible with the idealism and rebelliousness of the era, and introduced many previously unpublished photographers.

Harry Callahan and Aaron Siskind had worked together (along with Arthur Siegel) from the early fifties to the middle sixties at Chicago's Institute of Design. They expounded an aesthetic of experimental formalism first promulgated by the Institute's founder, László Moholy-Nagy. But though they might encourage such a proto-conceptual artist as Kenneth Josephson or a photographic iconoclast like Keith Smith, their own work adhered to classic modernist principles related to painting.

This famous teaching team (reunited in 1971 when Siskind left the Institute for the Rhode Island School of Design, where Callahan had moved in 1964) had an enormous impact on the work and attitudes of a number of young artists. Many of these students became influential innovators in the late sixties and early seventies, including Thomas Barrow, Linda Connor, Eileen Cowin, Barbara Crane, Emmet Gowin, Joseph Jachna, William Larson, Ray K. Metzker, Charles Swedlund, Geoff Winningham, John Wood, Josephson, and Smith.

In the western United States, the photographers entering the seventies with the widest reputations formed a coterie around America's most famous artist of the camera, Ansel Adams. Along with Adams, Wynn Bullock, Imogen Cun-

ningham, Brett Weston, and a few lesser-known artists constituted a "Carmel School" of landscape photography.[5] Most of the group consisted of devoted adherents to a code of photographic purism, which – though it served them well in their own work – became a kind of Establishment symbol for young photographers. As a result, their teachings and work, promoted through a seemingly endless flow of Sierra Club books and Yosemite workshops, ultimately had little influence on the major workers of the seventies.

In fact, the new generation of California photographers in the late sixties often saw itself in apposition – even directly in opposition – to the West Coast landscape tradition in photography. This was particularly true in Los Angeles, where Robert Heinecken spent much of the sixties expanding his ideas of manipulative photography and where, in 1969, Heinecken met Adams in public debate.[4] Heinecken's teaching at the University of California, Los Angeles, brought him

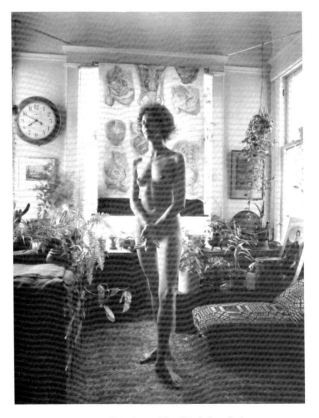

JACK WELPOTT, *Linda in Her Birthday Suit*, 1975

JUDY DATER, *Laura Mae*, 1973

into contact with other artists of like mind, notably Darryl Curran and Robert Fichter.

At San Francisco State College, Jack Welpott was formulating an approach to the medium that, while technically less anarchic than that of Heinecken, nonetheless rejected the notion of photography as necessarily straight (unmanipulated) and naturalistic. He and a group of former students and friends formed the Visual Dialogue Foundation, which by 1971 included a number of young artists who would have central roles during the decade to follow, Michael Bishop, Linda Connor, Judy Dater, and Leland Rice among them.[5]

Two photographers-turned-curators also held considerable sway at the cusp of the decades. These were John Szarkowski and Nathan Lyons.

Lyons, as curator and associate director of George Eastman House in Rochester, New York, had assembled several important exhibitions of new work by emerging photographers.[6] In 1969 he had left Eastman House to found the seminally influential Visual Studies Workshop in a Roches-

ter loft. Szarkowski had been appointed director of photography at the Museum of Modern Art in New York in 1962. Destined to become the most powerful critical and curatorial presence of the seventies, he articulated his approach through a series of carefully chosen exhibitions of contemporary work and, notably, in his 1966 book, *The Photographer's Eye*.[7]

Lyons demonstrated considerably more catholic taste than his Manhattan counterpart, including, in one show or another, virtually every contemporary approach to the medium. Szarkowski chose to look at the field from a single vantage point. But both clearly admired a new, gritty, bare-boned photographic style that was to change our concept of the documentary photograph. Szarkowski did a show in which he called the pictures "new documents." Lyons referred to some of the work as "social landscape" photography. The main practitioners were Lee Friedlander, Garry Winogrand, Larry Clark, Bruce Davidson, Danny Lyon, and the most horribly analytical photographer of the moment, the portraitist Diane Arbus. At the end of the sixties, these artists (all around forty, all with substantial exhibition records) burst into the mainstream with the force of a student riot.

The New Documentary: Strange Faces, Familiar Landscapes

In a world full of Young Turks and revolutionaries, the new documentary photographers were remarkable for their visibility and impact. Artistic offspring of Robert Frank, visual cousins to the New Journalists (then becoming known for their deeply personal written accounts of public events), these artists produced pictures that packed a near-physical wallop and that appealed to a broad audience. Though most had earlier received major grants and assignments and had numerous shows and magazine publications to their credit, only Lyon had previously published books of his personal work.

Now, in rapid succession, came some of photography's most stunning books of reportage: Winogrand's darkly humorous *The Animals*

(1969), Friedlander's alienated, disjointed *Self Portrait* (1970), and Davidson's *East 100th Street* (1970), with its cover image of a modern-day crucifixion. In 1971, Danny Lyon published *Conversations with the Dead*, his chronicle of life on a Texas prison farm, and Larry Clark released his story of death and addiction to speed in *Tulsa*.

But the photographs that most shocked the art world at this time and opened vast new areas of artistic investigation were those by Diane Arbus. Beginning in 1960, Arbus had worked as an editorial and fashion photographer for *Harper's Bazaar*, *Esquire*, and other publications.[8] She had also occasionally exhibited her work in art contexts and had received two Guggenheim fellowships. The May 1971 publication of one of her pictures as the cover of *Artforum* magazine, along with a five-page portfolio, was the contemporary art establishment's imprimatur.

Two months later she was dead, a suicide. This fact was not lost on the visitors to her post-humous exhibition at the Museum of Modern Art in 1972. For the thousands of people who flocked to the exhibition, standing three-deep to gaze at the sad and monstrous faces staring back from big, black-bordered prints, Arbus's self-inflicted death seemed a simple corollary.

The simultaneous opening of the Arbus exhibition and publication of a full-scale monograph[9] — one of the best-selling photography books of all time — was the single greatest influence on the medium of photography in the early seventies. In some cases, that influence was superficial, as photographers turned their cameras on the malformed of their own neighborhoods, or modified their enlargers to achieve the characteristic Arbus black border. But the great impact of Arbus and her art was her apparently dispassionate examination of a world others would rather ignore. This wasn't the *real* detachment of, say, the photorealist painters of her time, or the news photographers whose technical limitations she elevated to an artistic style. It was, instead, a despair of ever making more of a difference than merely to point — at events from which we ordinarily averted our eyes; at people we had learned to look straight through.

Paul Diamond and Larry Fink, each in his

PAUL DIAMOND, *Man Smoking (Larry), New York*, 1974

own way, assimilated and put to extraordinary use the essentials of this "New Journalism" of photography. Diamond's aggressive camera — his style gives new meaning to the photographic term "shoot" — poked at the scab of normalcy to find another reality beneath. Fink's pictures of classy parties revealed these events as stilted rituals performed on shallow stage sets.

An underlying hopelessness is also what separates Arbus from some of her "new documentary" contemporaries. Lyon, Clark, and Davidson had specific points to make, which they conveyed through the texts of their books and the visual narratives they constructed. Their work of the time assumes a cause of the effects they documented. The work Friedlander and Winogrand were doing then (over time Friedlander has proven capable of greater subtlety and range) instructs through metaphors that, we know, are not to be taken literally.

The early pessimism of Friedlander and Winogrand gave way over the course of the decade to more complex responses. Winogrand became a central symbol of a kind of pure photographic formalism, a master at snatching gestures from the ballet of life around him. Friedlander's pictures of the middle to late decade are philosophical, even

BILL OWENS, [from the Suburbia series],
ca. 1973

celebratory. His American Bicentennial contribution, *The American Monument*, is consciously Whitmanesque (the book begins with a quotation from the poet), and *Flowers and Trees* (1981) explores the aesthetically risky edge of Pretty. Still, no photographer of the decade produced a more consistent or widely respected body of work than the enigmatic Friedlander.

The most advanced social documentary photography of the seventies gradually revealed a change of approach. Young photographers began to think of their work not in terms of the alienation of, say, a Larry Clark, but in terms of the detachment of Arbus. Bill Owens was one such new artist. He claimed that his book *Suburbia* (1973) took no point of view, other than to show the simple reality of life in a Northern California suburb, and he included his own family as a demonstration of his ingenuousness. Like Diane Arbus, however — like any photographer, for that matter — he chose to point to specific aspects of his subject, and the cover image of a family sitting on lawn chairs in their driveway ("in the evenings we sit out front and watch the traffic go by") reveals his agenda.

Lynne Cohen, a Canadian, took a similar approach in photographing mundane business interiors. The unpeopled environments she described symbolized the emptiness and ennui of life in a dead-end, bourgeois job.

Two books, both published in 1978 but photographed over the entire decade, provide examples of the divergent paths available to the new documentary photographer. Eugene Richards's *Dorchester Days* pieces together a diaristic chronicle from darkly printed fragments: extreme close-ups filling double-page spreads, crying faces providing thematic continuity. The photographs in *Interior America* by Chauncey Hare, on the other hand, were taken from several steps back with a view camera on a tripod. The design of the book is simple — one picture per spread — and the printing is high key and open. As in a good novel, the strength of both books is in the handling of details, but where Richards pushes the relevant detail into our faces, Hare fills the frame with myriad elements we must take the time to inventory.

The 1975 exhibition *New Topographics* brought together ten photographers with an interest in the "man-altered landscape." Among the group were several artists mining the new documentary vein of social criticism, whose work had remarkable influence both in the United States and abroad, and who have come to be associated as an artistic school. These were Robert Adams, Lewis Baltz, Joe Deal, Frank Gohlke, and Stephen Shore.[10] The show was organized by William Jenkins for the International Museum of Photography at George Eastman House (where Deal, who had considerable influence on the exhibition concept, also worked).

New Topographics had an important precedent — a link in the chain from *Toward a Social Landscape*, the Eastman House exhibition of 1966 — in a less well known exhibition organized by Fred R. Parker in 1971. *The Crowded Vacancy*, presented at the University of California, Davis, and the Pasadena Museum of Modern Art, included one of the *New Topographics* artists, Lewis Baltz (as well as Anthony Hernandez and Terry Wild), and outlined some of the issues. Baltz also produced a major book of his minimalist work the year before *New Topographics* opened, *The*

New Industrial Parks near Irvine, California, which had an impact far beyond its sales on artists here and in Germany, where it was simultaneously released.

The photographers of *New Topographics* continued to figure prominently in the contemporary scene. Robert Adams published four books between 1974 and 1980. Shore was a leader in the acceptance of color among serious photographers and museums. Deal and Gohlke each produced fascinating contemplations of disaster, Deal photographing innocuous-looking housing tracts perched on the infamous, and mostly invisible, San Andreas fault, Gohlke turning his camera to the terrible changes wrought by tornadoes and volcanic eruptions.

A more traditional documentary project bearing the mark of the new style was published in 1978 as *Court House*. This corporate-funded record of county courthouses across America, edited by Richard Pare, took three years and involved some twenty-five noted photographers.

Personal Narrative: True Stories

If a Diane Arbus photograph is a social document, it is also an intensely, uniquely personal response. On this level, the effect of a typical Arbus photograph can be compared to that sought by a completely *anti*documentary group of her contemporaries, such novelistic, neosurrealist photographers as Ralph Eugene Meatyard, Les Krims, and Arthur Tress. Certainly, her work's acceptance helped gain a wider audience for their sometimes disturbing images.

Meatyard, who lived and worked far from the urban setting that engulfed Krims and Tress, brought to photographic reality the disturbing visions we think we experience on dark country roads and in deserted houses. Though he had shown at various venues in the sixties and published a small monograph in 1970, his work did not receive wide attention until the 1974 release of an Aperture monograph.[11]

The work of Krims and Tress caused great controversy when released in their first books in

LEWIS BALTZ, *Nevada 33, Looking West*, 1977

JOE DEAL, *Brea, California*, 1979

1972,[12] but its implausibility (the pictures seem "phonied up") has become more apparent and more problematic as time has passed. Perhaps sophisticated photographic technologies and ever more outrageous mainstream film and video have stripped them of their specialness. (Krims continued throughout the seventies to make new work, which was widely shown and published, though the unabashed misogyny of his *Fictcryptokrimso-*

graphs, published in 1975, and other work undermines his inventiveness.)

Treading some of the same spooky ground at this time, Duane Michals worked with a unique sequential technique borrowed from film and the comic strip. Michals's early work was published in several popular small books.[13] Unlike his neo-surrealist colleagues, Michals got better with time, giving up the sequential format for individual word/picture combinations. *Homage to Cavafy*, his 1978 "coming out" as a homosexual, is his best book, perhaps because it is personal without being idiosyncratic.

Ralph Gibson's *The Somnambulist* was based not on the filmic sequence but on that of the book form itself.[14] When it appeared in 1970 it had a strong and immediate impact. Many of the pictures were strikingly enigmatic, presenting faceless figures and disembodied hands and arms. Others, in a different context, would seem mundane: a corner of a room, for example. Assembled in book form, however, they showed photography to be a medium well suited to recording dreams – real enough to be believed, but so incomplete as to make no linear sense.

Two other personal narratives were autobiographical projects that also expanded ideas of the book form. Gaylord Oscar Herron's *Vagabond* (1975) combined painting, writing, Bible quotations, and photographs in a Tulsa odyssey of a different sort than Larry Clark made several years earlier. *Trunk Pieces* (1978), a limited-edition book by Jacki Apple, through its elegant scrapbook format and compelling story of failed love, transformed ordinary snapshots into relics of a contemporary life.

A kind of "photobiography," whether fictional or based on fact, was the recurring theme of a number of photographers working in the seventies. Early in the decade, Eleanor Antin had her performances as a Crimean War nurse, a ballerina, and other characters photographed to look like nineteenth-century images. William DeLappa's 1974 series, *Portraits of Violet and Al*, was a convincing, yet completely fabricated, post–Korean war snapshot album chronicling the courtship and

separation of a typical American couple. And in 1978, Marcia Resnick produced a hilarious and sexy story of a bad girl, produced as *Re-visions* by Toronto experimental printer/publisher Stan Bevington at his Coach House Press.

In 1971 conceptualist Douglas Huebler began a biographical project of a different sort: his *Variable Piece #70: 1971* committed him to "photographically document, to the best of his ability, the existence of everyone alive." His work throughout the seventies consisted of subsets of that overall piece.

Lucas Samaras produced his famous "autopolaroids," a bizarre and self-obsessed document published as *Samaras Album* in 1971, over the two-month period December 1969–January 1970. He published the book as "autointerview, autobiography, autopolaroid" and continued to make altered Polaroid self-portraits (as well as paintings, quilts, and other objects) throughout the decade.

Emmet Gowin sees everyday life as a series of epiphanies and is one of few artists who successfully makes photographs intended as spiritual metaphors. Somehow Gowin avoids the cliché, and though the pictures – portraits of family members and vignettes of the world close by his Virginia home – are replete with sentiment, they are believable because they precisely balance their spirituality with a bold sensuality.[15]

Some artists were challenged by their inability to delve deeply into personality and biography through the single, unaltered photograph and sought alternative means. Among these were Mark Berghash, Wendy Snyder MacNeil, Esther Parada, Barbara Jo Revelle, Meridel Rubenstein, Keith Smith, and Alex Traube. All of this group was included in a 1980 exhibition, *The Portrait Extended*, which examined the photographers' varying approaches, ranging from serial imagery (Berghash, MacNeil) and word/picture combinations (Rubenstein, Traube) to installation (Revelle, Parada) and hand-reworking (Smith).[16] These approaches, sublime failures in that the results (the pictures) can never replicate or replace their subjects, nevertheless rationalize the highly emotional process of picturing love.

Recycling Photography's Past

At no time since photography's first public announcement one hundred thirty years earlier did the field pay so much attention to its own history than in the seventies. As the photography fad spread, those involved became immediately aware of a huge gap in the historical record. Artists pored over old photographs, collected postcards and anonymous snapshots, and reinvented early processes. Scholars republished long-out-of-print texts, and a whole new area of art collecting sprang up virtually overnight.

Thus, the decade opened upon another major arena of artistic investigation: the work of a number of photographers who incorporated mass media images and reinvestigated historical photographic processes.

Certainly the best-known artists working in this area were Robert Rauschenberg and Andy Warhol, who, beginning in the sixties, extensively explored the reuse of photographic images in their silk-screen prints. Their groundbreaking ideas brought on a reflexive era in photography, as well as in other media. Though they worked with photographic images, they were relatively uninvolved with photographic processes (in fact, most of the technical photographic work was carried out by assistants and technicians). Moreover, the context within which they exhibited and were considered was the world of painting, in major galleries and museums: they seemed distant from the picture-maker trained in photographic techniques and concepts.

A number of photography-trained workers of similar bent were associated with UCLA professor Robert Heinecken, whose own work dealt extensively with the impact of popular electronic and print media. Committing simple acts of artistic vandalism, Heinecken pointed up the incongruity of a conservative culture selling sex and violence. One of his most famous pieces, for example, is *TV/Time Environment, 1970*. For it, he covered an ordinary television screen with a black-and-white positive transparency of a nude woman. The chance juxtapositions of broadcast television — whether commercial messages or TV-version

ROBERT FICHTER, untitled, June 1976

human affairs — with the overlaid soft-core porn reveals the silliness and emptiness of both. At the same time, it makes explicit the implicit sexual messages of supposedly innocuous media hyperbole.

Other Heinecken work made even more direct reference to photography, as in his *Documentary Photograms* (1971) of daily meals, his enormous enlarged filmstrips and film data sheets (1972–1974), and his ongoing use of photographic techniques such as double exposure.[17]

The social-critical attitude evidenced by Heinecken's work and a corresponding irreverence for the traditions of straight, unmanipulated photographic printmaking were shared by Robert Fichter. Though he had studied photography with Jerry Uelsmann and Henry Holmes Smith, Fichter was also a painter and printmaker. From 1968 to 1971 he held faculty positions at UCLA and experimented with such nontraditional art/photography techniques as cyanotype, Verifax, and gum bichromate, and with hand-coloring and collage. In 1972 he returned to his home state to teach at Florida State University.

Their jobs teaching in large art departments at major universities certainly exposed both

TODD WALKER, *Chris, Veiled*, 1970, solarized gelatin silver print

Fichter and Heinecken to then-current ideas in the arts. Both were aware of the pop artists of the sixties and their interest in advertising and mass communication, and the renewed use of collage and mixed-media techniques. Other photographic artists, subject to the same direct influences, simultaneously launched their own investigations; many were, in effect, "given permission" by these prolific and charismatic leaders to pursue new directions. Through their teaching (at their own schools and at workshops nationwide) and their work, Heinecken and Fichter encouraged formal and technical experimentation and a reanalysis of the role of communications media in American life.

This experimentation and analysis involved a range of strategies, many of them reflexive upon photography's history, characteristics, and practice.[18] These strategies included the rediscovery and reuse of early printing techniques, the appro-

priation of popular and mass-media images, solarization, chemical toning and staining, collage and mixed media, and hand-drawing and -coloring. Many of the artists who first attracted notice during this exhilarating period continued to exert influence throughout the decade. Among these were Thomas Barrow, Michael Bishop, Ellen Brooks, Lawrie Brown, Eileen Cowin, Darryl Curran, Fichter, Robbert Flick, Benno Friedman, Betty Hahn, Jerry McMillan, Roger Mertin, Joyce Neimanas, Bea Nettles, John Pfahl, Douglas Prince, Naomi Savage, Evon Streetman, and Todd Walker.

Peter Bunnell curated an exhibition in June 1970 at the Museum of Modern Art that was important for its recognition of the value of intermedia experimentation. *Photography into Sculpture* looked at various means for expanding the flat paper photograph into three dimensions, presenting more than twenty artists, including Brooks, Curran, Heinecken, McMillan, Nettles, and Prince.[19]

Formal Considerations

From an era of experimentation and manipulation emerged an attitude of freedom from tradition and standard practice. A new interest in materials and in the nature of photography led to an examination of the specific and special qualities of photography and related media.

Some photographers pursued a "new formalist" aesthetic, finding visual pleasure in inelegant subject matter. Michael Bishop, for instance, in the first half of the decade made large, bold close-ups of road signs and industrial equipment, transforming the mundane into the monumental and pointing up its rough, sculptural beauty.[20] Gary Hallman reduced the world before his camera to mere hints of landscape or figure in big, almost-white photographs. Mark Cohen focused camera and strobe on a child's gum bubble — huge and round and shiny — or on ants in a sidewalk crack, or on fragments of bodies frozen in motion.

Thomas Barrow, influential as artist, curator, and teacher throughout the decade, produced his important series Cancellations between 1974 and 1978. Barrow consciously scratched and tore his

8 x 10-inch negatives, adding a strong formal element to otherwise bland pictures and contradicting the windowlike illusion of the photographic print, while at the same time commenting on the art market value of prints and photographs.[21]

Color photography, widely used by commercial photographers and amateurs since the thirties, had not been fully accepted by artists and editorial photographers prior to the seventies. (Among the rare exceptions were Marie Cosindas and Eliot Porter, whose best work since the early sixties was in color.) Perhaps one reason for this resistance was color's very acceptance by the commercial and amateur worlds – worlds the art photographer disdained. Color was also more expensive than black-and-white, more difficult to reproduce, and more likely to fade. But these factors became moot during the sixties and early seventies as the photographic-materials market changed, magazines adopted color almost exclusively, and more stable color processes appeared.

Though a number of people had begun working in color early in the decade, it was the Museum of Modern Art and John Szarkowski who, as they had done many times before, both signaled and spurred a major shift. The 1976 MOMA exhibition of William Eggleston's color photographs and – even more important – Szarkowski's introduction to the accompanying book[22] announced the respectability of color for serious work. Though some were outraged at Szarkowski's pronouncement that Eggleston's pictures were "perfect," the very fact of his edict and the serious debate that followed brought color squarely to the fore.

Michael Bishop had made the move to color in 1974, incorporating yet another element into his painterly approach to subject matter. Joel Meyerowitz had expanded the range of his much-praised black-and-white street photography with a palette full of intimations of intense heat and cold. Stephen Shore's straightforward views of American streets used color mainly for its descriptive powers. William Christenberry made modest snapshots in the manner of Walker Evans – and of the intelligent tourist amateur on a trip to the South. Eggleston's work in the 1976 show, actually shot around 1971, vaguely anticipated all these approaches but never embraced any of them – thereby hinting at the kind of ingenuousness Szarkowski has never been able to resist.

Language, Bookworks, and Generative Systems

At the same time as these formal investigations were taking place, other artists were dealing with photography's uses in cultural contexts, rather than with the look of their pictures. The 1976 book *Photography and Language*, edited by Lew Thomas, brought together more than thirty artists working with the interactions/interrelationships of photographs and words. Many others who had not entered the juried show on which the book was based were also working in this area. In fact, probably no innovation of the seventies was more ubiquitous than the incorporation of words into pictures by some means or other.

More specific to individual artists (and overlapping media other than photography) was the burgeoning interest in bookworks, or artists' books, and in what has been called "generative systems."

The idea of the artist's book is at least a hundred years old, dating to nineteenth-century original-print illustrations for *livres d'artiste*. But today's artist's book is generally a low-cost, artist-controlled production. Crucially, the book itself is the original; it is not a collection of reproductions or an illustrated text, but a final work of art in its entirety.

Dick Higgins and the Fluxus group in the early sixties may have launched the new obsession with the book as artistic medium, but it was late in that decade that the photographic artist's book made a serious appearance. Los Angeles artist Ed Ruscha made a series of pioneering and influential photographic books in the sixties, among them his classic *Every Building on the Sunset Strip*.[23] (The title describes the book perfectly.) Todd Walker, who eventually bought his own offset press and has developed strikingly beautiful technical innovations, also began work in the medium at about the same time.[24]

THOMAS BARROW, untitled, 1973, verifax

The distinctions between the work of Walker and Ruscha are worth noting here: Walker, the consummate technician (he had been a successful commercial photographer), is most concerned with the physical form of the book – its printing quality, color, paper, and design. Ruscha, though a fine craftsman as a painter and printmaker, sees the book more as a conceptual tool; his books are simply designed and cheaply printed and generally photographed by someone else. The differences between these two artists and their books symbolize the two basic approaches to the book apparent throughout the coming decade.

The seventies saw enormous growth in the development of the book as an art medium,[25] and photographically derived productions were particularly in evidence. Hundreds, perhaps thousands, of artists worldwide took up the form, if not exclusively, then for a single project. Among the central figures of the craft-oriented approach were several people who led independent presses, helping other artists produce work in the difficult medium, new to them, of offset lithography (the technology used to print most books): Joan Lyons at the Visual Studies Workshop Press, Stan Bevington at Coach House Press, Michael Becotte at Tyler School of Art, and Conrad Gleber at Chicago Books. Also important as experimenters were Keith Smith, whose one-of-a-kind and multiple works numbered nearly a hundred different books at decade's end, and Scott Hyde, who popularized the notion

of "original" offset photolithographs and published such works in several journals.

Often overlooked as a major photographic statement of the seventies is Canadian artist Michael Snow's *Cover to Cover* (1975), a richly complex investigation of the nature of the book, the sequence, pictures, and the act of picturing. Others working with the book form as a conceptual vehicle were John Baldessari, George Blakely, Miles DeCoster, Lew Thomas, and innumerable others.

The generative systems movement was founded single-handedly by Chicago artist Sonia Landy Sheridan, who realized the potential of copy machines such as those made by 3M and Xerox, and of the imaging processes and materials developed along with the machines. A few other artists had made "copy art" in the sixties (notably Linton Godown, Bruno Munari, and Esta Nesbitt), and a great many people worked with the various machines and processes throughout the seventies, including Thomas Barrow, Ellen Land-Weber, Keith Smith, and Peter Hunt Thompson.

Sheridan, however, saw the role of the artist working with new technologies not as mere picturemaker but as a kind of Philosopher King, leading by virtue of his knowledge. These new artists would be concerned not with product but with process; they would be facilitators to the masses, who, provided with art-making tools and techniques developed by artists, scientists, and engi-

neers, could make their own pictures, exactly to their liking.

Photography as Political Action

Sonia Sheridan was not alone in her belief that photography and related media could serve a political function, nor was she the most vocal spokesperson for that point of view. In fact, Marxist and feminist theory became central elements of a major wave of photographic practice that originated late in the decade and was still building force as the eighties dawned.

This new wave had its origins in the writings of a German critic of the thirties, Walter Benjamin; in the photographic agitprop of Benjamin's countryman and contemporary John Heartfield; and in the modern writings of John Berger and other British critics. Benjamin's essay "The Work of Art in the Age of Mechanical Reproduction"[26] is certainly this century's most influential writing on photography. Heartfield's work, though rarely imitated in style, is exemplary for its specific and direct criticism of a repressive political and economic system. Berger's writing on society and seeing is some of the clearest and most convincing contemporary criticism.

In the United States the new political awareness did not come easily. Allan Sekula, Martha Rosler, Fred Lonidier, and Philip A. Steinmetz, working in San Diego in the political art climate of the University of California campus there, developed an activist photographic vocabulary relying upon "fictions" (photographs) to explain "facts" (repressive social structures).

Sekula and Rosler wrote some of the strongest political critiques of the medium,[27] but though their articles appeared in venues widely accessible to artists, there was considerable resistance to their ideas. The 1978 national conference of the Society for Photographic Education, the main academic organization in the field, saw the first public confrontation of the issues when both critics lectured to hostile houses and a group of women organized a boycott of a politically objectionable presentation.

Within a few years, however, two serious jour-

nals, *Afterimage* and *Exposure*, would have strong feminist editorial philosophies, and new theorists and artists would be identified, including Catherine Lord, Jan Zita Groover, Deborah Bright, and Martha Gever.

Boom and Bust

If the time period between 1970 and 1980 had no readily identifiable aesthetic character, and thus cannot be seen as a cohesive artistic "era," the same can hardly be said of the decade's photo/art-world economy. Though it is impossible to measure how many art photographs were made at different points in the ten-year continuum, the responses of the audience and the market can be gauged.

A chart of photography's popularity in the seventies would reveal a steep rise from 1970, when the famous Strober auction at one of New York's most prestigious houses revealed strong interest in photography among collectors,[28] through the 1975 appearance of National Endowment for the Arts photography grants and Susan Sontag's first writing on the subject in the *New York Review of Books*. The photography boom peaked at mid-decade, with the establishment of gallery and museum programs around the country (including Light Gallery and the International Center of Photography in New York), an *Art in America* magazine symposium on "Collecting the Photograph"[29] and ever-higher auction prices, and the establishment of at least eight major journals and magazines. By 1976, however, the popular (and profit-oriented) newspaper *Photograph* had failed, and by the late seventies political and postmodernist critiques of photography were revealing major weaknesses in the structure of the "photography world." As the eighties dawned, many of the most potent symbols of the decade were being dismantled as galleries closed, auction prices fell, and upscale art photography magazines ceased publication.

What happened to cause such traumatic shifts in the popular acceptance of photography as art? What brought about the original, near-frantic

excitement, and why did an entire field seem to fall apart in five short years?

The answers are less exciting than the questions. The fact is that there was not one, but two, for the most part separate, photography "booms." One of these – it could be called the "commercial boom" – was ignited by rapid increases in the prices of historical photographs at auction. At a time when little was known about the rarity, history, or relative importance of old photographs, the supposed free market of the auction began to signal their economic value. There quickly developed a new breed of dealer/entrepreneur, different in motivation from the amateurs who, for the love of it, had opened early galleries like Limelight, the Underground Gallery, Carl Seimbab, and Focus.[30]

In the early seventies you could count the photography historians on one hand; historical significance and rarity – basic building blocks of any collectibles market – had not yet been established. Moreover, what expertise existed had not yet been disseminated to the art audience. A shallow market was being built largely upon the ignorance of a buying public anxious to share in what it saw as an opportunity for fast wealth, yet unable to distinguish between a vintage Strand and a film still of a movie star.

There were many excellent and reputable dealers – conscientious scholars in their own rights. But there were also those who succumbed to the pressure to sell people what they wanted: virtually valueless snapshots of celebrities, pretty landscapes, and, most insidious of all, tax-dodge "packages."[31] There were even a few cynical dealers who actually tried to manipulate the market, bidding up the prices of their own holdings at auction. When the general recession of 1979–1982 came, the precarious photography market began to fall apart, taking good galleries as well as bad along with it. Among the major galleries crippled or closed were Light (Los Angeles and New York), Harry Lunn, Robert Samuel, Photograph, Jeffrey Gilbert, Focus, Kiva, and David Mancini.

Ironically, other elements of the commercial boom had taken their leadership from the galleries and dealers, and the "bust" brought down or seriously hurt several magazines (*Photograph*, *Picture*,

Camera Arts) and book publishers (Morgan and Morgan, Curtin and London, Callaway).

Another, more creditable and substantial expansion also took place in the seventies. This had to do with the acquisition and dissemination of knowledge about photography, its history, and its place in our culture. To be sure, this "knowledge boom" also suffered a deflation, partly in response to the commercial bust, partly as a result of changes in government funding, and partly because the winds of intellectual fashion shifted. Education, from informal workshops to university programs in photography, was affected, as was the grant support structure for artists working in photography. Scholarly interest in photography, though, remains strong.

The single most important element contributing to the growth of the medium of photography in the seventies was government funding, embodied in a comparatively small federal agency, the National Endowment for the Arts. Founded in 1965, the NEA awarded its first grant to a photographer in 1968, to Bruce Davidson, for his East 100th Street project. In 1971, at the urging of Visual Arts Program director Brian O'Doherty, the Endowment established a special category for Photographers' Fellowships, setting a precedent for specific support of the medium. This was followed by establishment of grant categories for Photography Exhibitions (1973), Photography Publications (1973), and Photography Surveys (1976) – all of which were eliminated or subsumed into other programs in 1981. All told, from 1973 (the first year a large number of grants was made) through 1980 some six million dollars was specifically earmarked for photography.[32]

The federal government's implied sanction of photography as fine art did not hurt the medium's image in the eyes of the art world; in fact, some observers have argued that such recognition was more important than the money. There is little doubt, though, that the cash – along with state-level grant programs encouraged by the NEA, and matching private donations frequently prompted by the federal and state grants – had a tremendous impact.

Through the fellowships, individual photogra-

phers were freed from financial pressure to concentrate on their work. The exhibition grants enabled small nonprofit galleries and artists' spaces to present new and experimental work in photography and encouraged general museums to devote space and resources to photography shows. Marginally viable publishing projects became more attractive with the aid of publications grants, and the survey grants – an offshoot of American Bicentennial fever, meant to encourage FSA-type documentary projects – engendered a flurry of new work specifically in response to the availability of funds.[33]

The Knowledge Boom

Alongside the 1971–1981 development of a government funding base – to a degree, perhaps, because of it – an institutional and intellectual foundation was being built. New public exhibition and collection programs were founded, and new publications, from the scholarly to the popular, flourished. A critical and theoretical dialogue was initiated, and the history of photography became a legitimate field of academic study.

A number of art museums across the country had shown early interest in photography, including the Museum of Modern Art (the first museum to establish a department of photography), the Metropolitan Museum of Art, the Art Institute of Chicago, the Amon Carter Museum, and the San Francisco Museum of Modern Art. Prior to the late sixties, however, the only museum programs specific to photography were the George Eastman House and the short-lived American Museum of Photography in Philadelphia.

In 1967, Ansel Adams, Beaumont Newhall, and others established the Friends of Photography as an exhibit center in Carmel, California, thus instituting the first artists' space in photography. No longer run by an artist board, the Friends evolved into a major photography publisher, workshop organizer, and membership organization. At about the same time, Nathan Lyons began a series of private workshops that resulted in the 1969 establishment of a permanent facility in Rochester,

New York, for the Visual Studies Workshop, which grew during the seventies into a combination school, publisher, library, and exhibit center.

An important late entry among art museums was the New Orleans Museum of Art, which in 1973 began an aggressive effort to build a distinguished collection of photographs. By the end of the decade, museum collections, even museum departments, of photography were no longer a rarity and were fast becoming the norm.

Museums devoted specifically to photography also sprang up at a rapid rate, adding the California Museum of Photography (1973), the International Center of Photography (1974), the Center for Creative Photography (1975), and the Chicago Center for Contemporary Photography (later Museum of Contemporary Photography; 1977). Noncollecting exhibit centers and artist organizations also proliferated and achieved financial stability, including, among many others, the Los Angeles Center for Photographic Studies, Photographic Research Center (Boston), Lightworks (Syracuse), San Francisco Camerawork, Nexus (Atlanta), and CEPA/Hallwalls (Buffalo). This flourishing scene continued unabated throughout the decade.

Theoretical Issues

As the institutional base for the medium grew and widened, so did its intellectual base. The process first began with scattered attempts to uncover – or rediscover – its history. Important texts such as Richard Rudisill's *Mirror Image* (1971), William Stott's *Documentary Expression and Thirties America* (1973), and Estelle Jussim's *Visual Communication and the Graphic Arts* (1974) appeared, along with republications of virtually every major nineteenth- and early-twentieth-century book and periodical on photography.

Nathan Lyons and John Szarkowski had already been identified as the medium's most visible and articulate critics, and A. D. Coleman started writing regular reviews for the *Village Voice* (1968–1973) and the *New York Times* (1970–1974). Some of the leading art journals, notably

Artforum and *Art in America*, began to turn attention to photography, and photography publications like *Camera* (published in Switzerland), *Creative Camera* (England), and *Aperture* expanded their critical writing.

The periodical *Afterimage* was introduced by Lyons in 1972; under managing editor Charles Hagen it grew into an important vehicle for new ideas, new critics, and new work. *Exposure*, begun as a newsletter for the Society for Photographic Education in 1968, evolved into a serious critical and historical journal beginning around 1973, and *Untitled* was founded as a quarterly organ for the Friends of Photography in 1972.

With the 18 October 1973 edition of the *New York Review of Books*, the face of photography criticism changed radically. In forty-four beautifully written paragraphs, Susan Sontag initiated a high-level intellectual discussion that would reverberate for the rest of the decade and beyond.

"Taking pictures is a soft murder," she wrote, with reference to the medium's seeming ability to turn people into objects. "To photograph people is to violate them." Her ideas upset not a few professionals in the field, but they also brought before a large audience — for the first time — some of photography's basic philosophical dilemmas. The first essay grew to six, and thence to a widely read book.

Sontag's main themes are the ubiquity of photographs and their inauthenticity. She argues: "The knowledge gained through still photographs will always be some kind of sentimentalism, whether cynical or humanist. It will be a knowledge at bargain prices — a semblance of knowledge, a semblance of wisdom; as the act of taking pictures is a semblance of appropriation, a semblance of rape. . . . The omnipresence of photographs has an incalculable effect on our ethical sensibility. By furnishing this already crowded world with a duplicate one of images, photography makes us feel that the world is more available than it really is."[34] The implications for art, and for photographs that aspire to art, are fundamental: "As most works of art (including photographs) are now known from photographic copies, photography . . . has decisively transformed the traditional fine arts and the traditional norms of taste, including the very idea of the work of art. Less and less does the work of art depend on being a unique object, an original made by an individual artist. Much of painting today aspires to the qualities of reproducible objects."[35]

Sontag's articles raised the level of discourse on photography, both within the field and in the larger world of arts and letters. They coincided with — and, to some extent, caused — a concerted, serious study of other writings on photography by writers who, like Sontag, had developed their critical thought in the film and literature arenas. And that study led further to the application to photography of critical theory developed in those arenas. Walter Benjamin (to whom Sontag dedicated a chapter of her book), Jacques Derrida, and Roland Barthes, in particular, began to influence the thought of a whole different audience than they had originally written for, and words like *semiotics* and *deconstruction* entered the photography lexicon for the first time.

The articles also anticipated the postmodern criticism that at decade's end had risen to prominence. Championed first by the journal *October*, postmodernism by the early eighties had become a central preoccupation of several influential art magazines and theoretical journals. The movement, a theory-heavy argument for the primacy of the image over experience, was launched by two important articles, one by Craig Owens and the other by Douglas Crimp. Both writers, like Sontag, rejected the idea of originality in photography.

To quote Owens: "Photographs are but one link in a potentially endless chain of reduplication; themselves duplicates (of both their objects and, in a sense, their negatives), they are also subject to further duplication, either through the procedures of printing or as objects of still other photographs, such as [Walker] Evans's *Penny Picture Display, Savannah*, 1936."[36]

Crimp admiringly describes a film by Robert Longo, one of the preeminent postmodernists: "Longo's movie camera was trained on a photograph, or more precisely a photo-montage whose separate elements were excerpted from a series of photographs, duplicate versions of the same shot.

That shot showed a man dressed and posed in imitation of a sculpted aluminum relief that Longo had exhibited earlier that year. The relief was, in turn, quoted from a newspaper reproduction of a fragment of a film still taken from *The American Soldier*, a film by Fassbinder."[37]

Whether the postmodernist argument is ultimately a circular one, providing little more than wordy apologies for a cynical, dead-end fad, is an

issue that was yet to be resolved as photography entered the eighties. It may already have been clear, though, that the best of the artists associated with the movement (among them obsessive self-portraitist Cindy Sherman, neo-Duchampian appropriationary Sherrie Levine, political placardist Barbara Kruger, and Longo) could not be contained by mere theory.

NOTES

1.a. "Profound" is a relative term: this essay is concerned primarily with photography in an art context. As seen from other points of view, the events of the seventies might appear much less significant than those of other eras – even trivial. For example, the rise of photographically illustrated newspapers and magazines from the 1880s to the 1950s is a far more widespread and far-reaching phenomenon than any art photography event.

b. Most history is an assimilation of the "facts" as they have been recorded. Moreover, the period under discussion here was photography's most prolific, in terms of the sheer mass of published and republished books, periodicals, and other materials. Thus this essay draws heavily on books and catalogs published during or about the seventies, many of which are cited here. However, because the author was a personal witness to (and even a participant in) many of the events discussed, it relies also on personal recollection and opinion.

2. White subtitled the catalog for *Light*[7] "Photographs from an Exhibition on a Theme," did not identify any of the pictures by their original titles, and grouped the artists' names at the back of the book rather than printing them with the individual photographs. The approach was more sensitive in the catalog to the second show, but these and White's other thematic shows of the seventies continued to draw fire.

3. The landscape purists I am thinking of were not confined to any particular geographic area, but many did live in or near Carmel, California. Many served, at one time or another, on the board of trustees of the Friends of Photography in Carmel. Among the best of them: Morley Baer, Robert Byers, Steve Crouch, Richard Garrod, Henry Gilpin, Al Weber, and Cole Weston.

4. James Enyeart, ed., *Heinecken* (Carmel, Cal.: Friends of Photography, 1980), p. 139. According to Heinecken [telephone conversation with the author, 9 March 1987] the "debate" took place in conjunction with a pair of exhibitions the two had at Occidental College in Los Angeles. He does not recall if the event was billed as a debate, "but it turned into a debate."

5. *The Visual Dialogue Foundation*, Davis, Cal.: Visual Dialogue Foundation, 1971, p. 1. Other mem-

bers: Edward Douglas, Oliver Gagliani, Michael L. Harris, Timo Pajunen, John Spence Weir, Don Worth; associates: Karl L. Folsom, Steven D. Soltar.

6. The group shows had equally influential catalogs: *Toward a Social Landscape* (New York: Horizon Press, 1966); *The Persistence of Vision* (New York: Horizon Press, 1967); *Photography in the Twentieth Century* (New York: Horizon Press, 1967); and *Vision and Expression* (New York: Horizon Press, 1969).

7. The approaches of these two important curators are compared in Candida Finkel, "Photography as Modern Art: The Influence of Nathan Lyons and John Szarkowski on the Public's Acceptance of Photography as Fine Art," *Exposure* 18, no. 2 (1981): 22–37.

8. Doon Arbus and Marvin Israel, eds., *Diane Arbus: Magazine Work* (Millerton, N.Y.: Aperture, 1984). Southall's essay gives an excellent account of this facet of Arbus's career. Also see Patricia Bosworth, *Diane Arbus: A Biography* (New York: Knopf, 1984).

9. *Diane Arbus* (Millerton, N.Y.: Aperture, 1972).

10. Other participants were Bernd and Hilla Becher, Nicholas Nixon, John Schott, and Henry Wessel, Jr.

11. *Ralph Eugene Meatyard* (Lexington, Ky.: Gnomen Press, 1970); James Baker Hall, ed., *Ralph Eugene Meatyard* (Millerton, N.Y.: Aperture, 1974). Also of interest: *The Family Album of Lucybelle Crater* (Millerton, N.Y.: Jargon Society, 1974).

12. Les Krims: *The Deerslayers, The Incredible Case of the Stack o' Wheats Murders, Little People of America, 1971, Making Chicken Soup* (all Buffalo, N.Y.: self-published, 1972). Arthur Tress: *The Dream Collector* (Richmond, Va.: Westover Publishing, 1972).

13. Duane Michals: *Sequences* (Garden City, N.Y.: Doubleday, 1970); *The Journey of the Spirit after Death* (New York: Winter House, 1971); *Things Are Queer* (Cologne: A. & J. Wilde, 1973); *Take One and See Mt. Fujiyama and Other Stories* (Rochester, N.Y.: Stefan Michal, 1976); *Homage to Cavafy* (Danbury, N.H.: Addison House, 1978).

14. The book was the first in a trilogy that also included *Déjà-Vu* (New York: Lustrum Press, 1973) and

Days at Sea (New York: Lustrum Press, 1974).

15. Emmet Gowin, *Photographs* (New York: Knopf, 1976).

16. Charles Desmarais, ed., *The Portrait Extended* (Chicago: Museum of Contemporary Art, 1980). The show was curated by the author for the MCA in September 1980 and also included Martha Madigan, an excellent printmaker whose work does not typically deal with portraiture.

17. James Enyeart, ed., *Heinecken.*

18. A very important early survey of this work is Donald L. Werner, ed., *Light and Lens: Methods of Photography* (Yonkers, N.Y.: Hudson River Museum, 1973). Dennis Longwell's introduction makes much of the work's historical roots and references.

19. This information was provided by Joyce Carp of MOMA's Department of Photography from the exhibition checklist.

20. Michael Bishop, *Catalogue, Winter-Spring, 1974* (1974); Charles Desmarais, ed., *Michael Bishop* (Chicago: Chicago Center for Contemporary Photography, 1979).

21. Kathleen McCarthy Gauss, *Inventories and Transformations: The Photographs of Thomas Barrow* (Albuquerque: University of New Mexico Press, 1986).

22. John Szarkowski, *William Eggleston's Guide* (New York: Museum of Modern Art, 1976).

23. Ed Ruscha, *Every Building on the Sunset Strip* (Los Angeles: self-published, 1966). Some other Ruscha books include *Twentysix Gasoline Stations* (1962); *Various Small Fires* (1964); *Some Los Angeles Apartments* (1965); *Thirtyfour Parking Lots in Los Angeles* (1967); [with Mason Williams and Patrick Blackwell (photographer)] *Royal Road Test* (1967); [with Billy Al Bengston] *Business Cards* (1968); *Nine Swimming Pools* (1968); *Crackers* (1969); *Real Estate Opportunities* (1970); *Babycakes with Weights* (1970); *A Few Palm Trees* (1971); [Photos by Jerry McMillan] *Records* (1971); *Dutch Details* (1971); *Colored People* (1972); and [with Lawrence Weiner] *Hard Light* (1978). One wonders how long the bibliography would run if Ruscha, a painter and printmaker, devoted his primary attention to books.

24. An early Walker effort is *A Few Poems by John Donne and Photographs by Todd Walker* (Tarzana, Cal.: Thumbprint Press, 1966).

25. Franklin Furnace Archive, a nonprofit group founded in 1976 to collect and preserve artists' books, had a collection of 11,000 books in 1984, 75 percent of them published since 1975. Joan Lyons, ed., *Artists' Books: A Critical Anthology and Sourcebook* (Rochester, N.Y.: Visual Studies Workshop Press, 1985), p. 228. Though the collection is comprehensive, it is unlikely that it acquires *all* books produced. The nonprofit Printed Matter, Inc., the largest distribution outlet for artists' books, was also founded in 1976.

26. Walter Benjamin, *Illuminations*, Hannah Arendt, ed., Harry Zohn, trans. (New York: Harcourt, Brace and World, 1968), pp. 217–251.

27. Allan Sekula, "On the Invention of Photographic Meaning," *Artforum* 13 (January 1975): 36–45; "The Instrumental Image: Steichen at War," *Artforum* 14 (December 1975): 26–35. Martha Rosler, "Lookers, Buyers, Dealers, and Makers: Thoughts on Audience," *Exposure* 17, no. 1 (1979): 10–25.

28. The collection of Sidney Strober was auctioned at Parke-Bernet (now Sotheby's) on 7 February 1970, bringing what were then considered to be extraordinary prices. [Amy Murphy of Sotheby's provided specifics on the Strober auction, for which I am grateful.]

29. The affair was seen at the time as a major indication that photography had "come of age" and entered the art world. For a contemporary account, see Charles Hagen, " 'Collecting the Photograph': Was It Worth It?" *Afterimage* 3, no. 4 (October 1975): 2–3.

30. Since Stieglitz, the only major photography galleries prior to the seventies were the first Julien Levy Gallery (1931–1937), Limelight (Helen Gee, 1954–1961), both in New York; Focus (Helen Johnston, San Francisco), Carl Seimbab (Boston), both beginning in the sixties; and three New York galleries of the sixties: Underground, Heliographers, and Image. The Witkin Gallery opened in New York in 1969.

31. Several galleries and a few "investment advisors" developed schemes whereby investors bought photographic prints in bulk at wholesale prices, then donated the pictures to museums, writing the retail value off their taxes. The quality of the work changing hands varied greatly, depending on the knowledge and reliability of the deal's organizer. An excellent description of this legal but market-destabilizing practice, and of other aspects of the subject, can be found in David Trend, "Take the Money and Run, or, Life after the Photo Boom," *Afterimage* 10, no. 8 (March 1983): 3.

32. Paul Carlson, National Endowment for the Arts, Visual Arts Program, telephone conversation with the author, 10 February 1987. A useful analysis of the role of the NEA in the photographic art of the seventies is found in Merry Amanda Foresta, *Exposed and Developed: Photography Sponsored by the National Endowment for the Arts* (Washington, D.C.: Smithsonian Institution Press, 1984), pp. 6–12.

33. The Photography Surveys category had an NEA-funded prototype in a 1974 project, conceived by James Enyeart, to document aspects of Kansas. The results were published in James Enyeart, Terry Evans, and Larry Schwarm, *No Mountains in the Way* (Lawrence, Kans.: University of Kansas Museum of Art, 1975).

34. Susan Sontag, *On Photography* (New York: Farrar, Straus and Giroux, 1977), p. 24.

35. Ibid., p. 147.

36. "Photography *en abyme*," *October* 5 (Summer 1978): 85–86.

37. "Pictures," *October* 8 (Spring 1979): 83.

Afterword

NATHAN LYONS

The relevance of photography to art and society has been characterized in several ways since its invention in 1839. During its formative years prior to the turn of the century, photography mediated between art and science. It was certainly not the only reproducible imaging system, but it was a medium with unique attributes allowing it to delineate images with implied authenticity. Through the turn of the century, arguments concerning form and content, reality and truth abounded. In time, a dichotomy in practice occurred between expressive applications and informational concerns.

From the 1890s until just after World War II, through developments in photomechanical systems, the use of the medium for illustration expanded dramatically. At the same time, the expressive or aesthetic concerns were embraced more actively, yet somewhat reluctantly, by the art world. Throughout this period, the "picture magazine," which gave birth to the extended photo essay, experienced a rise to prominence, followed by a rapid decline a decade later. Support systems for expressive photography struggled for survival prior to the turn of the century, continued through the fifties, gained momentum in the sixties, and reached explosive proportions in the seventies.

During this progression, and paralleling other media developments in independent film and video, photography came under scrutiny as an object of theoretical and critical speculation. Intense and elaborate discussions revised, as well as severely questioned, many earlier precepts. Acknowledging, certainly, that revisionist attitudes have dissenters as well as supporters, the one statement that may best characterize photography in the eighties is that it is still adjusting to the field's rapid expansion over the past thirty years.

In retrospect, there seem to be four contributing factors that illuminate general trends. Institutional, educational, interpretive, and publications activity in history, theory, criticism, and practice are the key areas to be reviewed to determine and evaluate general patterns associated with development and change.

The dramatic support activity through the late seventies diminished entering the eighties. The demise of many commercial galleries and workshop programs, a leveling of grant support, a temporary softening of the auction market, and a decrease in student enrollment and academic teaching appointments contributed to the depressed climate of the field. In spite of these conditions, a series of developments during the current decade suggest the field's stability rather than decline.

Institutional Activity

In 1984, the J. Paul Getty Museum acquired a series of major private collections, including those of Arnold Crane, André Jammes, Sam Wagstaff, and Jurgun Wilde. These acquisitions immediately established a major public collection of approximately twenty thousand prints for the new Getty museum to be built in Brentwood, California.

After almost six years of debate, the George Eastman House in Rochester reversed an earlier decision of the Board of Directors to divest the museum of its major collections to relieve economic difficulties. Stimulated by public reaction and an endowment from Eastman Kodak Company, the divestiture plan was abandoned and a new building and renovation fund was raised by the institution. The new archive building of

seventy-three thousand square feet is scheduled for completion in 1988.

Another event of major importance to this growing pattern of museum activity is the construction of a new fifty-five-thousand-square-foot building for the Center for Creative Photography at the University of Arizona in Tucson. Serving as the model research museum for the field, the Center houses a collection of approximately fifty thousand master prints by major twentieth-century photographers. Its archives also contain some half-million study prints, an equal number of negatives, and correspondence and artifacts of the largest number of photographers in any museum. In addition, the Center's program of publishing information about its collections has made it a valuable resource.

In Riverside, California, the University of California's Museum of Photography was completing plans for a move to a twenty-five-thousand-square-foot building; and in Boston, the Photographic Resource Center developed an expanded facility on the campus of Boston University. During a two-year period from 1983 to 1984, the Museum of Photographic Arts opened in Balboa Park in San Diego; Columbia College opened the Museum of Contemporary Photography in Chicago; and the Museum of Modern Art in New York opened an enlarged Edward Steichen Photography Center with increased gallery space.

Other notable activities were the establishment by the International Center for Photography of a satellite gallery in midtown Manhattan in space provided by the International Paper Company, and finally, the opening by Lightwork Community Darkrooms of Syracuse University of the Robert Menschel Gallery.

Within traditional museums, collecting activity has expanded and a number of other organizations serving photography that developed since the late sixties continue to survive in the eighties. These organizations provide alternative programs and goals to more traditional museums or commercial galleries, often by combining exhibition and workshop activities with residency programs for photographers and by publishing activities devoted to contemporary photography. During the most dramatic phase of the medium's development in the seventies, these organizations encouraged and absorbed a high influx of practitioners in the field. They have existed primarily with support from the National Endowment for the Arts, from some state arts councils, and through their own initiatives. While most of these organizations are between ten and twenty years old, it is important to realize that very few photography institutions in the United States are more than thirty years old.

Alternative organizations that have continued into the eighties are Lightwork in Syracuse; San Francisco Camerawork; Catskill Center for Photography, Woodstock, New York; Houston Center for Photography; Visual Studies Workshop, Rochester; Photographic Resource Center, Boston; Los Angeles Center for Photographic Studies; CEPA Gallery, Buffalo; and The Light Factory of Charlotte, North Carolina.

Never before in the history of the medium has its development been affirmed by such institutional activity. The expanded educational activity that began in the early sixties is a part of a progression of events that developed audiences, private collecting, publication, and access to the work of individual photographers. Simultaneously, critical, theoretical, and historical writing enhanced the overview of the field. Certainly, an improved support structure is evident.

History, Theory, Criticism

Historical research tests photographic theory and criticism. Over an extended period, a tension should exist among the various elements: history, theory, criticism, and practice. The historian's responsibility is ultimately to align these elements, providing a credible analysis of what we term the past. A history of the theory of photography or a history of photographic criticism all too often does not reveal a history of photographic practice. The dilemma is, of course, how to view photography in the larger context of visual history. In the eighties, theoretical and critical discourse has departed from the traditional assumptions used to interpret photographic practice.

The expansion of the field has brought with it a parallel expansion of its literature. The establishment of more collections of general research value, complementing those that primarily collect individual objects, has begun to enhance the resources available to researchers and scholars for study.

Publishing Activity

The literature of the field has expanded appreciably in the past forty years. Beyond the earlier pattern of technical manuals and travel books, or sporadic monographs on an individual photographer's work, there has been an infusion of general histories, anthologies, biographical studies, critical and theoretical studies, and collections and exhibition catalogs. In general, historical boundaries have been expanded and an international perspective is more evident. The eighties saw an even more pronounced increase in critical and theoretical writings. While many popular photography magazines have disappeared, a pattern of new publications has emerged. Most of them are being produced by alternative organizations and include *Center Quarterly*, The Catskill Center for Photography; *C.E.P.A. Quarterly*, C E P A Gallery; *Views*, The Photographic Resource Center; *Afterimage*, The Visual Studies Workshop; and *Spot*, The Houston Center for Photography. *The Archive*, a scholarly publication of the Center for Creative Photography, was the major new museum magazine to enter the field a decade ago, and *Aperture* and *History of Photography* are the oldest surviving nonprofit photography magazines.

Education

Prior to the early sixties, few universities had departments of photography or had incorporated photography programs into their departments. Most formal studies were technical and supported other disciplines, primarily in the sciences or in schools of journalism. Added to this limited pattern of activity were a few independent workshops and programs within independent art schools.

In 1963, with the founding of the Society for Photographic Education (S P E), the first major forum for the discussion of educational issues was established. From the time it was founded, with fewer than one hundred members, the society has grown to fourteen hundred members, subsequently providing a base of support for individual photographers that generally had not existed in the past. The expansion of educational activity and increased student interest were probably the dominant catalysts in shifting the prevailing perceptions of photography from a field for amateurs and hobbyists to an arena of serious study.

Although the founders of S P E hoped to encourage a broad-based evaluation of educational issues within photographic education, the organization evolved with an emphasis on the fine art tradition, primarily at the university level. As university student enrollment declined in the late seventies and early eighties, reflecting the end of the "baby boom," economic retrenchment and decreased job opportunities contributed to a general reevaluation of priorities. Today, educators seek broader interpretations of the field with renewed interest in cross-disciplinary studies, integrating media concerns in terms of their social and political importance. An imposing question that educators will have to face is the role of electronic imaging – a technology that is beginning to displace the dominance of conventional photographic systems.

Practice

In 1959, the George Eastman House sponsored the exhibition *Photography at Mid-Century*. In the catalog essay for the exhibition, Beaumont Newhall characterized the existence of a progression of four stylistic trends that dominated photography at mid-century in America and Europe. He termed these "straight approach," the "experimental," the "photo-journalistic," and the development of the theory of the "equivalent" as first explored by Alfred Stieglitz. Newhall then clarified these distinctions by stating: "These approaches generously overlap each other and defy oversim-

plification which, in the interest of clarification, we have suggested. One characteristic they have in common, which marks photography at mid-century apart from the photography of the four preceding decades: emulation of the painter has ceased to be an overwhelming preoccupation for the majority of photographers. Today photography is almost unanimously accepted as a medium in its own right, with its own characteristics, limitations, and potentials. A short time ago this attitude was limited to a handful of pioneers. By common consent, the effects which the painter alone can obtain with his own special art are no longer imitated. The fields the painter has neglected – the representation of man and nature – have become the special province of the photographer."

Within a few years, the distinctions that Newhall had observed began to blur, and the domains of painting and photography tended to merge. Ironically, the primary distinction that did form was between the artist who used photography and the photographer. This distinction was maintained by galleries that would exhibit photographic works by artists but not photographers and, conversely, by photographic galleries that would not exhibit work by artists who photographed. Subsequently, this division has become less rigid, largely as a result of changing institutional collecting policies.

In addition, the apparent insecurity of the postmodern condition has established within photographic practice, theoretical discourse, and critical debate the question of assimilating the overwhelming presence of the mass media into the confines of art. In the eighties the iconic interest of many contemporary photographers has once again created a wide-ranging photographic inquiry along less traditional lines. This activity strongly parallels many of the experimental concerns that dominated the art world between the two world wars, for many of the same reasons. In view of its recent history, American photography in the future will face the adjustments of addressing a rigorous climate of theoretical and critical debate that places it in the broader context of visual history.

Duotone Portfolio

PLATE 1

Frank Eugene, *La Cigale*, 1898, photogravure

PLATE 2

Adelaide Hanscomb,

[Charles Keeler posing for an illustration from the Rubaiyat of Omar Khayyam], ca. 1903–1905

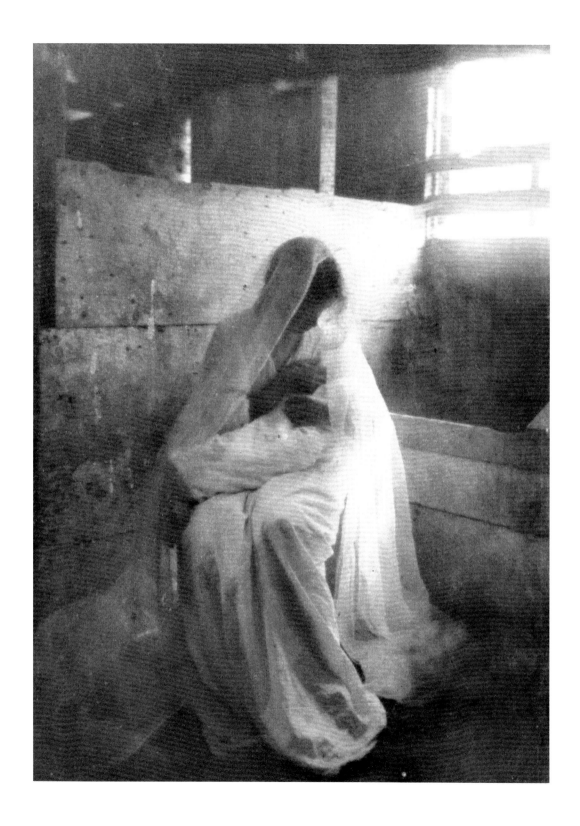

PLATE 3

Gertrude Käsebier, *The Manger*, ca. 1899, photogravure

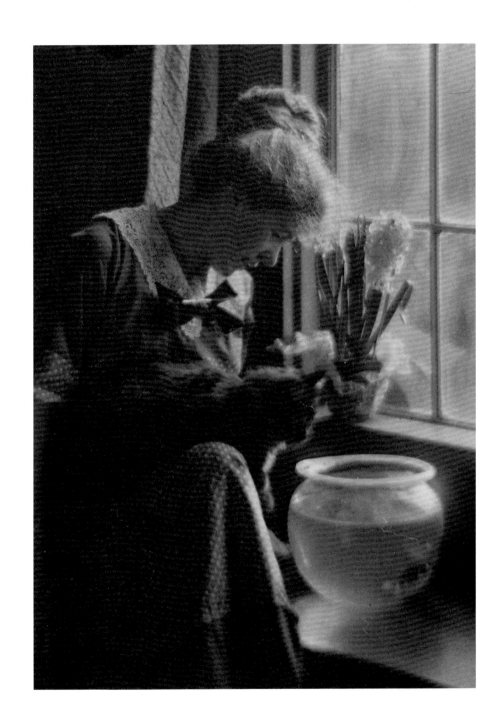

PLATE 4

Imogen Cunningham, *In My Studio in Seattle, 1117 Terry Avenue*, 1910, platinum print

PLATE 5

George H. Seeley, *Maiden with Bowl*, ca. 1915, platinum print

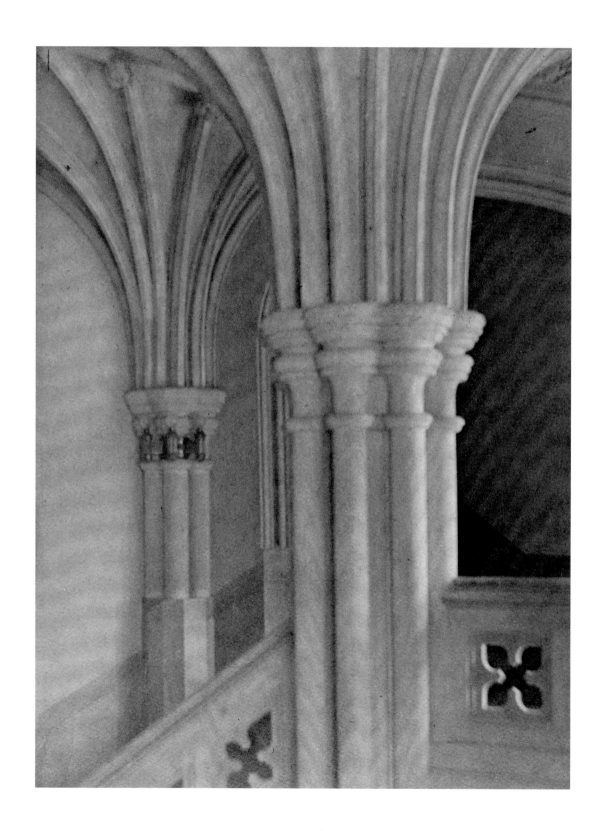

PLATE 6

Clarence White, [Columbia College, New York], ca. 1910, platinum print

Laura Gilpin, *The Marble Cutters*, 1917, platinum print

PLATE 8

Paul L. Anderson, *Under the Brooklyn Bridge*, 1917/1945, palladium print

Alvin Langdon Coburn, *The Park Row Building*, 1910, photogravure

PLATE 10

Lewis Hine, *Albanian Woman, Ellis Island*, 1905

PLATE 11

Ernest Bloch, *Fair in Fribourg, Switzerland*, ca. 1902/1974

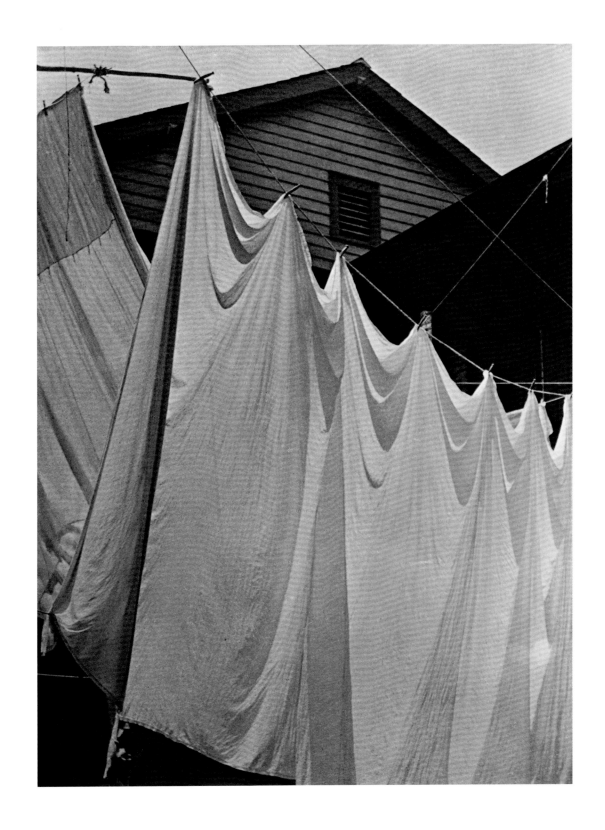

PLATE 12

Paul Strand, *White Sheets, New Orleans*, 1918, palladium print

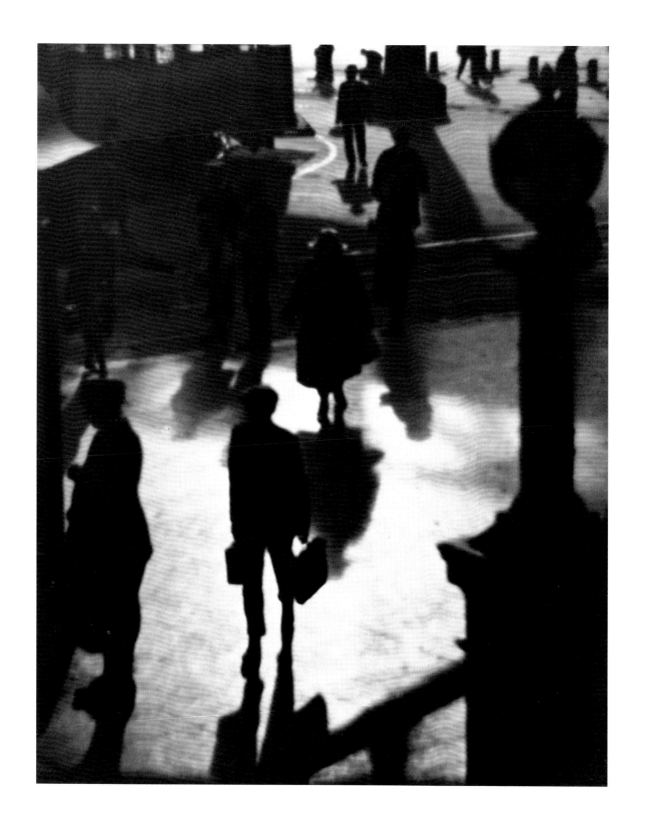

PLATE 13

Johan Hagemeyer, *Pedestrians*, 1921

PLATE 14
Paul Strand, *Nude – Rebecca*, ca. 1922, palladium print

PLATE 15

Margrethe Mather, *Japanese Wrestler's Belly*, 1927

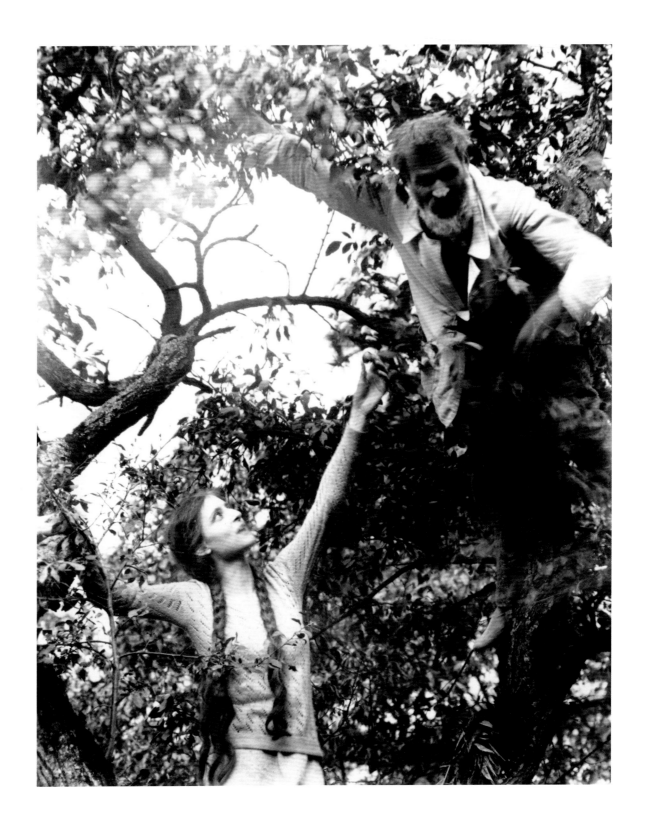

PLATE 16

Edward Steichen, [Brancusi and his daughter], 1922

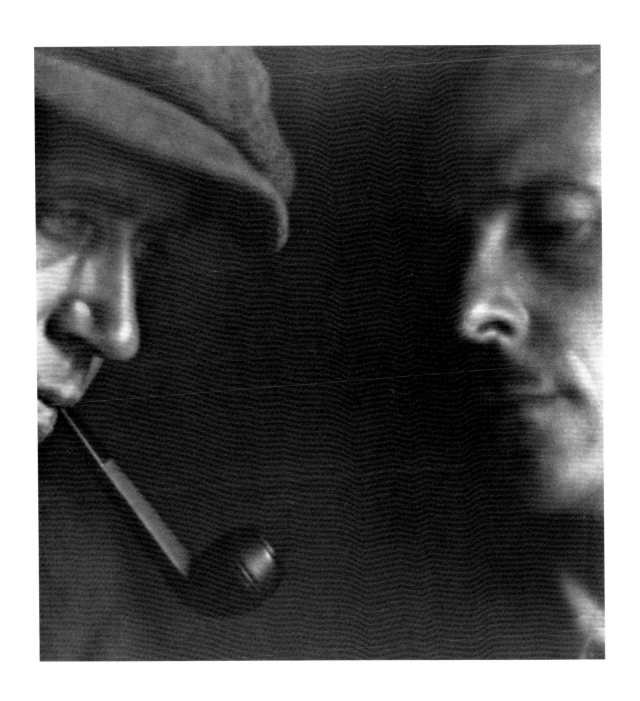

PLATE 17

Margrethe Mather, *Johan Hagemeyer and Edward Weston*, 1921, platinum print

PLATE 18

Paul Strand, *Akeley Camera*, 1922

PLATE 19

Edward Weston, *Wash Bowl, Mexico,* 1926

PLATE 20

Laura Gilpin, *Narcissus*, 1928, platinum print

PLATE 21

Ralph Steiner, *Electric Switches*, 1930

PLATE 22

Laura Gilpin, *Dominoes*, 1930, platinum print

PLATE 23

Sonya Noskowiak, untitled, ca. 1930s

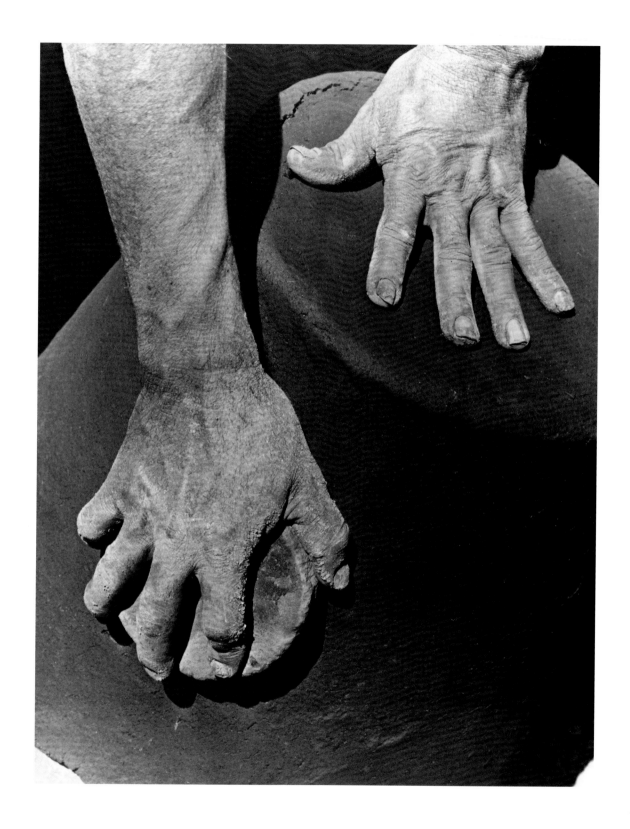

PLATE 24

Anton Bruehl, *Mexican Potter*, 1932

PLATE 25

Edward Weston, [Sonya Noskowiak], 1934

PLATE 26

Eudora Welty, *A Woman of the 'Thirties*, 1935/1980

PLATE 27

Ralph Steiner, *Painter Henry Billings against Chevy and Tire*, 1930/1979

PLATE 28

Walker Evans, *Breakfast Room at Belle Grove Plantation, White Chapel, Louisiana*, 1935/1974

PLATE 29

John Gutmann, *Elevator Garage, Chicago,* 1936

PLATE 30

Imogen Cunningham, *Frida Kahlo Rivera*, 1937

PLATE 31

Francis Bruguière, [Cynthia Fuller], ca. 1935

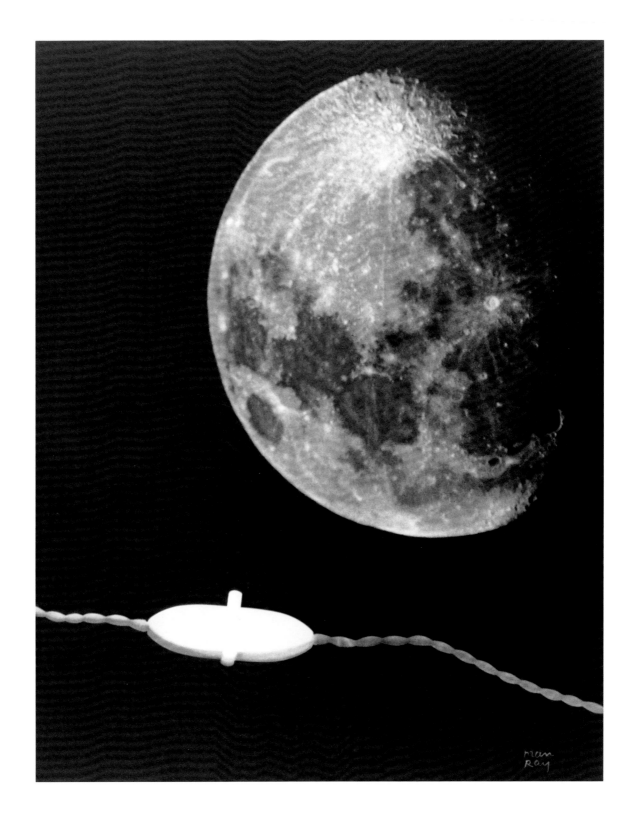

PLATE 32

Man Ray, *Le Monde*, 1931, photogravure

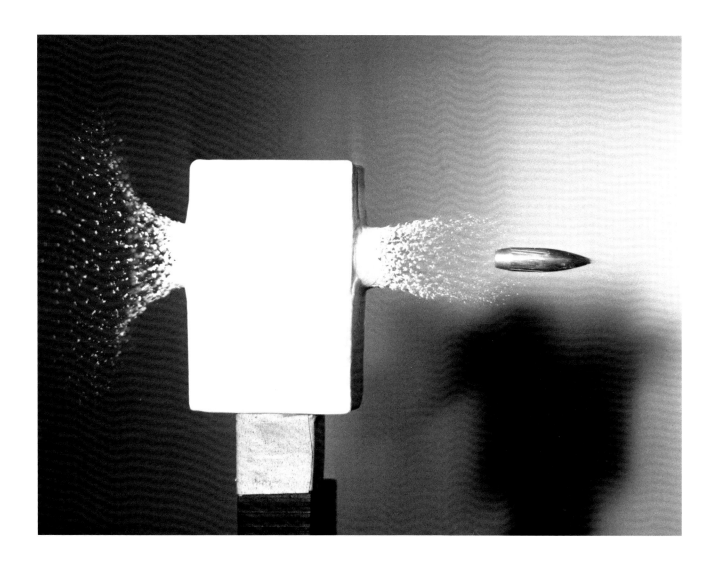

PLATE 33

Harold Edgerton, *.30 Caliber Bullet as It Crashes through a Bar of Soap*, undated/ca. 1976

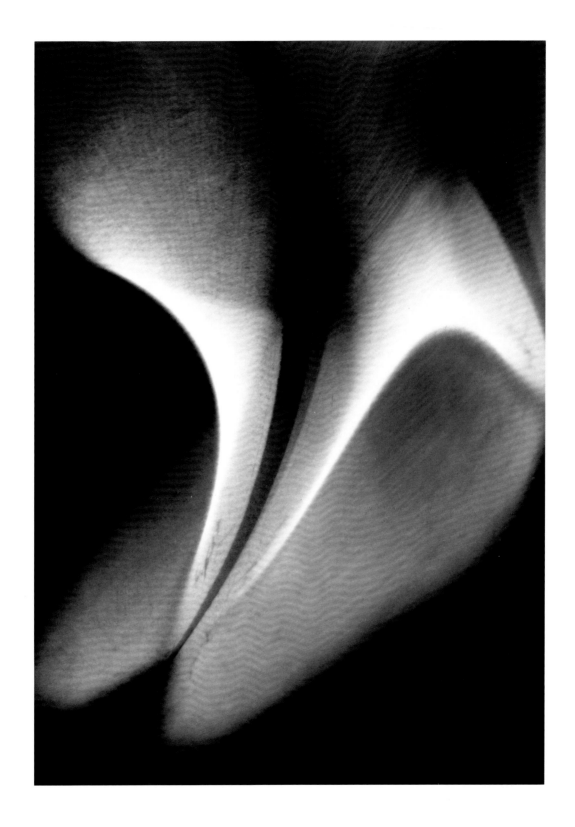

PLATE 34

Wynn Bullock, *Light Abstraction*, 1939

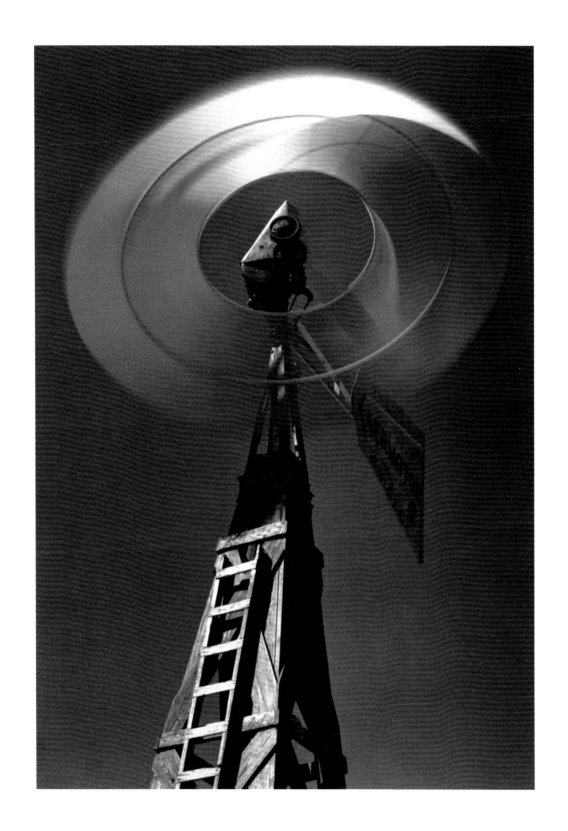

PLATE 35

Ansel Adams, *Windmill, Owens Valley*, 1938

PLATE 36

Weegee, [Metropolitan Opera House recital], undated

PLATE 37

Lisette Model, *Singer at the Café Metropole, New York City*, undated

PLATE 38

Arthur Rothstein, *Aletia Berdolph in Log Cabin, Gee's Bend, Alabama,* 1937/ca. 1982

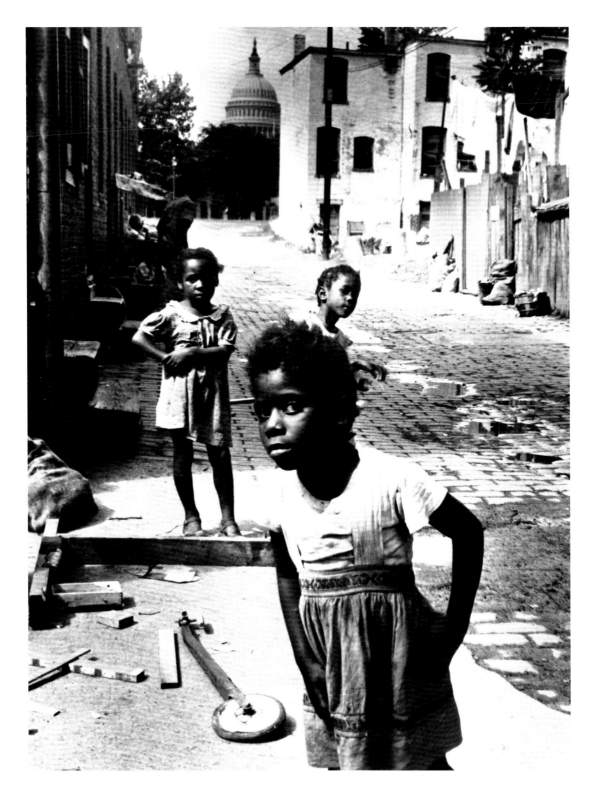

PLATE 39

Marion Palfi, *In the Shadow of the Capitol, Washington, D.C.*
[from the Suffer Little Children series, 1946–1949]

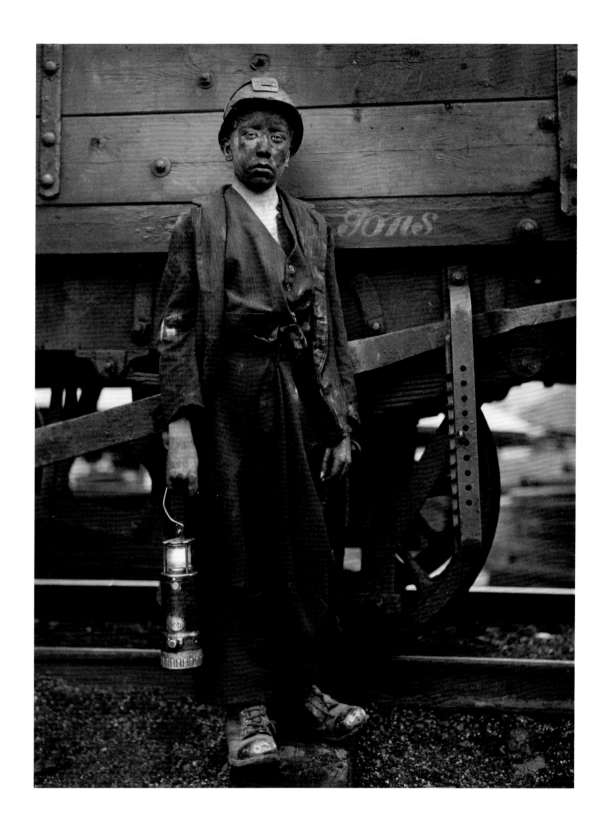

PLATE 40

Arthur Rothstein, *Young Coal Miner, Wales,* 1947/ca. 1982

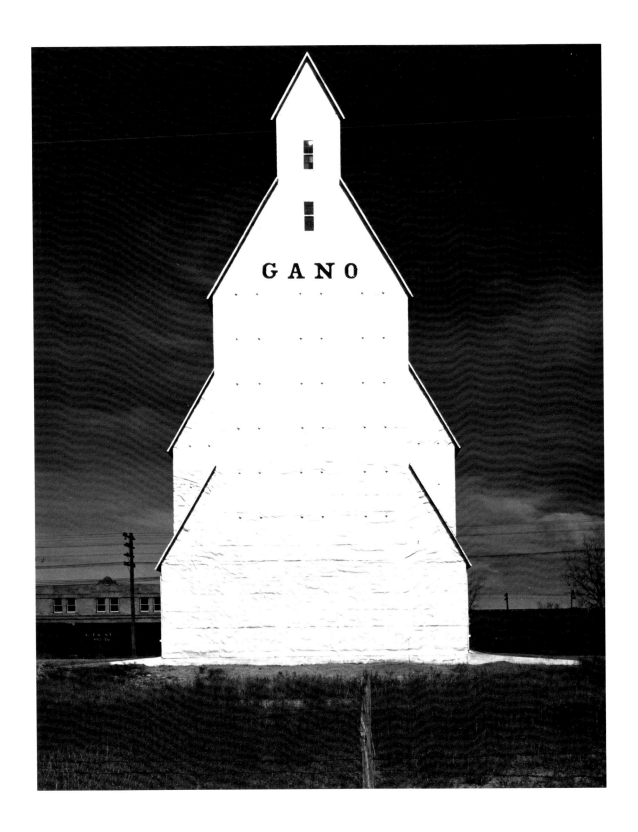

PLATE 41

Wright Morris, *Gano Grain Elevator*, 1940

PLATE 42

Edward Weston, *Mr. and Mrs. Fry Burnett, Austin, Texas*, 1941

PLATE 43

Harry Callahan, *Eleanor*, 1949

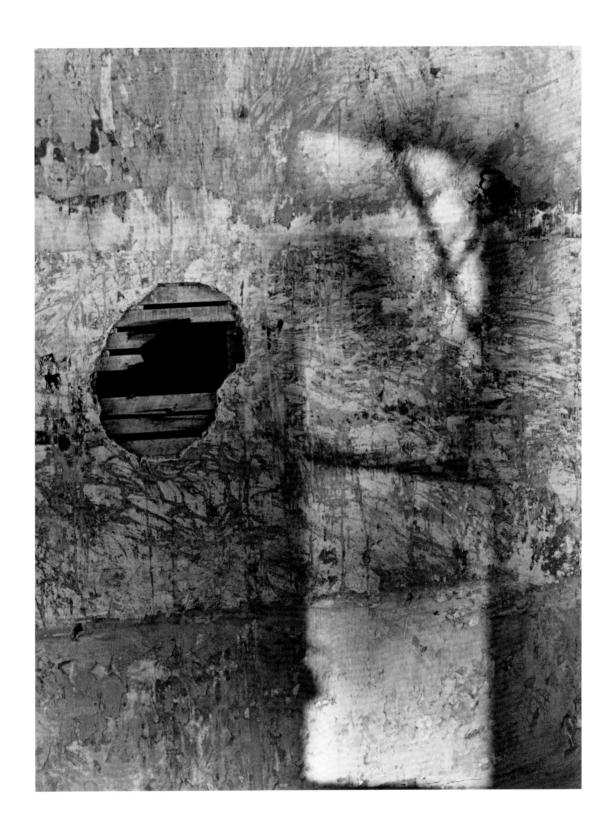

PLATE 44

Clarence John Laughlin, *Light and Time*, 1949

PLATE 45

Frederick Sommer, *Medallion*, 1948

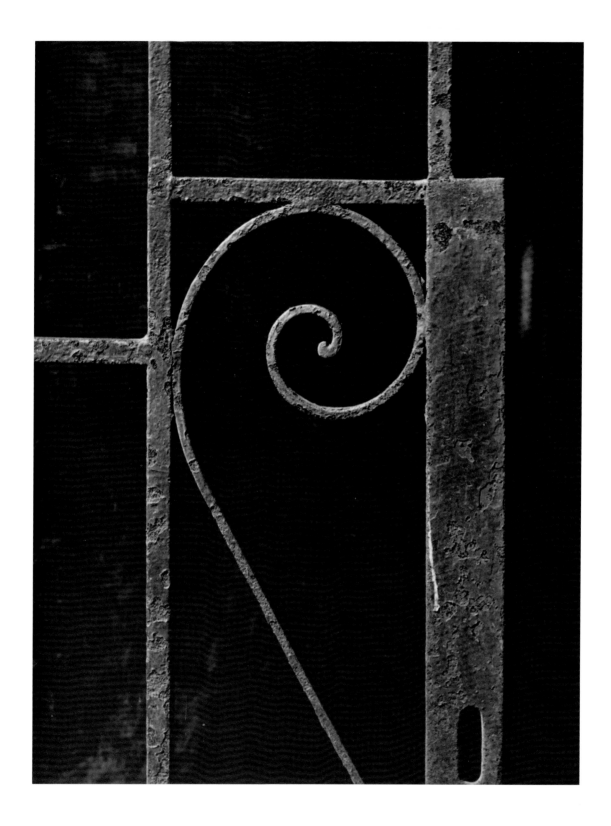

PLATE 46

Aaron Siskind, [ironwork, New York City], 1947

PLATE 47

Minor White, *Sun over the Pacific – Devil's Slide*, 1947

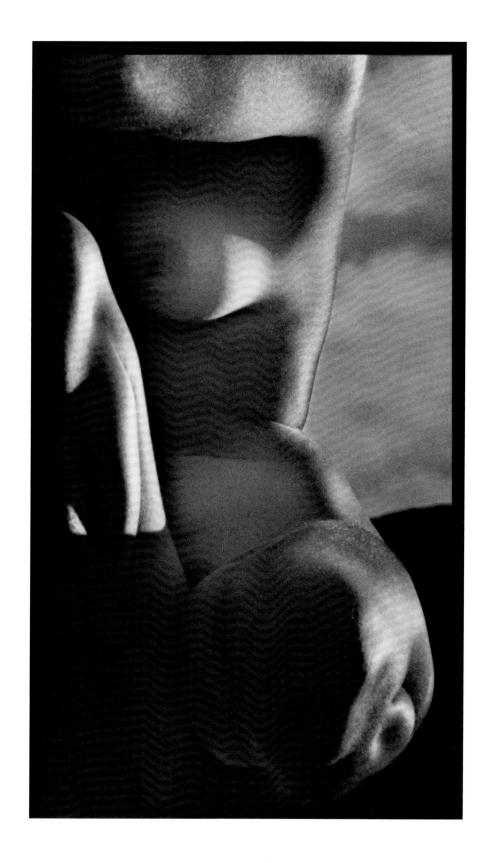

PLATE 48

Ruth Bernhard, *Rockport Nude*, ca. 1946

PLATE 49

Barbara Morgan, *Martha Graham – El Penitente – Erick Hawkins Solo as El Flagellante*, 1940

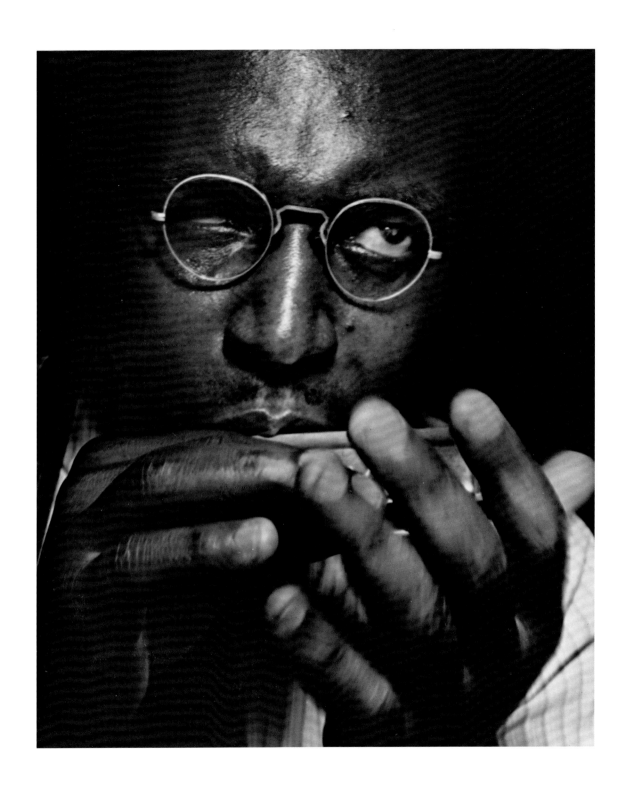

Sid Grossman, *Folksingers I – Sonny Terry*, ca. 1946–1948

PLATE 51

Arnold Newman, *Kuniyoshi*, 1941

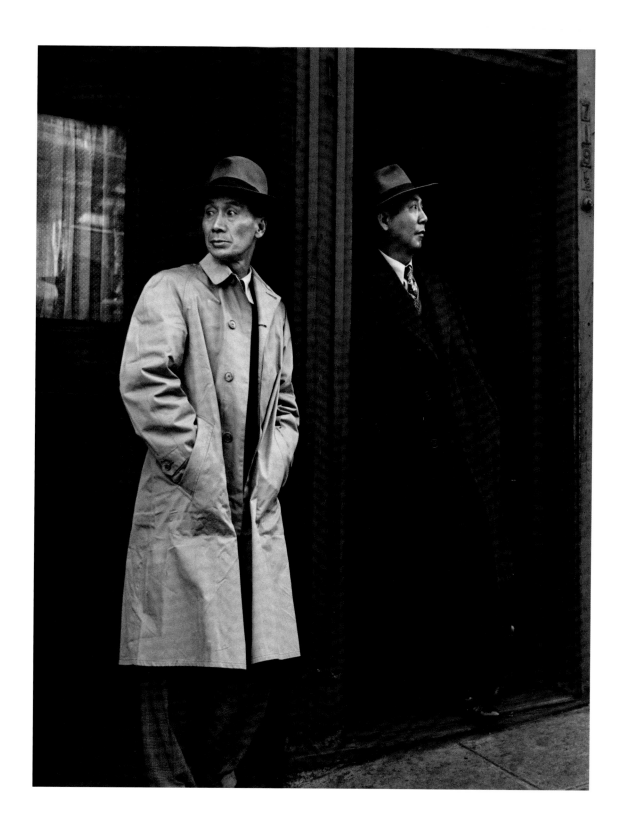

PLATE 52

Max Yavno, *Two Chinese*, 1947

PLATE 53

Louise Dahl-Wolfe, *In Sarasota*, 1947

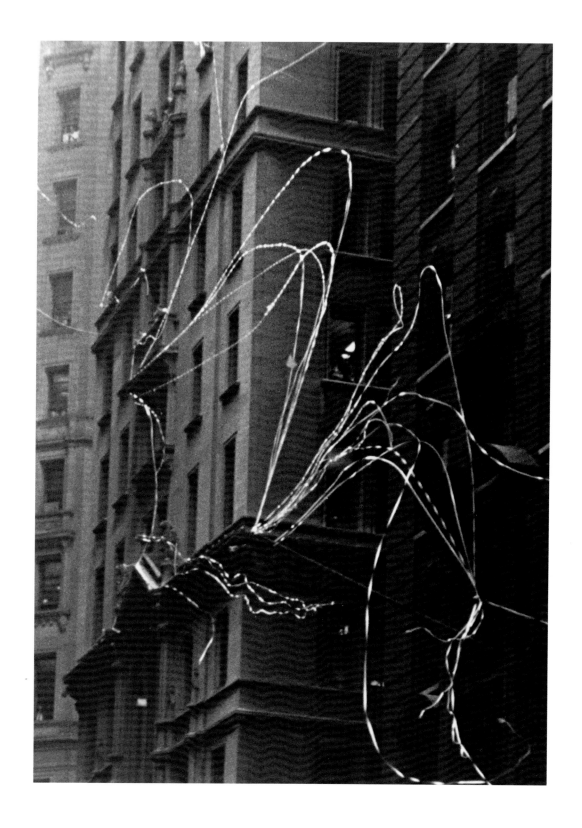

PLATE 54

Robert Frank, *New York City*, 1948

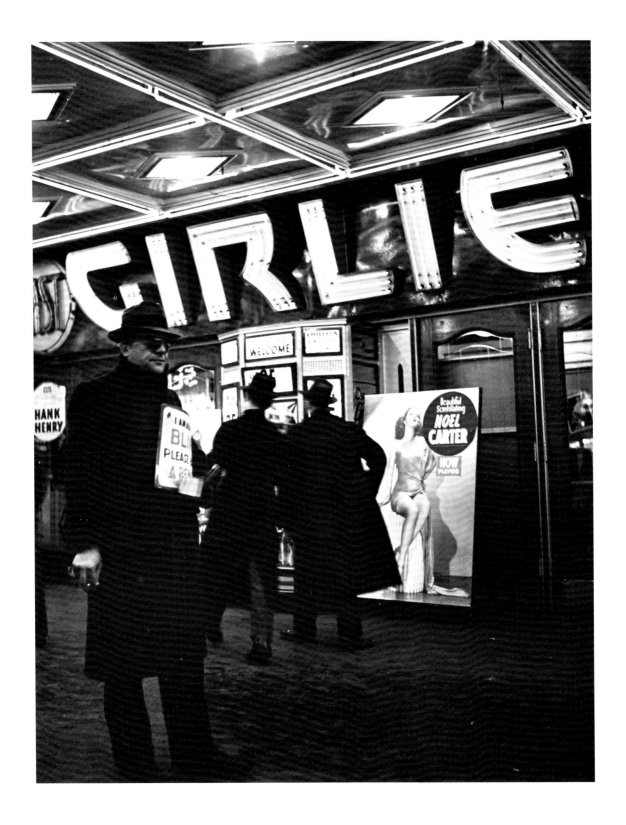

PLATE 55

Andreas Feininger, *Burlesque in New York*, ca. 1941

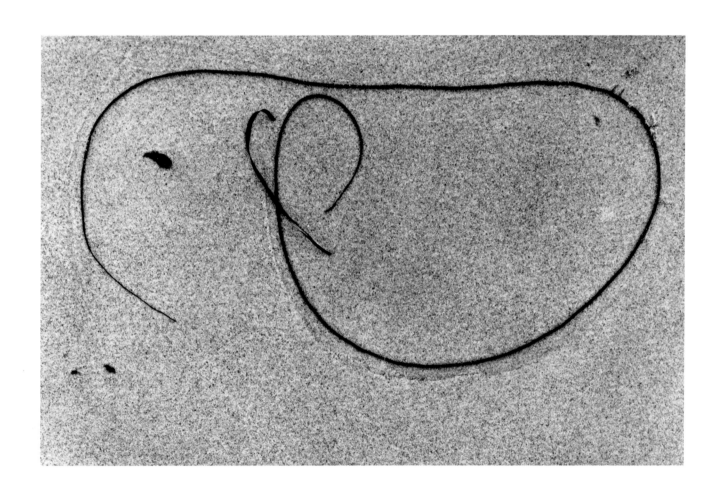

PLATE 56

Aaron Siskind, *Martha's Vineyard 20*, 1953

PLATE 57

W. Eugene Smith, *Jeep at Guadalcanal*, 1944

PLATE 58

Charles Sheeler, *RCA Building*, 1950

PLATE 59

Margaret Bourke-White, *George Washington Bridge*, 1953

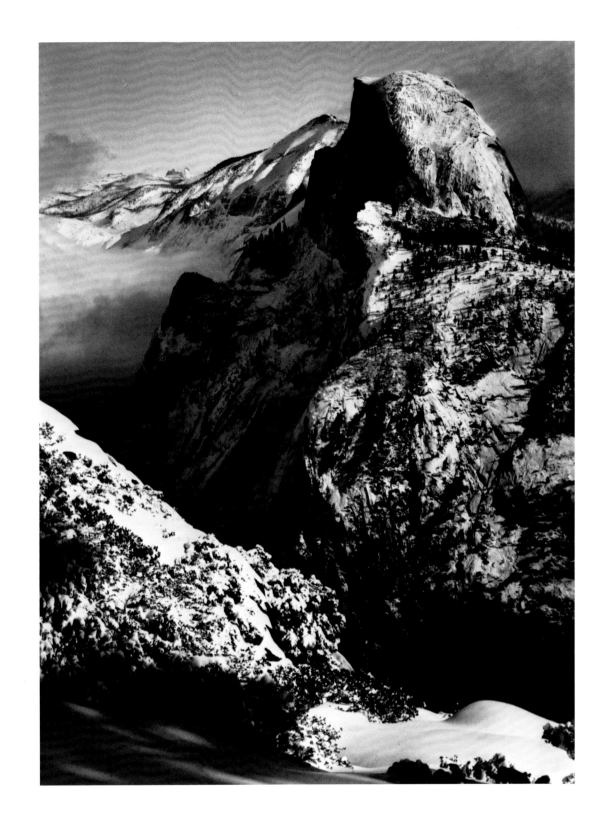

PLATE 60

Ansel Adams, *Half Dome from Glacier Point, Yosemite National Park*, ca. 1956

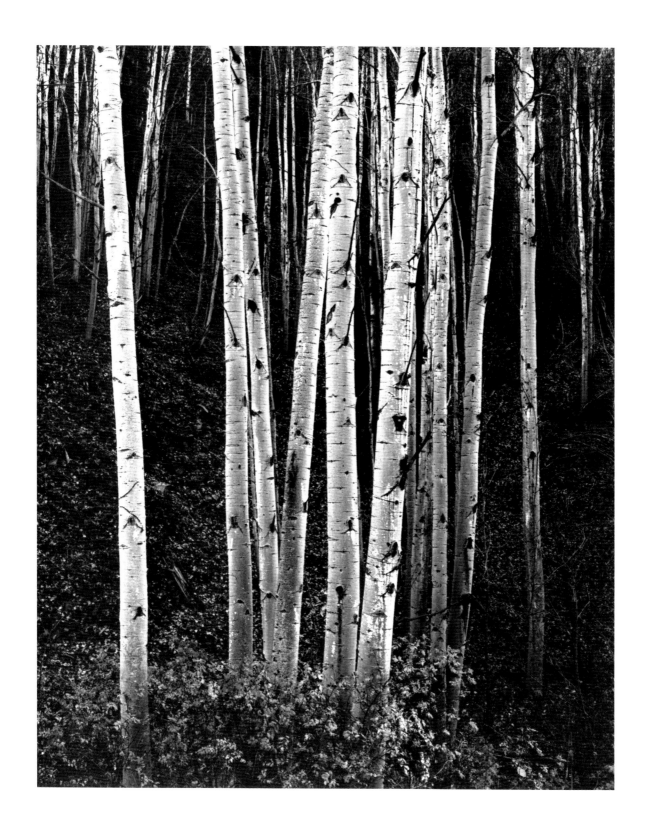

PLATE 61

Don Worth, *Aspen Trees, New Mexico,* 1958

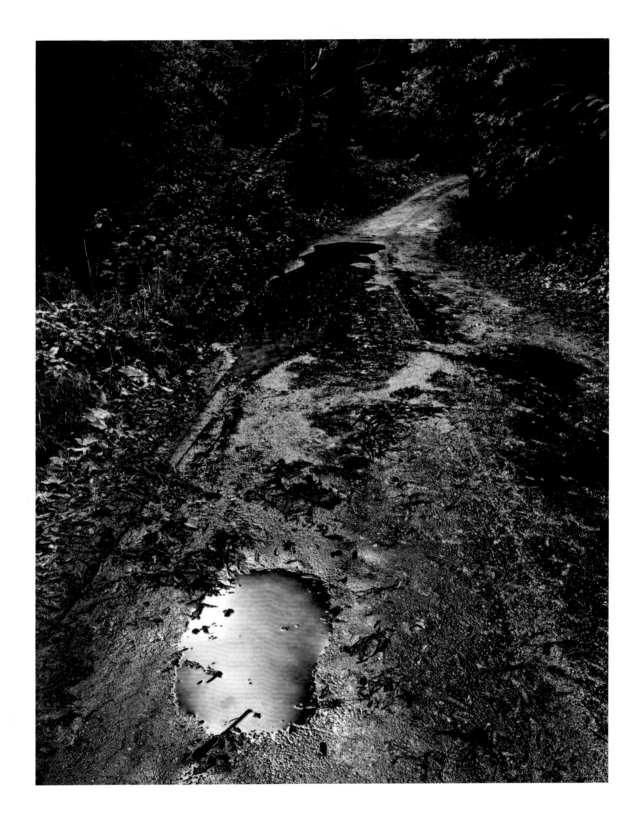

PLATE 62

Wynn Bullock, *Palo Colorado Road*, 1952

PLATE 63

Frederick Sommer, *The Thief Greater Than His Loot*, 1955

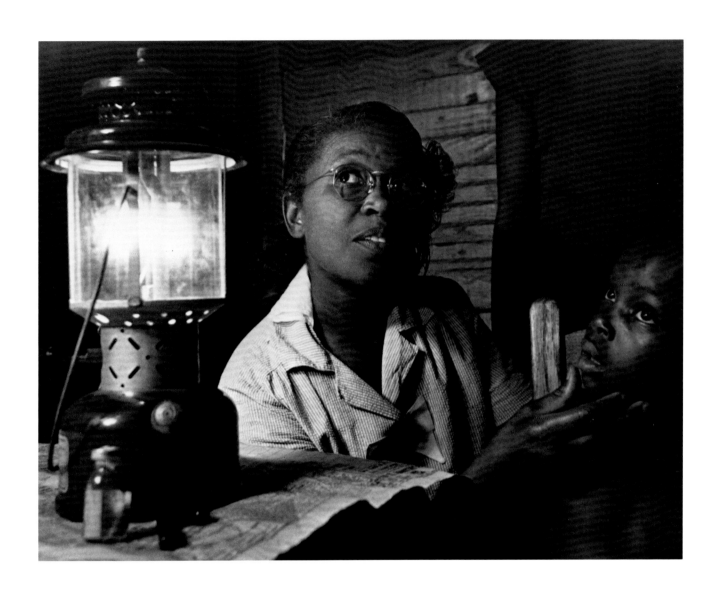

PLATE 64

W. Eugene Smith, [from the Nurse Midwife series], 1951

PLATE 65

William Klein, *Stickball Dance*, 1954

PLATE 66

Weegee, *Cannon Shot*, 1952

PLATE 67

Richard Avedon, *Marian Anderson*, 30 June 1955

PLATE 68

Jerry Uelsmann, untitled, 1959

PLATE 69

Imogen Cunningham, *Minor White, Photographer,* 1963

PLATE 70
Garry Winogrand, untitled, undated

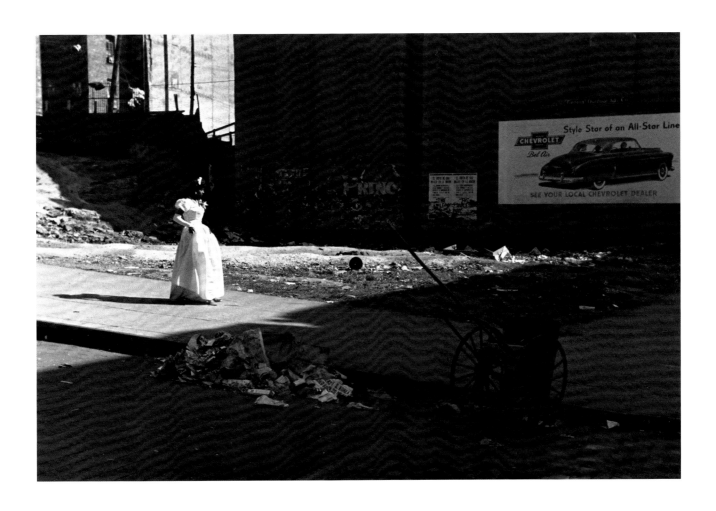

PLATE 71

Roy DeCarava, *Graduation*, 1952

PLATE 72

Harry Callahan, *Collage, Chicago*, 1957

PLATE 73

Barbara Crane, *Neon Cowboy, Las Vegas, Nevada,* 1969

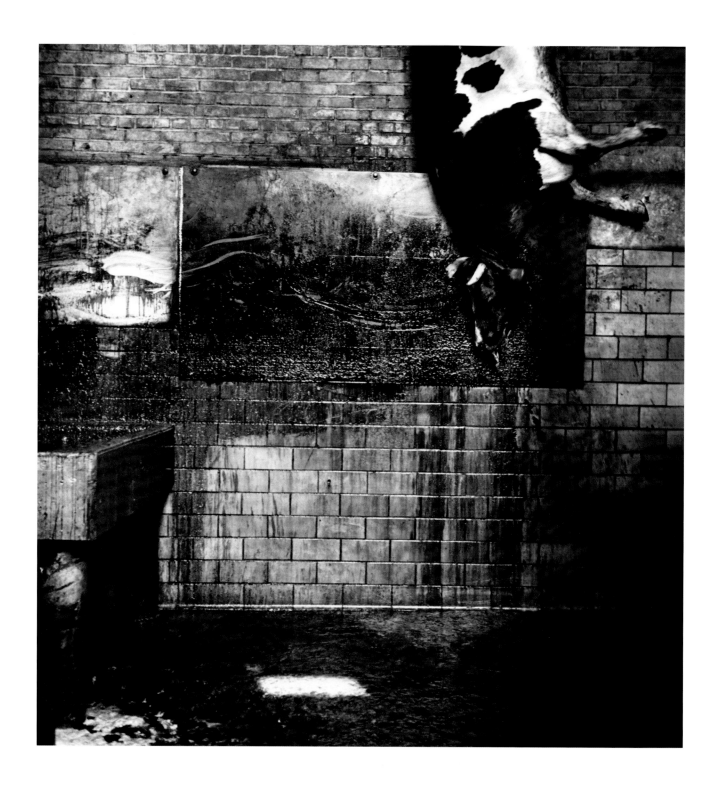

PLATE 74

Jerome Liebling, *Slaughter House, South St. Paul, Minnesota*, 1962

PLATE 75

George Tice, *Horse and Buggy in Farmyard, Lancaster, Pennsylvania,* 1965

PLATE 76

Lee Friedlander, *Route 9W, New York*, 1969

PLATE 77

Kenneth Josephson, *Stockholm*, 1967

PLATE 78

Bradford Washburn, *Annual Banding ("Ogives") of Yentna Glacier, near Mt. Foraker, Alaska*, 4 October 1964

Ansel Adams, *The Great Plains from Cimarron, New Mexico,* 1961

PLATE 80

W. Eugene Smith, *Earl Hines*, undated

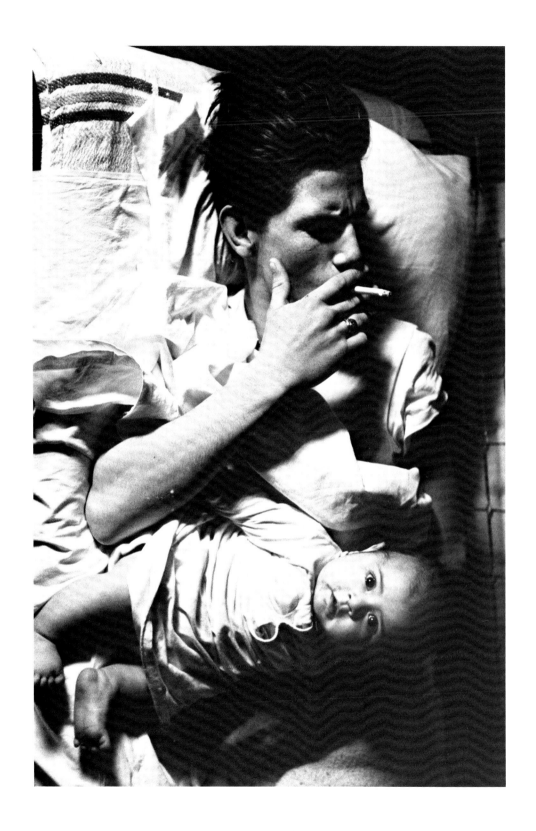

PLATE 81

Larry Clark, [from the Tulsa series], 1963

PLATE 82

Emmet Gowin, *Edith, Ruth, and Mae, Danville, Virginia,* 1967

PLATE 83

Dean Brown, [from the Martin Luther King series], 1969

PLATE 84

Danny Lyon, *Shakedown, Ramsey Unit, Texas* [from the Conversations with the Dead series], ca. 1967–1969

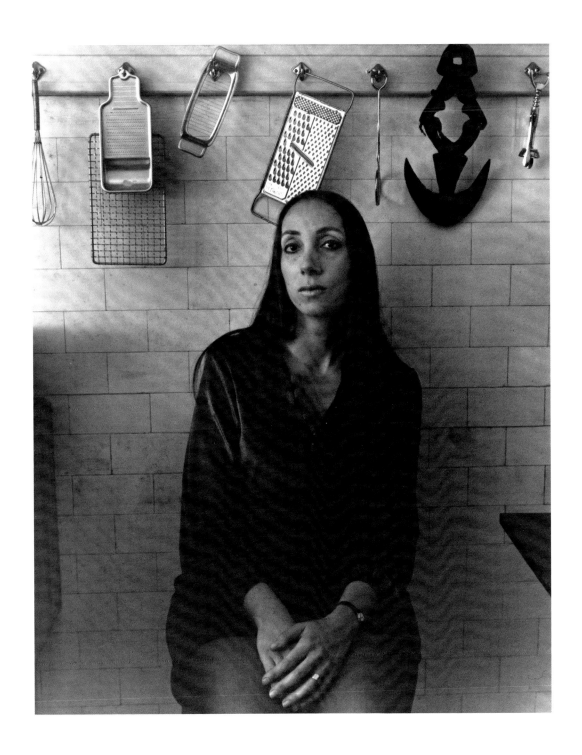

PLATE 85

Judy Dater, *Joyce Goldstein in Her Kitchen*, 1969

PLATE 86

Mary Ellen Mark, *Victor Orellanes in Brooklyn*, June 1978

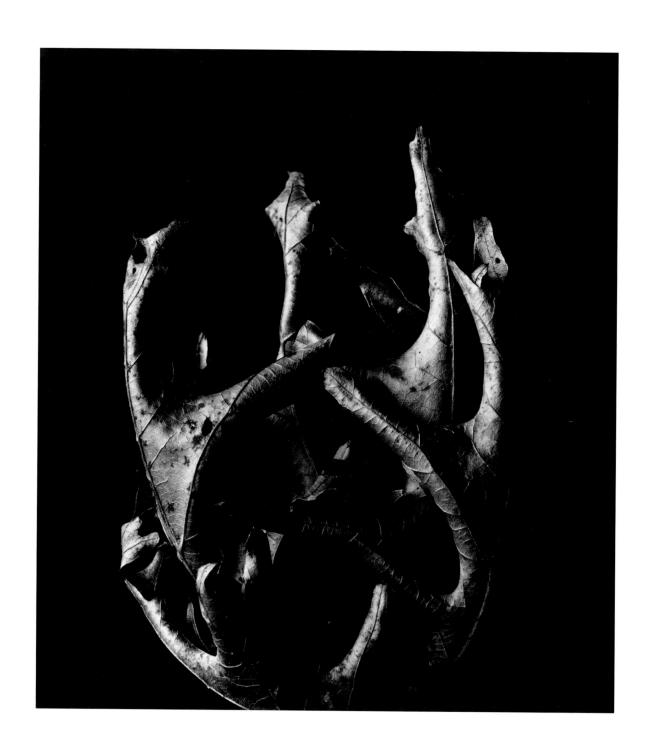

PLATE 88

Aaron Siskind, *Leaves 50*, 1970

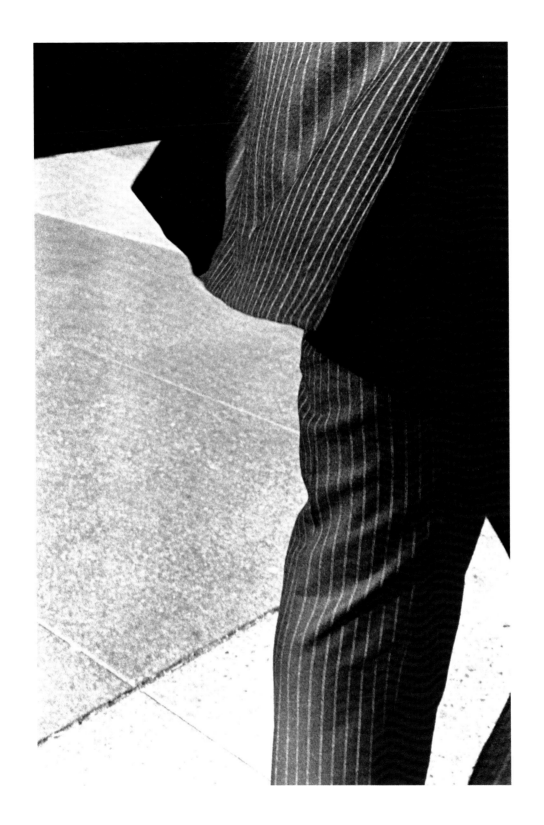

PLATE 89

Ralph Gibson, untitled, 1975

PLATE 90

Duane Michals, *Joseph Cornell*, 1976

PLATE 91

Jerry Uelsmann, *Gifts of St. Ann*, 1976

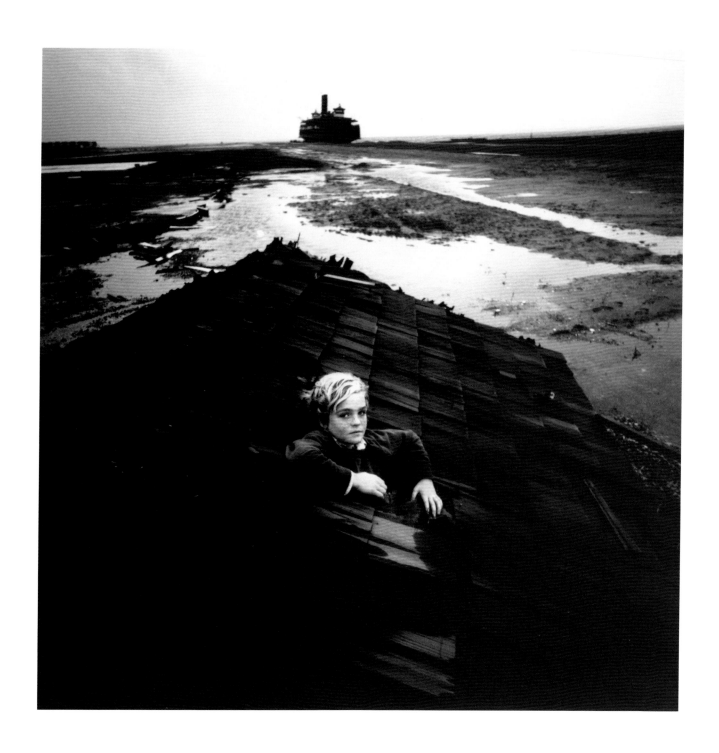

PLATE 92

Arthur Tress, *Boy in Flood Dream*, 1970

PLATE 93

Joseph Jachna, *Door County, Wisconsin,* 1970

PLATE 94

William Clift, *Law Books, Hinsdale County Courthouse, Lake City, Colorado,* ca. 1975

PLATE 95

Harry Callahan, *Providence*, 1976

PLATE 96

Paul Berger, *Camera Text or Picture #2*, 1979

PLATE 97

Frederick Sommer. *Cut Paper.* 1971

PLATE 98

Robert Adams, *Garden of the Gods, El Paso County, Colorado*, 1977

PLATE 99

Lawrence McFarland, *San Simeon, California*, 1978

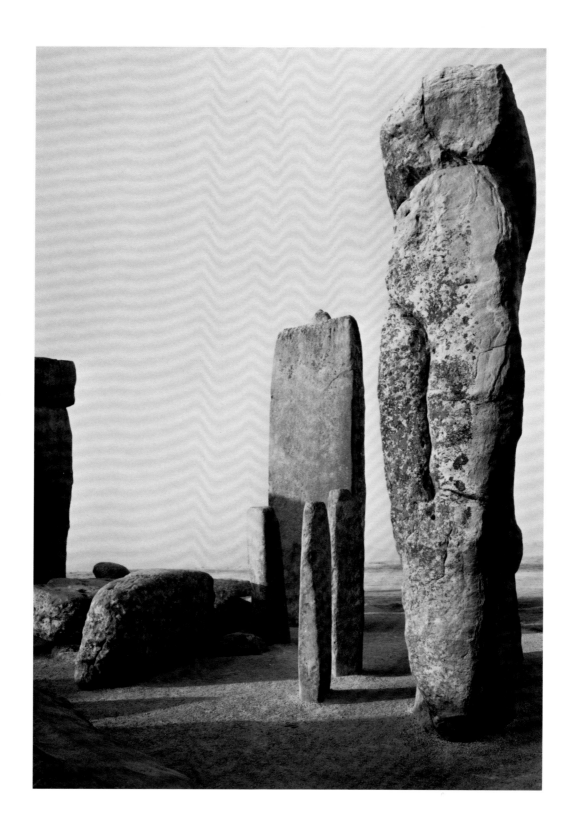

PLATE 100

Paul Caponigro, *Stonehenge, England,* 1967

PLATE 101

Brett Weston, *Hawaii*, 1983

PLATE 102

Robbert Flick, *Solstice Canyon #8*, 24 November 1982

PLATE 103

Michael A. Smith, *New Orleans*, 1985

PLATE 104

Robert Mapplethorpe, *Michael Roth*, 1983

Color Portfolio

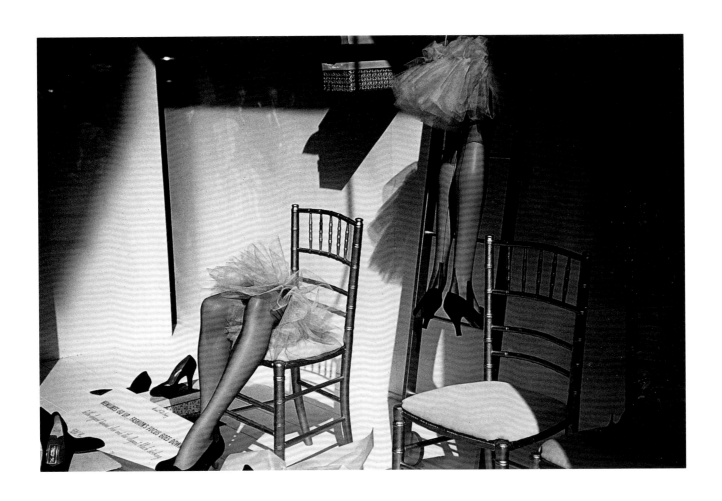

Harry Callahan. *New York*. 1955. dye transfer print

PLATE II

Dean Brown, *Navajo Reservation, North of Cameron, Arizona*, August 1969, dye transfer print

Richard Misrach, *Sounion (Island)*, 1979, dye transfer print

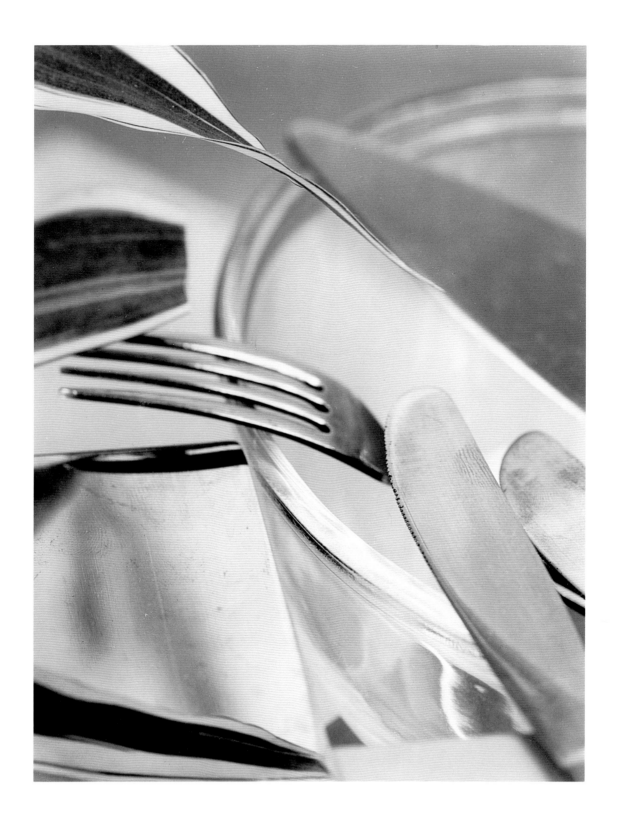

PLATE IV

Jan Groover, untitled, 1978, incorporated color coupler print

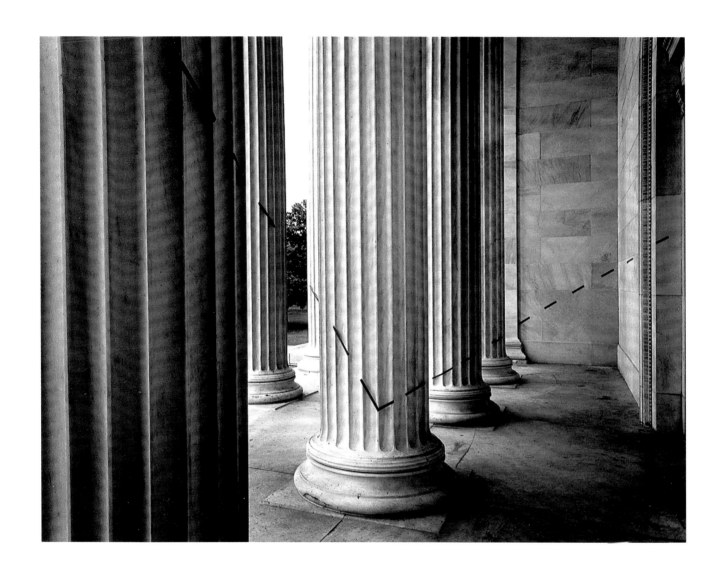

PLATE V

John Pfahl, *Blue Right Angle, Buffalo, New York*, 1975, dye transfer print

PLATE VI

Joyce Neimanas, *Topographical*, 1978, gelatin silver print with paint, pencil, ink, and cut surfaces

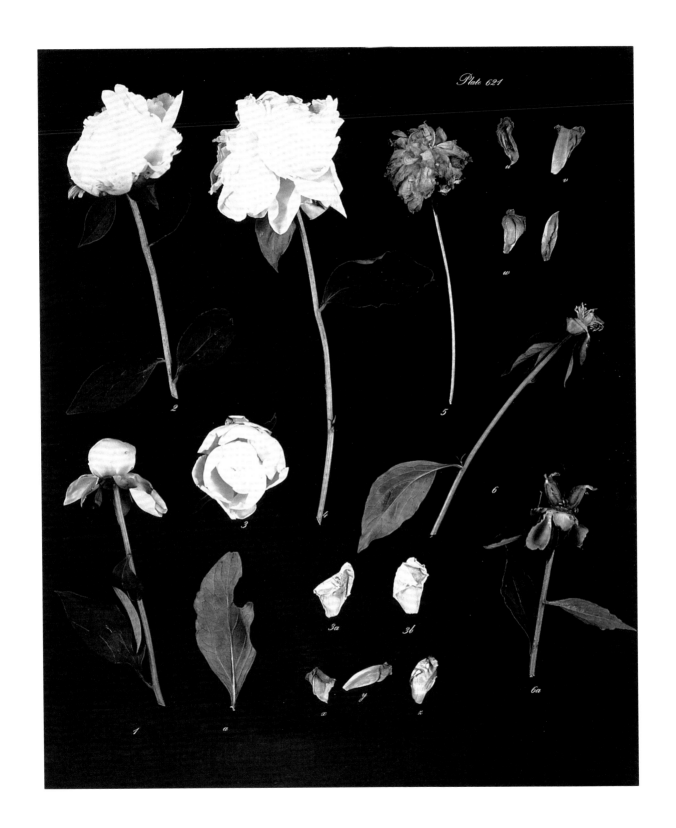

PLATE VII

Betty Hahn, *Botanical Layout (Peony)*, 1979, Polaroid 20 x 24 print

PLATE VIII

Joan Myers, *Los Angeles Frieze*, 1977, hand-colored gelatin silver print

PLATE IX

Gwen Akin and Allan Ludwig, *Goose*, 1985, platinum palladium print

PLATE XI

Barbara Kasten, *Construct II-C*, 1980, Polaroid print

PLATE XII

Mark Klett, *Tracks on Arid Land, Coral Sand Dunes, Utah*, 21 July 1984, dye transfer print

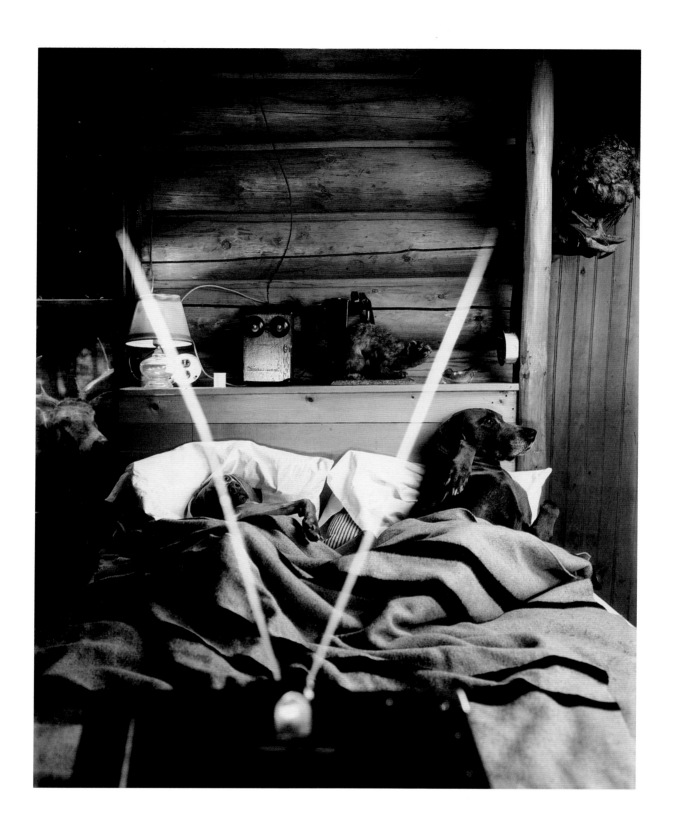

PLATE XIV

William Wegman, *Ray and Mrs. Lubner in Bed Watching TV*, 1982, Polaroid Polacolor ER 20 x 24-inch print

PLATE XV

Robert Heinecken, *Waking Up in News America*, 1984, lithograph

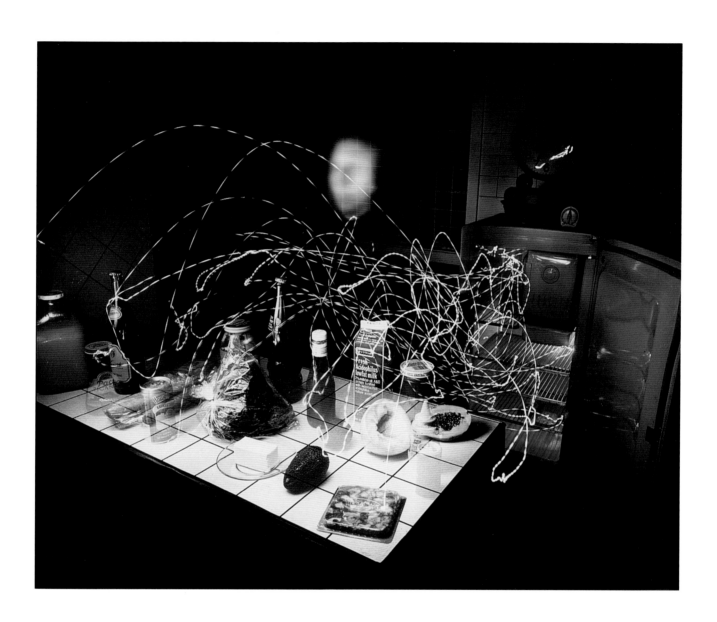

PLATE XVI

Mike Mandel, *Emptying the Fridge*, 1984, Cibachrome print

ILLUSTRATIONS

Accession numbers are included for works in the collection of the Center for Creative Photography. Where two dates are given, the first represents the creation of the original negative and the second is for the print reproduced here.

TEXT ILLUSTRATIONS

PAGE 2
Albert Sands Southworth and Josiah Johnson Hawes
[baby on chair], ca. 1850
Daguerreotype, half-plate, 16.0 x 13.7cm
76:351:002
Gift of Ansel and Virginia Adams

PAGE 2
Oscar Gustav Rejlander
Grief, 1864
Albumen print, 19.0 x 14.9cm
76:026:002

PAGE 3
Felix Bonfils
Vendeurs d'eau fraîche dans les rues du Caire,
undated
Albumen print, 28.1 x 21.4cm
78:123:009

PAGE 3
Carleton Watkins
View from Camp Grove [from *Yosemite Valley:
Photographic Views, Falls and Valley*, 1863]
Albumen print, 19.2 x 29.4cm
76:276:015

PAGE 4
George Fiske
*Upper Yosemite Fall (1600 feet) and Ice Cone
(550 feet)*, ca. 1878
Albumen print, 18.0 x 10.8cm
79:127:030
Gift of Virginia Adams

PAGE 5
Edward and Henry T. Anthony & Co.
El Capitan, 3300 Feet High, from Merced River,
undated
Albumen stereoview, 9.2 x 7.9cm each
80:111:011
Gift of Virginia Adams

PAGE 7
Peter Henry Emerson
Gathering Water Lilies, 1886
Platinum print
Courtesy of the International Museum of
Photography at the George Eastman House

PAGE 9
George Davison
Onion Field, 1890
Photogravure
Courtesy of the International Museum of
Photography at the George Eastman House

PAGE 10
Clarence White
Lady in Black with Statuette, 1908
Photogravure
Courtesy of the International Museum of
Photography at the George Eastman House

PAGE 11
Eugène Atget
Magasin, Avenue des Gobelins, 1925
Gelatin silver print by Berenice Abbott,
22.5 x 17.1cm
76:201:003

PAGE 11
Edward S. Curtis
*Woman's Costume and Baby Swing –
Assiniboin*, ca. 1900–1906 [from *The North
American Indian*, vol. 18, 1926]
Photogravure on tissue, 18.4 x 14.1cm
84:024:099
Gift of Bill Buckmaster
© 1926 E. S. Curtis

PAGE 12
Lewis Hine
Homework, Artificial Flowers, New York City,
1908
Gelatin silver print, 11.5 x 16.8cm
82:096:003
Gift of Robert Harrah

PAGE 13
Edward Weston
Sadakichi Hartmann, ca. 1920
Platinum print, 24.3 x 19.4cm
76:003:030
Edward Weston Archive
© 1981 Center for Creative Photography,
Arizona Board of Regents

PAGE 14
Edward Steichen
Henri Matisse, undated
Photogravure, 12.9 x 17.0cm
76:117:006
Gift of Ansel and Virginia Adams
© 1989 Joanna T. Steichen

PAGE 15
Alvin Langdon Coburn
The Octopus, New York [a variant], 1912
Gelatin silver print
Courtesy of the International Museum of
Photography at the George Eastman House

PAGE 15
Alvin Langdon Coburn
The Singer Building, Noon, ca. 1910 [from
New York, 1910]
Photogravure, 20.8 x 6.5cm
78:196:010

PAGE 16
Karl Struss
*Vanishing Point II: Brooklyn Bridge from the
New York Side*, 1912
Platinum print, 9.7 x 11.8cm
79:062:010
© 1983 Amon Carter Museum

PAGE 16
Jacques Henri Lartigue
Cousin "Bichonade" in Flight, 1905
Gelatin silver print, 16.9 x 23.0cm
76:245:001
© Association des Amis de Jacques-Henri
Lartigue – Paris, France

PAGE 17
Alvin Langdon Coburn
Vortograph, 1917
Gelatin silver print
Courtesy of the International Museum of
Photography at the George Eastman House

PAGE 17
Paul Strand
*Still Life, Pear and Bowls, Twin Lakes,
Connecticut*, 1915/1983
Platinum print by Richard M. A. Benson,
25.4 x 28.7cm
84:028:028
© 1981 Aperture Foundation, Inc., Paul
Strand Foundation

W. Eugene Smith Archive
Reprinted from *Master of the Photographic
Essay*, © 1981 The Heirs of W. Eugene Smith

PAGE 68
Wynn Bullock
Child in the Forest, 1951
Gelatin silver print, 19.1 x 24.5cm
76:051:001
© 1971 Wynn and Edna Bullock Trust

PAGE 68
Harry Callahan
[Eleanor and Barbara], 1954
Gelatin silver print, 17.2 x 16.8cm
79:049:001
© 1954 Harry Callahan

PAGE 69
Paul Caponigro
Ice, Nahant, Massachusetts, 1958
Gelatin silver print, 18.8 x 24.0cm
82:017:014
© 1989 Paul Caponigro

PAGE 70
Robert Frank
Newburgh, New York, 1955–1956 [from *The
Americans*]
Gelatin silver print, 31.7 x 21.0cm
78:172:005
Anonymous gift
© 1958 Robert Frank
Courtesy Pace/MacGill Gallery, New York

PAGE 71
Robert Frank
City Fathers, Hoboken, New Jersey, 1955–1956
[from *The Americans*]
Gelatin silver print, 35.8 x 47.6cm
79:045:004
© 1958 Robert Frank
Courtesy Pace/MacGill Gallery, New York

PAGE 72
Harry Callahan
Chicago, 1961
Gelatin silver print, 24.1 x 15.9cm
79:049:002
Harry Callahan Archive
© 1961 Harry Callahan

PAGE 73
Frederick Sommer
Dürer Variation #2, 1966
Gelatin silver print, 24.2 x 19.5cm
77:073:001
Frederick Sommer Archive
© 1984 Frederick Sommer

PAGE 76
Garry Winogrand
New York City, 1969
Gelatin silver print, 22.4 x 33.6cm
79:030:005
© 1984 The Estate of Garry Winogrand

PAGE 76
Lee Friedlander
TV in Hotel Room, Galax, Virginia, 1962
Gelatin silver print, 14.2 x 22.4cm
76:224:001
© 1978 Lee Friedlander

PAGE 77
W. Eugene Smith
[from the Protest in the 1960s series], 1960s
Gelatin silver print, 31.4 x 22.0cm
82:135:002
W. Eugene Smith Archive
Reprinted from *Master of the Photographic
Essay*, © 1981 The Heirs of W. Eugene Smith

PAGE 78
Danny Lyon
The Line, Ferguson Unit, Texas [from the
Conversations with the Dead series, 1967–
1969]
Gelatin silver print, 22.0 x 32.9cm
86:064:011
Gift of Robert Callaway
© 1969, 1970, 1971 Danny Lyon

PAGE 78
Bruce Davidson
[child with doll carriage], 1965 [from the
Welsh Miners series]
Gelatin silver print, 20.2 x 29.8cm
85:038:001
Gift of Bruce Davidson in memory of Lee
Witkin
© 1965 Bruce Davidson

PAGE 78
Roy DeCarava
Three Men with Hand Trucks, New York, 1963
Gelatin silver print, 22.8 x 32.7cm
81:095:012
© 1981 Roy DeCarava

PAGE 78
Larry Clark
[man with bowed head, hands clasped behind
neck] [from the Tulsa series, 1963–1971]
Gelatin silver print, 20.7 x 31.0cm
82:092:016
Gift of Mimi and Ariel Halpern
© 1971 Larry Clark

PAGE 79
Emmet Gowin
Edith, Danville, Virginia, 1967
Gelatin silver print, 16.1 x 16.1cm
79:061:010
1979 National Endowment for the Arts
Museum Purchase
© 1976 Emmet Gowin

PAGE 79
Ralph Gibson
San Francisco, 1960
Gelatin silver print, 31.4 x 20.6cm
86:054:017
© 1960 Ralph Gibson

PAGE 80
Aaron Siskind
Chicago 56, 1960
Gelatin silver print, 35.4 x 45.4cm
76:065:006
Aaron Siskind Archive
© 1989 Aaron Siskind

PAGE 80
Minor White
Bill LaRue, Shore Acres, Oregon, 1960 [from
the *Sequence 17* portfolio, Second Movement
series, 1963]
Gelatin silver print, 23.1 x 15.2cm
76:008:016
Gift of Arnold Rustin, M.D.
© 1982 The Trustees of Princeton University

PAGE 81
Wynn Bullock
Sea Palms, 1968
Gelatin silver print, 19.7 x 24.2cm
76:051:081
Wynn Bullock Archive
© 1971 Wynn and Edna Bullock Trust

PAGE 81
Paul Caponigro
Stone and Tree, Avebury, England, 1967
Gelatin silver print, 17.3 x 24.0cm
76:213:004
© 1989 Paul Caponigro

PAGE 82
Robert Heinecken
U.C.B. Pin Up, 1968
Black-and-white film transparency over
magazine collage, 21.7 x 14.8cm
81:010:023
© 1980 Robert Heinecken

PAGE 83
Jerry Uelsmann
Small Woods Where I Met Myself, 1967
Gelatin silver print, 26.6 x 52.4cm
76:007:023
© 1967 Jerry Uelsmann

PAGE 86
Linda Connor
[pyramid of metal cans], 1976
Gold-toned printing-out-paper print,
19.2 x 23.3cm
76:217:002
© 1979 Linda Connor

PAGE 86
Kenneth Josephson
Chicago, 1970
Gelatin silver print, 23.0 x 22.9cm
80:009:011
© 1989 Kenneth Josephson

PAGE 86
Barbara Crane
Bicentennial Polka, 1975 [from the Baxter/
Travenol Lab series]
Gelatin silver print, 50.5 x 40.4cm
81:195:011
© 1981 Barbara Crane

PAGE 86
William Larson
[from the Transmissions series], 1975
Electro-carbon print transmitted by the
Graphic Sciences Teleprinter, 28.1 x 21.5cm
82:067:006
Gift of William Larson
© 1975 William Larson

PAGE 87
Jack Welpott
Linda in Her Birthday Suit, 1975
Gelatin silver print, 29.6 x 22.8cm
80:150:004
© 1975 Jack Welpott

PAGE 88
Judy Dater
Laura Mae, 1973
Gelatin silver print, 23.5 x 18.5cm
76:219:010
© 1975 Judy Dater

PAGE 89
Paul Diamond
Man Smoking (Larry), New York, 1974
Gelatin silver print, 39.5 x 49.9cm
80:085:002
© 1989 Paul Diamond

PAGE 90
Bill Owens
[young couple in bedroom], ca. 1975 [from the
Suburbia series]
Gelatin silver print, 16.1 x 20.5cm
80:095:007
© 1973 Bill Owens

PAGE 91
Lewis Baltz
Nevada 33, Looking West, 1977 [from the
Nevada portfolio, 1978]
Gelatin silver print, 16.2 x 24.2cm
86:097:014
Gift of Marvin E. Pitts
© 1978 Lewis Baltz

PAGE 91
Joe Deal
Brea, California, 1979 [from the *Fault Zone*
portfolio, 1981]
Gelatin silver print, 28.5 x 28.5cm
82:074:006
© 1979 Joe Deal

PAGE 93
Robert Fichter
[palm tree and grass], June 1976
Gelatin silver print collage, 33.3 x 27.9cm
[irregular]
76:097:004
Gift of Robert Fichter
© 1989 Robert Fichter

PAGE 94
Todd Walker
Chris, Veiled, 1970
Solarized gelatin silver print, 24.7 x 18.5cm
86:027:002
Gift of Todd Walker
© 1970 Todd Walker

PAGE 96
Thomas Barrow
[from *Trivia 2*], 1973
Verifax, 22.8 x 41.0cm [book]
76:207:000
© 1989 Thomas F. Barrow

DUOTONE PORTFOLIO

PLATE 1
Frank Eugene
La Cigale, 1899
Photogravure, 12.1 x 16.7cm
76:204:003

PLATE 2
Adelaide Hanscomb
[Charles Keeler posing for an illustration from
the Rubaiyat of Omar Khayyam], ca. 1903–
1905
Gelatin silver print, 17.0 x 11.2cm
88:056:001

PLATE 3
Gertrude Käsebier
The Manger, ca. 1899
Photogravure, 21.0 x 14.7cm
76:204:002

PLATE 4
Imogen Cunningham
In My Studio in Seattle, 1117 Terry Avenue,
1910
Platinum print, 16.0 x 11.4cm
87:018:001
Gift of Dan Berley
© 1978 The Imogen Cunningham Trust

PLATE 5
George H. Seeley
Maiden with Bowl, ca. 1915
Platinum print, 24.1 x 19.3cm
86:049:001

PLATE 6
Clarence White
[marble pillars and railings, Columbia
College, New York], ca. 1910
Platinum print, 20.9 x 15.8cm
87:070:001

PLATE 7
Laura Gilpin
The Marble Cutters, 1917
Platinum print, 20.3 x 15.3cm
77:023:009
©1981 Amon Carter Museum

PLATE 8
Paul L. Anderson
Under the Brooklyn Bridge, 1917/1945
Palladium print, 15.2 x 20.1cm
80:170:042
Gift of Mrs. Raymond C. Collins
© 1985 Mrs. Raymond C. Collins

PLATE 9
Alvin Langdon Coburn
The Park Row Building, 1910 [from *New York*,
1910]
Photogravure, 20.3 x 15.8cm
78:196:018

85:056:014
©1989 Harold Edgerton

PLATE 34
Wynn Bullock
Light Abstraction, 1939
Gelatin silver print, 20.3 x 14.5cm
76:051:084
Wynn Bullock Archive
© 1971 Wynn and Edna Bullock Trust

PLATE 35
Ansel Adams
Windmill, Owens Valley, 1958
Gelatin silver print, 28.3 x 19.6cm
84:090:056
Ansel Adams Archive
Courtesy the Ansel Adams Publishing Rights
Trust

PLATE 36
Weegee (Arthur Fellig)
[Metropolitan Opera House recital], undated
Gelatin silver print, 27.1 x 34.0cm
76:067:001

PLATE 37
Lisette Model
Singer at the Café Metropole, New York City,
undated
Gelatin silver print, 49.1 x 38.9cm
77:020:010
© The Estate of Lisette Model, Joseph G.
Blum, executor

PLATE 38
Arthur Rothstein
*Aletia Berdolph in Log Cabin, Gee's Bend,
Alabama*, 1937/ca. 1982 [from *A Portfolio of
Photographs by Arthur Rothstein*, ca. 1982]
Gelatin silver print, 22.4 x 30.6cm
85:096:012

PLATE 39
Marion Palfi
In the Shadow of the Capitol, Washington, D.C.
[from the Suffer Little Children series, 1946–
1949]
Gelatin silver print, 24.2 x 18.4cm
83:103:145
Marion Palfi Archive/Gift of the Menninger
Foundation and Martin Magner
© 1978 Martin Magner

PLATE 40
Arthur Rothstein
Young Coal Miner, Wales, 1947/ca. 1982 [from
A Portfolio of Photographs by Arthur Rothstein,
ca. 1982]

Gelatin silver print, 30.4 x 22.7cm
85:096:044
Photograph by Arthur Rothstein: all rights
reserved

PLATE 41
Wright Morris
Gano Grain Elevator, 1940
Gelatin silver print, 24.3 x 19.3cm
81:015:005
© 1946 Wright Morris

PLATE 42
Edward Weston
Mr. and Mrs. Fry Burnett, Austin, Texas, 1941
Gelatin silver print, 24.3 x 19.3cm
81:110:111
© 1981 Center for Creative Photography,
Arizona Board of Regents

PLATE 43
Harry Callahan
Eleanor, 1949
Gelatin silver print, 19.3 x 24.3cm
76:051:006
Harry Callahan Archive
© 1949 Harry Callahan

PLATE 44
Clarence John Laughlin
Light and Time, 1947
Gelatin silver print, 24.7 x 18.7cm
76:246:001
© 1981 The Historic New Orleans Collection

PLATE 45
Frederick Sommer
Medallion, 1948
Gelatin silver print, 19.4 x 24.2cm
76:052:027
Frederick Sommer Archive
© 1984 Frederick Sommer

PLATE 46
Aaron Siskind
[ironwork, New York City], 1947
Gelatin silver print, 23.7 x 18.0cm
80:165:008
Aaron Siskind Archive
© 1989 Aaron Siskind

PLATE 47
Minor White
Sun over the Pacific – Devil's Slide, 1947 [from
the *Jupiter Portfolio*, 1975]
Gelatin silver print, 18.8 x 25.2cm
76:267:001
© 1982 The Trustees of Princeton University

PLATE 48
Ruth Bernhard
Rockport Nude, ca. 1946
Gelatin silver print, 34.7 x 20.2cm
85:076:009
Gift of Ruth Bernhard
© 1947 Ruth Bernhard

PLATE 49
Barbara Morgan
*Martha Graham – El Penitente – Erick
Hawkins Solo as El Flagellante*, 1940
Gelatin silver print, 45.5 x 34.3cm
76:558:003
Gift of Ansel and Virginia Adams
© 1980 Barbara Morgan

PLATE 50
Sid Grossman
Folksingers I – Sonny Terry, ca. 1946–1948
Gelatin silver print, 23.9 x 19.7cm
87:020:003
© 1987 Miriam Grossman Cohen

PLATE 51
Arnold Newman
Kuniyoshi, 1941
Gelatin silver print, 19.5 x 24.6cm
78:045:012
Anonymous gift
© Arnold Newman

PLATE 52
Max Yavno
Two Chinese, 1947
Gelatin silver print, 33.9 x 26.4cm
79:024:014
© 1989 The Estate of Max Yavno

PLATE 53
Louise Dahl-Wolfe
In Sarasota, 1947
Gelatin silver print, 25.8 x 22.7cm
85:017:009
Gift of Louise Dahl-Wolfe
© 1989 Louise Dahl-Wolfe

PLATE 54
Robert Frank
New York City, 1948
Gelatin silver print, 24.6 x 17.8cm
79:045:001
Gift of Mr. and Mrs. Harry H. Lunn, Jr.
© 1980 Robert Frank
Courtesy Pace/MacGill Gallery, New York

PLATE 55
Andreas Feininger
Burlesque in New York, ca. 1941

Gelatin silver print, 34.1 x 26.7cm
81:039:248
Andreas Feininger Archive
© 1941 Andreas Feininger

PLATE 56
W. Eugene Smith
Jeep at Guadalcanal, 1944
Gelatin silver print, 25.6 x 34.1cm
82:102:055
W. Eugene Smith Archive
Reprinted from *Master of the Photographic
Essay*, © 1981 The Heirs of W. Eugene Smith

PLATE 57
Aaron Siskind
Martha's Vineyard 20, 1953
Gelatin silver print, 15.4 x 24.0cm
76:063:016
Aaron Siskind Archive
© 1989 Aaron Siskind

PLATE 58
Charles Sheeler
RCA Building, 1950
Gelatin silver print, 23.4 x 15.8cm
76:350:002

PLATE 59
Margaret Bourke-White
George Washington Bridge, 1953
Gelatin silver print, 34.0 x 24.2cm
83:116:001
Gift of John and Wendy Kriendler
© 1989 Margaret Bourke-White Estate

PLATE 60
Ansel Adams
*Half Dome from Glacier Point, Yosemite
National Park*, ca. 1956
Gelatin silver print, 32.9 x 24.6cm
84:091:121
Ansel Adams Archive
Courtesy the Ansel Adams Publishing Rights
Trust

PLATE 61
Don Worth
Aspen Trees, New Mexico, 1958
Gelatin silver print, 28.0 x 22.5cm
79:042:001
© 1989 Don Worth

PLATE 62
Wynn Bullock
Palo Colorado Road, 1952
Gelatin silver print, 24.0 x 19.1cm
76:051:058

Wynn Bullock Archive
©1973 Wynn and Edna Bullock Trust

PLATE 63
Frederick Sommer
The Thief Greater Than His Loot, 1955
Gelatin silver print, 24.1 x 18.7cm
76:032:033
Frederick Sommer Archive
© 1984 Frederick Sommer

PLATE 64
W. Eugene Smith
[Maude Callen examining young boy's face by
lamp], 1951 [from the Nurse Midwife series]
Gelatin silver print, 26.7 x 34.2cm
82:116:070
W. Eugene Smith Archive
Reprinted from *Master of the Photographic
Essay*, © 1981 The Heirs of W. Eugene Smith

PLATE 65
William Klein
Stickball Dance, 1954
Gelatin silver print, 26.0 x 36.0cm
81:140:002
© 1989 William Klein

PLATE 66
Weegee (Arthur Fellig)
Cannon Shot, 1952
Gelatin silver print, 32.6 x 26.8cm
76:066:003

PLATE 67
Richard Avedon
Marian Anderson, 30 June 1955
Gelatin silver print, 37.5 x 49.8cm
87:034:001
© 1955 Richard Avedon, Inc.; all rights
reserved

PLATE 68
Jerry Uelsmann
[hands and torn screen], 1959
Gelatin silver print, 15.8 x 14.8cm
77:021:034
On loan from Jerry Uelsmann
© 1959 Jerry Uelsmann

PLATE 69
Imogen Cunningham
Minor White, Photographer, 1963
Gelatin silver print, 17.5 x 18.2cm
76:060:024
© 1970 The Imogen Cunningham Trust

PLATE 70
Garry Winogrand

[car interior, laughing driver, view of house
trailer], undated
Gelatin silver print, 23.1 x 34.1cm
83:195:004
Garry Winogrand Archive
© 1984 The Estate of Garry Winogrand

PLATE 71
Roy DeCarava
Graduation, 1952
Gelatin silver print, 22.3 x 32.8cm
78:135:006
© 1981 Roy DeCarava

PLATE 72
Harry Callahan
Collage, Chicago, 1957
Gelatin silver print, 19.4 x 24.4cm
79:029:017
Harry Callahan Archive
© 1957 Harry Callahan

PLATE 73
Barbara Crane
Neon Cowboy, Las Vegas, Nevada, 1969
Gelatin silver print, 35.1 x 27.3cm
81:195:001
© 1981 Barbara Crane

PLATE 74
Jerome Liebling
Slaughter House, South St. Paul, Minnesota,
1962
Gelatin silver print, 25.5 x 24.3cm
77:060:004
© 1989 Jerome Liebling

PLATE 75
George Tice
*Horse and Buggy in Farmyard, Lancaster,
Pennsylvania*, 1965
Gelatin silver print, 5.4 x 15.7cm
77:025:010
Gift of George Tice
© 1970 George Tice

PLATE 76
Lee Friedlander
Route 9W, New York, 1969
Gelatin silver print, 18.9 x 28.3cm
81:096:004
© 1978 Lee Friedlander

PLATE 77
Kenneth Josephson
Stockholm, 1967
Gelatin silver print, 20.2 x 30.6cm
© 1989 Kenneth Josephson

PLATE 78
Bradford Washburn
*Annual Banding ("Ogives") of Yentna Glacier,
near Mt. Foraker, Alaska*, 4 October 1964
Gelatin silver print, 58.8 x 48.2cm
82:079:006
© 1989 Bradford Washburn

PLATE 79
Ansel Adams
*The Great Plains from Cimarron, New Mexico,
1961*
Gelatin silver print, 56.5 x 48.5cm
84:092:551
Ansel Adams Archive
Courtesy the Ansel Adams Publishing Rights
Trust

PLATE 80
W. Eugene Smith
Earl Hines, undated [from the Jazz and Folk
Musicians series, ca. 1959–1969]
Gelatin silver print, 24.4 x 52.4cm
82:151:004
W. Eugene Smith Archive
Reprinted from *Master of the Photographic
Essay*, © 1981 The Heirs of W. Eugene Smith

PLATE 81
Larry Clark
[Billy Mann in bed smoking a cigarette and
holding his baby], 1965 [from the Tulsa series,
1963–1971]
Gelatin silver print, 51.6 x 20.9cm
82:092:023
Gift of Mimi and Ariel Halpern
© 1971 Larry Clark

PLATE 82
Emmet Gowin
Edith, Ruth, and Mae, Danville, Virginia, 1967
Gelatin silver print, 15.4 x 17.0cm
76:236:001
© 1976 Emmet Gowin

PLATE 83
Dean Brown
[from the Martin Luther King series], 1969
Kodalith transparencies, approximately 8.8 x
10.5cm each
78:203:015, 008, 005, 006
Dean Brown Archive
© 1982 Carol Brown

PLATE 84
Danny Lyon
Shakedown, Ramsey Unit, Texas [from the

Conversations with the Dead series, 1967–
1969]
Gelatin silver print, 22.2 x 33.0cm
80:050:017
© 1969, 1970, 1971 Danny Lyon

PLATE 85
Judy Dater
Joyce Goldstein in Her Kitchen, 1969 [from the
Ten Photographs portfolio, 1974]
Gelatin silver print, 25.4 x 18.8cm
76:219:001
© 1975 Judy Dater

PLATE 86
Mary Ellen Mark
Victor Orellanes in Brooklyn, June 1978
Gelatin silver print, 20.5 x 30.8cm
81:160:001
Gift of the American Telephone and
Telegraph Company
© 1978 Mary Ellen Mark

PLATE 87
Linda Connor
Ceremony, Sri Lanka, 1979
Gold-toned printing-out-paper print,
19.4 x 24.4 cm
82:047:006
© 1989 Linda Connor

PLATE 88
Aaron Siskind
Leaves 50, 1970
Gelatin silver print, 27.5 x 25.0cm
76:064:026
Aaron Siskind Archive
© 1989 Aaron Siskind

PLATE 89
Ralph Gibson
[partial view of pin-striped suit], 1975
Gelatin silver print, 45.9 x 30.4cm
77:016:001
© 1975 Ralph Gibson

PLATE 90
Duane Michals
Joseph Cornell, 1976 [from bound portfolio,
Album No. 8, 7 December 1976]
Gelatin silver print, 11.7 x 17.6cm
77:008:003
© 1972 Duane Michals

PLATE 91
Jerry Uelsmann
Gifts of St. Ann, 1976
Gelatin silver print, 26.3 x 30.2cm

76:007:080
© 1976 Jerry Uelsmann

PLATE 92
Arthur Tress
Boy in Flood Dream, 1970
Gelatin silver print, 39.0 x 39.0cm
85:009:004
© 1970 Arthur Tress

PLATE 93
Joseph Jachna
Door County, Wisconsin, 1970
Gelatin silver print, 17.7 x 26.7cm
79:086:022
Gift of Mr. and Mrs. Bernard R. Wolf
© 1989 Joseph D. Jachna

PLATE 94
William Clift
*Law Books, Hinsdale County Courthouse, Lake
City, Colorado*, ca. 1975 [from the *County
Courthouses* portfolio, undated]
Gelatin silver print, 26.7 x 35.7cm
80:005:004
© 1975 William Clift

PLATE 95
Harry Callahan
Providence, 1976
Gelatin silver print, 23.0 x 22.7cm
79:110:015
Harry Callahan Archive
© 1976 Harry Callahan

PLATE 96
Paul Berger
Camera Text or Picture #2, 1979
Gelatin silver print, 28.0 x 41.7cm
79:054:002
© 1989 Paul Berger

PLATE 97
Frederick Sommer
Cut Paper, 1971
Gelatin silver print, 23.3 x 16.6cm
76:032:041
Frederick Sommer Archive
© 1984 Frederick Sommer

PLATE 98
Robert Adams
Garden of the Gods, El Paso County, Colorado,
1977
Gelatin silver print, 22.3 x 28.4cm
81:157:003
Gift of the American Telephone and
Telegraph Company
© 1980 Robert Adams

ABOUT THE CONTRIBUTORS

VAN DEREN COKE
is a curator, a historian, and the author of books on the history of nineteenth- and twentieth-century photography. His extensive list of books, catalogs, and monographs includes *The Painter and the Photograph: From Delacroix to Warhol* (1972), *Avant-Garde Photography in Germany 1919–1939* (1982), and *Photography: A Facet of Modernism* (with Diana Du Pont, 1986). Formerly art department chairman of the University of New Mexico, director of the International Museum of Photography at George Eastman House, and director, department of photography of the San Francisco Museum of Modern Art, he is today a distinguished professor at Arizona State University in Tempe. He is a recipient of a Guggenheim fellowship (1975) and a member of the board of directors, College Art Association.

CHARLES DESMARAIS
is a curator and the author of essays and articles on twentieth-century photography. His essays have been published in *Afterimage*, *Art in America*, *Artweek*, and *Exposure*. Formerly assistant editor of *Afterimage*, director of the Chicago Center for Contemporary Photography, director of the California Museum of Photography at Riverside, he is currently director of the Laguna Art Museum. He received an Art Critic's Fellowship from the National Endowment for the Arts in 1979.

JAMES ENYEART
is a curator and historian of nineteenth- and twentieth-century photography. Among his books on twentieth-century artists are *Francis Bruguière: His Life and His Art* (1977), *Jerry Uelsmann: Twenty-five Years, A Retrospective* (1982), *Edward Weston's California Landscapes* (1984), and *Judy Dater: Twenty Years* (1986). Formerly director of the Friends of Photography and curator of photography and associate professor in the department of art history at the University of Kansas, he is currently director of the Center for Creative Photography, University of Arizona. He has received two fellowships from the National Endowment for the Arts, for writing (1974) and photography (1975). He is also the recipient of a Guggenheim fellowship (1987).

HELEN GEE
established Limelight, the first gallery devoted exclusively to photography, in New York in the fifties. From 1954 to 1961, she organized sixty-one exhibitions there. Since 1961, she has worked as a fine arts consultant to corporations and private collectors. She is the author of *Photography of the Fifties* (1980) and teaches at the Parsons School of Design, New York. Her personal correspondence, printed materials, and records of the Limelight are in the archives of the Center for Creative Photography, University of Arizona.

ESTELLE JUSSIM
is the author of books on the history and criticism of photography, communication theory, and the psychology of popular arts. Among her books are *Visual Communication and the Graphic Arts* (1974); *Slave to Beauty* (1982); and *Landscape as Photograph* (1985), with coauthor Elisabeth Lindquist-Cock. Professor Jussim teaches the history of photography and visual communication at Simmons College in Boston. She is the recipient of a Guggenheim fellowship (1982), a member of the board of the Visual Studies Workshop, and on the international board of advisers of *The History of Photography* magazine in London.

NATHAN LYONS
is a photographer, curator, author, and educator. As a writer and editor, Lyons has produced pioneering books and catalogs on twentieth-century critical concerns of photographers and critics. Among his publications are *Photographers on Photography* (1966), *Photography in the Twentieth Century* (1967), *Vision and Expression* (1969), and *Notations in Passing* (1974). Formerly editor of publications and associate director of the International Museum of Photography at George Eastman House and professor at SUNY at Buffalo, he is today director of the Visual Studies Workshop in Rochester, New York, which he founded in 1969. He also is professor and director of visual studies at SUNY at Brockport, New York. He is a founder of the Society for Photographic Education (1963) and has received a National Endowment for the Arts Fellowship (1974) and a Senior Fellowship (1986). He has been chairman of the board of the New York Foundation for the Arts from 1977 to the pres-

ent and in 1987 received its Champion for the Arts Award.

TERENCE PITTS
is a curator and historian of nineteenth- and twentieth-century photography. Among his publications are *One Hundred Years of Photography in the American West: Selections from the Amon Carter Museum* (1987), *Photography in the American Grain: Discovering a Native American Aesthetic 1923–1941* (1988), and *4 Spanish Photographers* (1988). He is curator of the Center for Creative Photography at the University of Arizona and has received a National Endowment for the Arts Fellowship for Museum Professionals (1985).

NAOMI ROSENBLUM
is a historian and essayist on nineteenth- and twentieth-century photography. Among her books are *America and Lewis Hine* (1977), coauthored with Walter Rosenblum and Alan Trachtenberg; *American Art* (1979), coauthored with Milton Brown, Sam Hunter, and John Jacobus; and *A World History of Photography* (1984). She is adjunct professor of art history and the history of photography at the Parsons School of Design, New York. She has also taught at the Tisch School of the Arts and the Graduate Center, CUNY. She has curated exhibitions for the Brooklyn Museum and the Royal Scottish Academy, Edinburgh.

MARTHA SANDWEISS
is a curator and historian of nineteenth- and twentieth-century photography. Among her books are *Carlotta Corpron: Designer with Light* (1980), *Masterworks of American Photography: The Amon Carter Collection* (1982), and *Laura Gilpin: An Enduring Grace* (1986). Formerly a teaching fellow in the department of art history at Yale University and curator of photographs at the Amon Carter Museum, she is currently conducting independent research and is adjunct curator of photography at the Amon Carter Museum. She has received a National Endowment for the Humanities–Smithsonian Institute Fellowship (1975), the George Wittenborn Award from the Art Libraries Society of North America for the outstanding art book of the year (1987), and a National Endowment for the Humanities Fellowship for Independent Scholars (1988).

INDEX

Designed by Susan Marsh
Production coordination by Christina M. Holz
Composition in Linotype Walbaum by Dix Type, Inc.
Display composition in Monotype Walbaum by Michael Bixler
Printed by Franklin Graphics
Bound by Horowitz/Rae Book Manufacturers, Inc.